ƎD TOONS

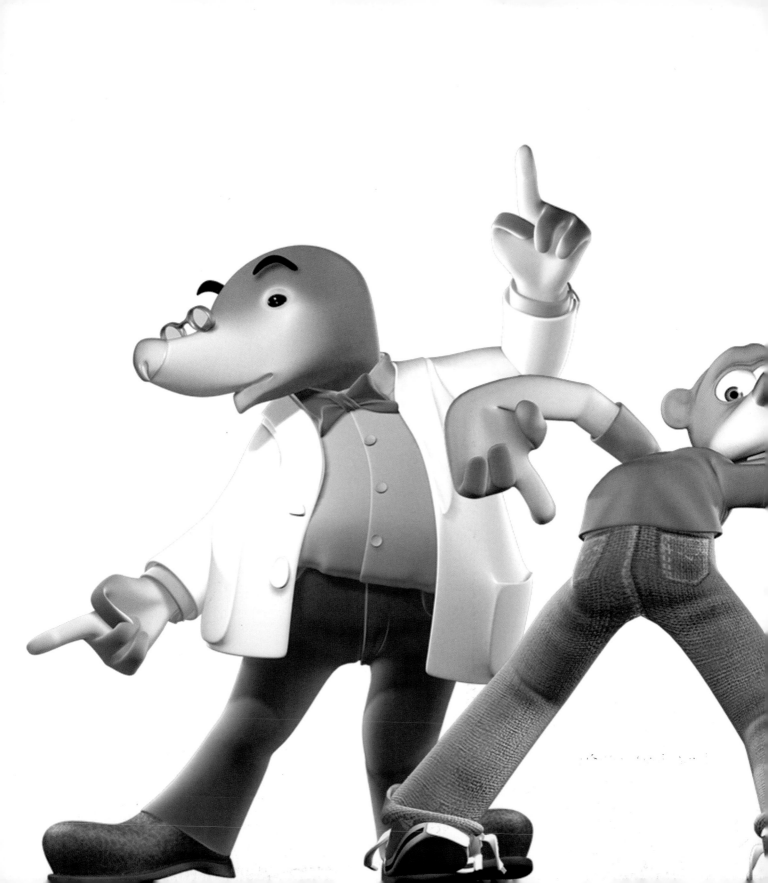

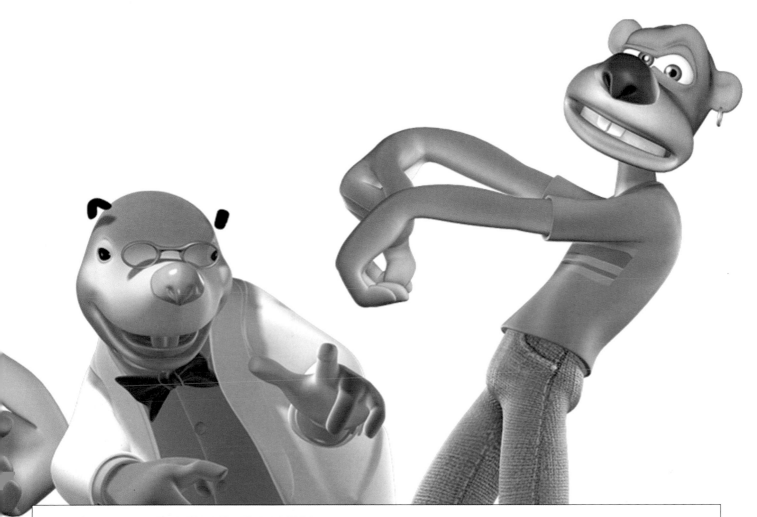

STEVE & RAF ANZOVIN

ƎD TOONS

CREATIVE ƎD DESIGN FOR CARTOONISTS AND ANIMATORS

BARRON'S

All inquiries should be addressed to:
Barron's Educational Series, Inc.
250 Wireless Boulevard
Hauppauge, NY 11788
www.barronseduc.com

International Standard Book No. 0-7641-2951-1

Library of Congress Catalog Card No. 2004107404

ILEX Editorial, Lewes:
Publisher: Alastair Campbell
Executive Publisher: Sophie Collins
Creative Director: Peter Bridgewater
Managing Editor: Tom Mugridge
Editor: Stuart Andrews
Design Manager: Tony Seddon
Design: Jonathan Raimes
Junior Designer: Jane Waterhouse

ILEX Research, Cambridge:
Development Art Director: Graham Davis
Technical Art Director: Nicholas Rowland

This book was conceived, designed, and produced by:
ILEX, Cambridge, England

For more information about this title, please visit:
www.web-linked.com/3DTOUS

Manufactured in China

9 8 7 6 5 4 3 2 1

CONTENTS

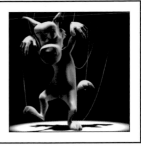

3D TOONS

INTRODUCTION

The cartoon, a simplified, often humorous or satirical drawing, developed early in the history of art—it is certainly possible to view ancient Egyptian, Greco-Roman, and pre-Colombian wall paintings and pictographic codices as cartoons of a sort— came into its own as a medium of entertainment in the 19th century with the development of the newspaper comics panel and political drawing. Nowadays, we apply the term *cartoon* very widely, not only to single-panel "funny pictures," but also to comic strips and comic books and sophisticated graphic novels, animation of all kinds, and even some forms of puppetry. The common thread among all these diverse media is the use of stylized, iconic characters, which we also call cartoons, or simply "toons." The fact that people rarely distinguish in speech between "the cartoon image" and "the cartoon character," using in English the same word for both, indicates their close association.

CARTOONS AND TRADITIONAL ANIMATION

Animation and comic books, the two dominant and interdependent forms of what Will Eisner has termed *sequential art*, a narrative series of related graphic images, have done the most to bring cartoon art to the widest possible world audience. Animation, the cinematic form of sequential art, naturally evolved from film, although it took several decades to perfect a basic industrialized animation process that could produce moving images of significant duration in a reasonable amount of time. The traditional animation method, as developed by the early animation artists and perfected in the 1930s by the Disney Studio, involved the creation by highly skilled artists of hundreds or thousands of related drawings on transparent sheets of plastic. The entire sequence was designed to tell a story in motion. Each cel was filmed by a movie camera, one picture per frame of film. When viewed at film speeds (12 to 24 frames per second), the film frames merged in the mind's eye to present a seamless animated motion picture.

The immense skill and labor involved in making traditional animation—the huge number of drawings and backgrounds, often in several layers, all of which had to be aligned and colored perfectly— naturally suggested (enforced, actually) the use of cartoon characters, which are far easier to draw, even for master draftsmen, than more realistic subjects. A few avant-garde efforts apart, essentially all traditional animation is cartoon animation.

The traditional animation process has changed little since roughly 1937 and is still very much in use today. Traditional animators still sit at special rotating drawing tables that allow them to see their drawings from any angle as they apply their pencils or pens to paper or cels. But the work of the lead animator is only the beginning. An army of redrawers, in-betweeners (who interleave additional drawings "inbetween" the lead animator's as needed to smooth the perceived motion), inkers and colorists and matte painters, camera operators, effects specialists, and production checkers are needed to craft the final product.

Just as the animation work process resembles a 19th-century mill operation, the technology of traditional animation is essentially 19th century in nature. The most technical piece of custom equipment in the traditional studio, the animation stand, is a fairly straightforward assemblage of pegs, plate glass, worm gears, and set screws. The biggest news in traditional toon technology, post *Snow White*, was the advent of the affordable copy machine in the 1960s. This technological stasis appears to have affected the artistic quality of the medium. It's generally acknowledged by critics that the animated film reached its nadir in the 1960s and '70s, with films by the Disney Studio especially registering a profound drop in imaginativeness.

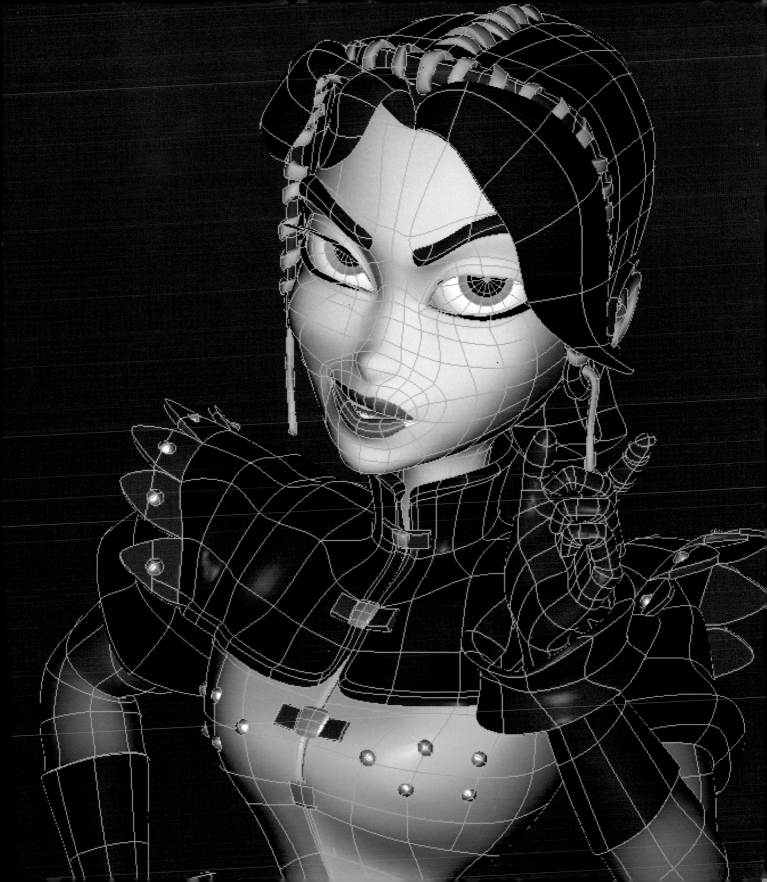

IT TOOK AN ENTIRELY DIFFERENT TECHNOLOGY—THREE-DIMENSIONAL (3D) DIGITAL COMPUTER GRAPHICS (CG)—TO INJECT NEW LIFE INTO THE ANIMATED CARTOON. THERE IS A PROFOUND IRONY IN THIS, FOR COMPUTER GRAPHICS WAS ORIGINALLY INTENDED BY ITS PIONEERS AS A MEANS TO SIMULATE REALITY WITH EVER-INCREASING SOPHISTICATION AND ACCURACY—EXACTLY THE REVERSE OF THE ESSENCE OF THE CARTOON, WHICH IS REDUCTIVE AND ICONIC.

INTRODUCTION

The driving force behind the development of digital graphics, beginning in the 1960s, was military and scientific. Researchers sought to create a "virtual space," a database of Cartesian coordinates that would be translated by software into an interactive illusion of three-dimensionality on a computer screen. Most of the early work was done to perfect such applications as flight simulators and computer-aided design (although the first computer game, Steve Russell's *Spacewar*, was developed at MIT as early as 1961). By today's standards, these first efforts look crude and unconvincing. But they were nonetheless revolutionary, and provided the basic tools for all that has come later.

By the mid-1970s, the necessary computer graphics hardware and algorithms were available to programmers outside the defense contractors and major university centers, and a number of companies began creating computer graphics entertainment for television, film, and the nascent field of computer gaming. However, artists who moved over from traditional media to CG found a very different and rather confusing world. Instead of the intuitional hand-eye process of wielding pencil or brush, artists had to accustom themselves to working secondhand through a keyboard, graphics tablet, and computer screen. Worse, their creative flow of ideas was broken, because 3D requires that everything be done in incremental little steps.

To get anywhere, 3D artists (and software designers) discovered they had to think successively like a designer, a sculptor, a painter, a puppeteer, an animator (if the work is to be animated), a set designer, a lighting technician, and a camera operator. The first step, after sketching out the basic concepts (usually on paper, ironically) is to model a form, a process vaguely analogous to building it with toothpicks or wire. Then you texture the model, which combines analogues of applying decals and painting with a brush, but also usually involves imbuing the model with mathematical attributes like specularity and sub-surface scattering. If you are building a character to be posed and animated, you typically rig it next, adding an internal "skeleton" to aid in manipulating the model in a lifelike manner. The animation stage comes next, and it is also quite different from the traditional method (a point made well by master Israeli animator Doron Meir in his essay later in this book). Finally, you light the scene you've

LEFT: Clean lines and smooth surfaces are perfect for the 3D toon, but it takes artistic imagination to make something witty or interesting out of it.

RIGHT: At heart, every 3D toon is little more than a mesh with added texture and lighting. With the right artist, however, it becomes something much, much more.

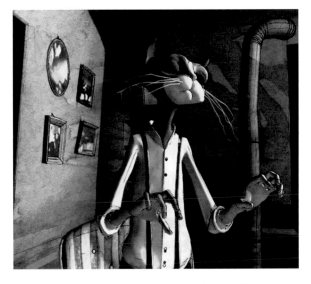

created with virtual lights based on real movie lighting kits, place a camera to capture the point of view you wish to show, then render or generate the individual images that, like traditional animation cels, will be projected fast enough to fool the human eye into perceiving smooth motion.

Early 3D animation typically featured spaceships and robots and other hard-edged objects, as these were relatively easy to build and depict with the software of the time (and congenial to the imaginations of the sci-fi-oriented CG community). But artists quickly turned to the cartoon as their primary style of expression when depicting characters. In large part, this is because similar constraints apply to both traditional and 3D animation. The graphic simplicity of the cartoon is forced on traditional animation because it is easier and quicker to draw. The cartoon was likewise favored by 3D artists because 3D software was still in a primitive state that makes it extremely hard to truly simulate reality.

It continues to be true that much CG research is obsessed with the quest for total photorealism. The field has advanced to the point where digital effects can be inserted into live-action movies and be completely undetectable.

However, most people know 3D mainly in the form of cartoon imagery. Many of the major artistic (and financial) successes in this new art form are in the cartoon realm. For every brilliant virtual performance by a photoreal Gollum—who in his physical proportion and outsized monomania is actually very much a cartoon character—there are equally impressive triumphs of pure iconic cartoon feeling by Pixar and clever cartoon satire by Dreamworks.

This surprising development has not been easy on the cartoonists. In the 3D world, technology is driving the evolution of the art of cartooning at an ever-faster pace, challenging artists to master and then surmount the imperfectly designed tools offered by programmers. Fortunately, these same tools enable toon artists to amuse and amaze us with new visions possible only in the 3D realm. And feedback from 3D artists is also driving software designers and developers toward new insights into the sources and processes of visual creativity. It's a turnabout not unknown in the history of art, but unique here in its speed, intensity, and global scope.

ABOUT THIS BOOK

Most books with "3D" in the title attempt to teach technique; how to use a particular piece of software to accomplish a particular task. In *3D Toons*, we've taken a different approach. We've concentrated not on tools or technical procedures but rather on artistic choices, the paths 3D cartoonists take to reach their goals. Nor have we tried to produce another of the innumerable "art of" books published by the same entertainment conglomerates producing so much of the new 3D cartooning. These books can be immensely valuable and inspiring, as examples of the polish that studio work can attain at the highest levels of professionalism, but they are always tied to familiar projects and rarely reveal the nitty-gritty inner workings of the creative process. There are as yet few inside examinations of how 3D is changing the cartoon art in the trenches, where the new ideas originate that are eventually skimmed and regurgitated by the majors. That's one of the things *3D Toons* attempts to provide. In the pages of this book, you'll find some of the very best new 3D cartoon images made by independent artists and studios around the world. Although 3D is still dominated by mass-culture films and games and television, and the marketing juggernauts that support them, it is the independents, the guy or gal with a computer and a program and a story to tell, who are now pushing the artistic envelope. Much of the work included here deliberately breaks the mold established by Pixar and Dreamworks and 20th Century Fox and offers alternative and very personal visions of what 3D toons are and can be.

This book is divided into seven parts, reflecting important facets of 3D cartooning. Part 1 looks at the conventions of cartoons and how they are reflected and amplified in 3D through a selection of character archetypes. Part 2 digs into the pre-production process—the imaginative construction of a 3D cartoon world. Part 3 details the anatomy of a toon, showing just how 3D characters are actually made.

In Part 4, we look at the fundamentals and elaborations of 3D cartoon animation, the most popular form of 3D art. Part 5 steps back and views the cartoon as a film narrative, using the grammar of cinema. Part 6 takes an even wider view, encompassing alternate forms of toon three-dimensionality such as stop-motion, brick animation, 3D comics, and Flash art. Finally, Part 7 is a gallery of work from a selection of independent artists and studios who are leading cartooning in new directions.

The 3D realm is still so new, we need the universal communicative power of cartoons to help us explore it. These odd, funny, sometimes disturbing icons of ourselves can be our guides, as they have been before, to the fresh worlds of imagination we create.

ABOVE: Although CGI cartoons rule at the Oscars, alternative forms of animation, including old-fashioned stop-motion, still have their part to play.

BELOW: A giant mirror ball spells the end to Blit's disco dream in Victor Navone's *Alien Song.*

RIGHT: Self-mockery is a good gag strategy, as in this illustration for a magazine article on character rigging.

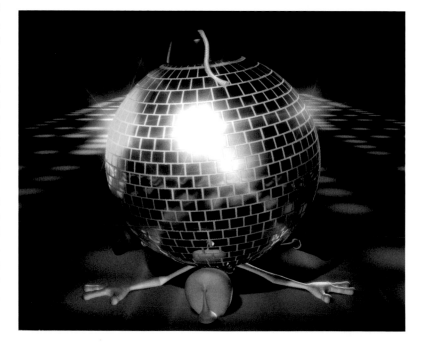

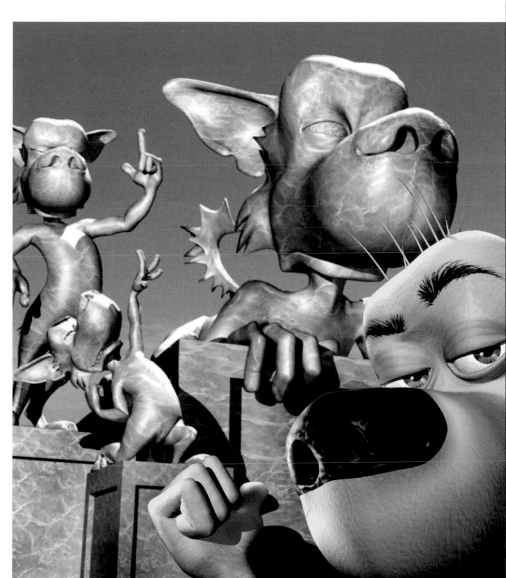

DEFINING TERMS

We've tried to keep this book as jargon-free as possible, but if you're new to animation—either traditional or 3D—there are some terms that might prove useful right away.

Animatic: A "planning" movie for an animation, an aid for visualization of shot layout, camera angles and moves, and blocking of basic character moves. Created with scanned drawings, toys, video, or simple 3D models and edited together to establish pacing and continuity.

Animation: Moving graphics. Created by quickly displaying a succession of related images, called frames, so that the brain blends them together into one continuous sequence.

Blocking: A rough working animation created to show where the characters and objects in a scene will be at specific points in the time line, to get a basic feel for how the scene will work.

Cartoon: 1) Any graphical work that employs stylization, economy of design, exaggeration, and caricature. 2) A humorous, character-based animation with a simplified graphic style and frenetic, exaggerated motion and pacing.

Compositing: Post-production process of layering images or animations to create a final work from the combined elements. Comping for short.

Frame: A single image from a motion picture. There may be more than 100,000 frames in an animated feature.

Geometry: The "skin" of a model, made of polygons or splines, before rigging and texturing. Also called mesh.

Keyframe: Frame that defines the beginning, ending, or important pose of character motion or object animation sequence.

Model: A 3D object built from polygons or splines.

Render: To create a 2D representation of a 3D scene from the mass of geometry, surface, and lighting data available.

Rigging: The process of adding bones, constraints, and controls to a character or other articulated model to prepare it for animation.

Short: A brief independent animation, usually less than 10 minutes long.

Toon: A cartoon character.

12

1

3D TOONSTYLE

CARTOON CONVENTIONS IN A 3D WORLD

WHAT MAKES A CARTOON CHARACTER? TOONS ARE SO FAMILIAR TO US, PERMEATING OUR POPULAR CULTURE LIKE SOME DIMINUTIVE, HYPERACTIVE, COMMENSAL SPECIES. PERHAPS THAT'S WHY SO MANY OF THE EARLIEST TOON CHARACTERS WERE CATS AND MICE. AS A RESULT, WE RARELY GIVE THEM MUCH THOUGHT, AND EVEN MORE RARELY DO WE ANALYZE WHY THEY LOOK, ACT, AND SOUND THE WAY THEY DO.

TOON CONVENTIONS

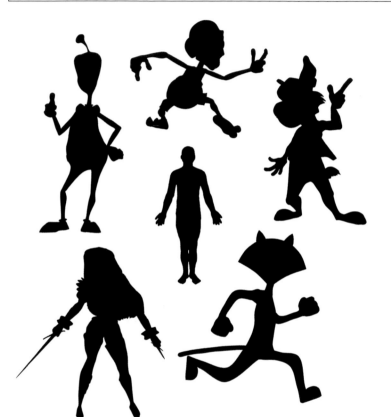

ABOVE: Toon body proportions compared with those of a human adult. Note the toons' huge heads, stumpy bodies, and exaggerated hands and feet.

Cartoonists do that analysis, of course, and it is fascinating that so many agree to accept the conventions of toon design, which seem to apply no matter the number of dimensions, illusory or real, used in their creation. However, it is not only a matter of artistic convention—a school of design that will evolve over time. There is something powerfully revealing in the way we see ourselves at work here.

In any analysis of toon design, the first thing to consider is body proportion. Looking at the image of some 3D toon silhouettes compared with a standard proportionate male figure, the differences are obvious. In the image, all the toons have big heads, a nearly universal toon trait. The bodies are relatively short, often tubby, and the legs are also short. Hands and feet are huge. And, allthough this illustration does

not show it, the more human and adult the toon design, the taller the toon tends to be in relation to other characters. So is the inescapable conclusion that, in our minds, toons represent children? Or do toons reflect our secret body image, a Penfield's homunculus of our self-imagination?

Each 3D toon body element has its own conventions, depending to a degree on how abstract or realistic the toon is. But in every case, there is some characteristic degree of exaggeration or stylization—that is what makes it a toon. Eyes can range from a black sphere floating just off the plane of the face, to the classic bulging double-oval adapted from 2D toons, to the hypertrophied anime eye with its many subtle variations, to a detailed realistic eye with lashes, iris textures, and multiple glints (glints being the ultimate indication of eye liveliness). No matter the design, cartoon eyes are much larger in relation to the face than real eyes, and usually closer together.

Mouths are also conventionalized, again appearing relatively larger on the cartoon face, and opening to more extreme expressions. The mouth may be nothing more than a flexible hole, or it may have rudimentary lip and teeth adequate for lip-syncing dialog. More elaborate mouth designs include curving lips with smile lines and individual teeth and tongue (with interior mouth shadows, a surprisingly tricky achievement in 3D).

Early toon designers developed a cartoon hand with three fingers rather than four to make hand animation easier. Many 3D toon artists have followed that lead. But the full-fingered hand is equally as popular, and, with the right designer, can be expressive, brutal, or even elegant.

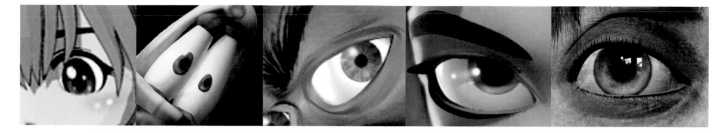

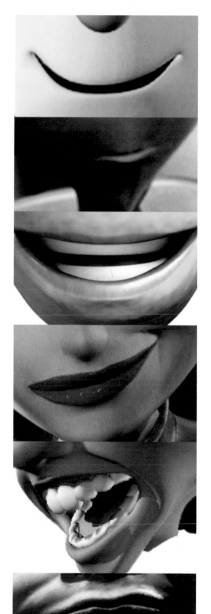

ABOVE: A selection of toon eye styles, from the starkly geometric to the sharply realistic.

LEFT: Toon mouths can be a simple slit or fully equipped with teeth, tongue, and associated facial muscles.

RIGHT: The three-finger toon hand is popular with 3D cartoonists, but so is the standard four-fingered model.

ON A NOTIONAL LINEAR SCALE OF GRAPHIC REPRESENTATION, WITH HIGH REALISM AND NATURALISM AT ONE END AND EXTREME SIMPLIFICATION AND STYLIZATION AT THE OTHER, TOONS HAVE ALWAYS RESIDED AT THE SIMPLIFIED END. (BY SIMPLIFIED, I DON'T MEAN SIMPLE, ONLY THAT SKILLFUL CARTOONISTS ACHIEVE MAXIMUM EFFECT WITH MINIMAL RESOURCES. NO LINE OR FORM IS WASTED; ALL HAVE SIGNIFICANCE.)

REALISM VS. STYLIZATION

16

The decision to put stylization over realism is mainly an esthetic choice—the nature of comics and cartoons is to be economical, stereotyped renderings of reality. But it has also been a choice driven by considerations of time and money. Cartoons, the native graphic art of the mass media, have to be simple because they must be produced fast and cheap.

To a great degree, the availability of 3D tools overturns this natural order, expanding the place where cartoons can reside (though not always comfortably) to both ends of the graphic scale. With sufficient technical knowledge and R&D time, the 3D artist can make his or her cartoon creations look absolutely real, at least in the sense that they will project certain visual surface cues we expect from real objects. This tempts artists to mix extreme realism and toon stylization, unreality of form and hyperreality of surface. At best, the result is pleasurably mind-bending; at worst, it is unpleasantly disorienting. Most often, however, we get only post-modern blendo kitsch, which is what we see every day in commercials and films. Notice how bizarre 3D cartoon characters can look when injected into live action films? The kind-of-sort-of realistic Bullwinkle the Moose (*The Adventures of Rocky and Bullwinkle,* 2000) and Scooby-Doo (*Scooby-Doo the Movie,* 2002) look absolutely out of place surrounded by real actors and settings; the weirdness these juxtapositions evoke actually appears to have been considered a box-office draw by the producers of those films. Richard Williams's brilliantly hand-drawn 2D toons for *Who Framed Roger Rabbit?* (1988) caused no such mental queasiness, once you bought the basic premise.

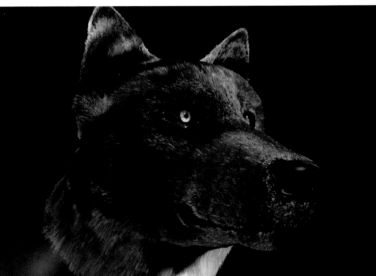

Significantly, it takes more cleverness and effort to achieve in 3D even a fraction of the artful spontaneity of an expert cartoonist. At the current state of the art, 3D software pushes toon artists toward the nitpicky and over-determined, in part because tools and interfaces are designed not by artists but by software designers, who privilege render realism and scripting-language-based automation over creative fluidity and freedom. Workarounds and third-party add-ons (such as cel-look renderers) are often required to force the software into more cartoony modes. Just now we are beginning to see a movement—not yet reflected in commercial software but hot among in-house programmers at larger studios—to finally provide toon animators with the complete control over form and motion that has always been enjoyed by their 2D counterparts.

IMAGES: A selection of images showing various approaches to 3D cartoon stylization, shading from simple toon forms to relatively realistic. The skeletal Elvis head (from the short film *Day Off the Dead*), the happy toon family, and the laughing swordsman all represent more or less traditional cartoon solutions to character representation, translated to 3D. Needles (left), a character from the game *Tak and the Power of Juju*; the goldfish by Oz Adi and Raz Oved, and the wolf (a work in progress lacking finer detail around the ears and muzzle) move toward the realistic end of the scale.

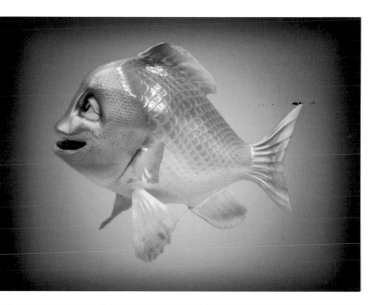

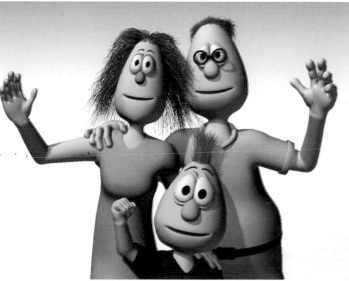

CREATING 3D HUMANS IS ONE OF THE HOLY GRAILS OF COMPUTER GRAPHICS. HOWEVER, THE QUEST FOR EVER-GREATER REALISM IN SYNTHESPIAN SIMULATION—WHOSE ESSENTIAL FUTILITY IS TYPIFIED BY THE FAILURE OF SQUARE'S *FINAL FANTASY* FEATURE—HARDLY INFLUENCES MOST TOON ARTISTS. FOR TOONS, ARTFUL STYLIZATION OF THE HUMAN FORM IS THE MORE FRUITFUL CREATIVE PATH.

TOON HUMANS

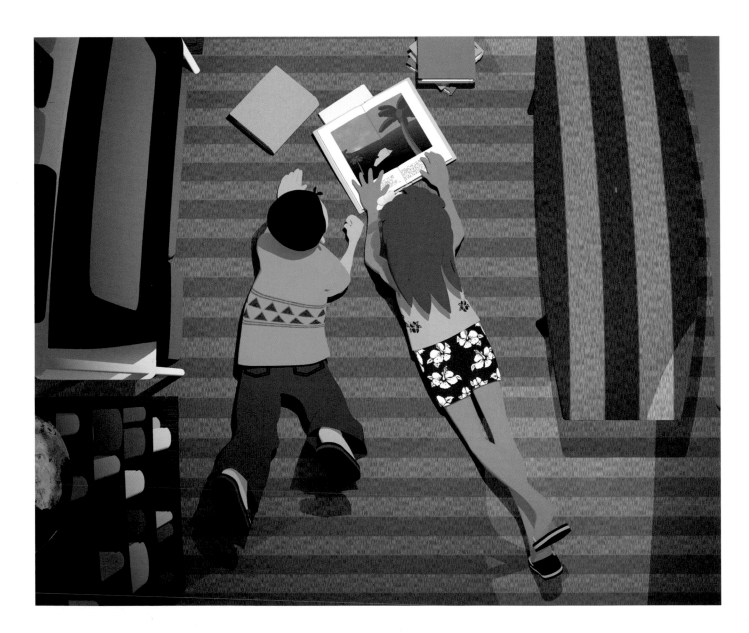

ABOVE LEFT: Scarlett, of Hasbro's GI Joe universe, is no girlie-girl, but a tough soldier on a demanding mission.

ABOVE: The tiny-seeming people created by François Gutherz for his Mandarine universe are the 3D counterparts of quick hand-sketched comic-strip characters.

LEFT: A blend of careful composition and the use of flat colors and strong patterns give this image by Scott Young its charm.

RIGHT: Concept art for a character from Avalanche Software's *Tak and the Power of Juju* console game; she adopts a classic girlie-poster pose.

Realism at any level is hardly a requirement for toons. Strange Company's *Steelwight* (*see page 140*), a machinima movie (a semi-automated 3D film made using game engine software) has spikily stylized characters who can at times look like animated sheets of painted steel in human form. Machinima can be a leisurely art and allows time for a tender moment between lovers, though you suspect that these two will have to go back to fighting soon.

3D toons, mainly the product of male imaginations, have assigned two predominant roles for women: fantasy goddess and tough techno-fighter. A concept design for Moon Juju, the lead spirit character in Avalanche Software's game *Tak and the Power of Juju*, is a perfect example of the goddess role. Great attention has been paid to the character's leg curves, finger poses, and other fetish points. And aren't her staff and the moon forming a fertility symbol?

Meanwhile, special-ops expert Scarlett from Reel FX's direct-to-DVD feature *GI Joe: Spytroops* is obviously facing some tough tactical crisis. She's got the skintight suit with gladiator shoulderpads typical of such characters, but unlike some other girlfighters, Scarlett isn't all pout and pose with a gun; she's a skilled soldier who is always ready to take on the enemy. In creating Scarlett, production house Reel FX faced the equally tough challenge of translating one of the most popular GI Joe characters into the 3D realm.

François Gutherz likes to push the limits of 3D human stylization even further. The little people of his Mandarine universe are made with the absolute minimum of resources—a few polygons, a few props, strong orange light—but are incongruously rendered with sophisticated global illumination techniques to give them unexpected substantiality. The character designs have almost nothing to them, but one or two well-chosen details serve to individualize each; note the black outfit and ponytail of the girl geek and the bluish pompadour of the fellow taking a drink at the park fountain.

So much human activity in 3D is of the frantic "kill monsters" variety that it's reassuring to come across an image that depicts a more normal realm of experience. American artist Scott Young has captured the precise poses of two children on a "book adventure," right down to the exact angles of their flip-flops. The flat colors are created with a cel shader, a method of rendering 3D to make it look like painting or drawing. The unusual camera angle—directly overhead—and the subtle employment of a wide-angle lens (some fish-eye distortion can be seen at the edges of the image) amplify the effect of peeking in on a child's daydream.

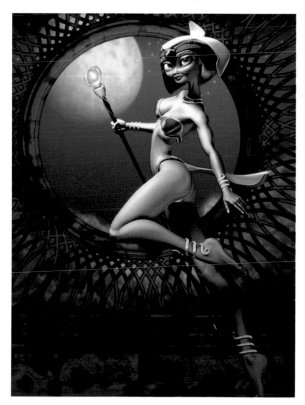

ANIMALS HAVE BEEN MAINSTAY SUBJECTS FOR CARTOONING AND ANIMATION FROM THE BEGINNING. GIVEN MODERN CARTOONING'S ORIGINS IN 18TH-CENTURY HUMOR ART AND POLITICAL CARICATURE, IT WAS ONLY NATURAL FOR 20TH-CENTURY NEWSPAPER AND MAGAZINE ARTISTS TO USE STYLIZED CATS, DOGS, FARM ANIMALS, AND PRACTICALLY EVERY OTHER SPECIES AS HUMAN SURROGATES.

TOON ANIMALS

20

Animal animation's most famous early breakthrough was Winsor McCay's cel-animated *Gertie the Dinosaur* (1914), but actually animal toons got their start much earlier; there are many examples of animal motion on fantascopes, zoetropes, and other 19th-century proto-cinema devices. It's hard to imagine what 2D animation would be like without cat-and-mouse gags or such animal stars as Mickey, Donald, Porky, Bugs, Daffy, Bambi, and Simba, just to name a few.

CG did not derive initially from the graphic art tradition. Instead, its evolution has been driven by software developments in modeling, kinematics, rendering, and

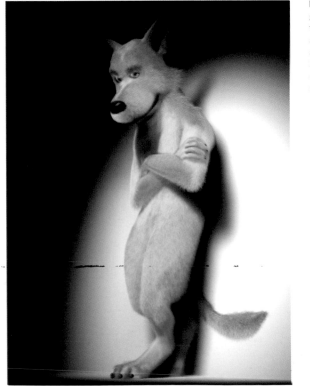

LEFT: Toon dog Dennis gets his air of cool from his pose. The fur, a feature only recently available in commercial 3D software, was developed after careful study of real dogs.

user interface design on the one hand, and the deep-rooted ambition to emulate reality rather than caricature it on the other. Animal characters came late to the party, but, interestingly, they increasingly dominate the field; witness such 3D features as *Antz, A Bug's Life, Finding Nemo,* and *Shrek 2* (with Donkey, Puss-in-Boots, and many other animal characters).

Toon cats are even more popular than toon dogs; there are no cartoon canines quite as famous as Otto Messmer's *Felix the Cat* (first animated short: 1919), Friz Freleng's *Sylvester the Cat* (1946), or William Hanna and Joseph Barbera's *Tom* (1940). Most comic cats are frustrated by maddeningly uncatchable little prey animals, but in their short film *Riba,* French animators Yves Dalbiez, Laurent Leleu, and Elise Garcette have come up with an interesting twist: their cat is a frustrated musician who lacks not a tasty mouthful, but a well-tuned piano. With its character design, its setting, and its theme of artistic yearning, the toon could hardly be more French.

Dogs do have their 3D champions. Raf Anzovin has been developing his Dennis the dog character for years. In his latest incarnation, Dennis has attained a mature air of relaxed cool. He is more realistic than many toons—Anzovin carefully studied the anatomy and fur patterns of his own two German shepherds—but with his big head and bipedal stance, he's still a cartoon.

Cartoon elephants may not be as common as cartoon cats and dogs, but they still have a long history, from *Dumbo* onward. The blue squeaky-toy pachyderm, designed by Israeli animator Oz Adi and modeler Raz Oved, has the ponderous paranoia of Colonel Hathi in Disney's animated *Jungle Book.* But most of the fun with this massive character is in seeing how light on his feet he can be. So polished a character requires a close collaboration between creators. "We both love the cartoony style," says Adi, "and complete each other in the process of creating and animating 3D toon characters."

LEFT & RIGHT: Israeli animators Oz Adi and Raz Oved used Maya to create this blue elephant for a corporate reel. Using only a few seconds of screen time, they gave the character a strong attitude and a remarkably lively motion style.

BELOW: This melancholy cat, designed by Yves Dalbiez, Laurent Leleu, and Elise Garcette for their animated short *Riba*, plays air piano as he longs for a real keyboard. The creators found a unique pencil-and-gouache look for the cat's world.

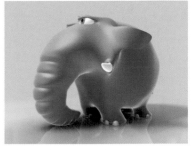

HOUSE PETS MAY BE THE MOST POPULAR SUBJECTS FOR TOONS, BUT OTHER ANIMALS ARE FAIR GAME AS WELL. BARNYARD CARTOONS ALWAYS USED TO BE ABLE TO COUNT ON A SYMPATHETIC RECEPTION FROM THE HEAVILY RURAL MOVIE-GOING AUDIENCES OF THE 1930S AND '40S, AND THEY EVEN RETAIN A CERTAIN TRANSMUTED APPEAL TODAY, WHEN MOST PEOPLE ENCOUNTER COWS AND CHICKENS ONLY AS THE TASTY STUFF BETWEEN HALVES OF A BUN.

BARNYARD TOONS

22

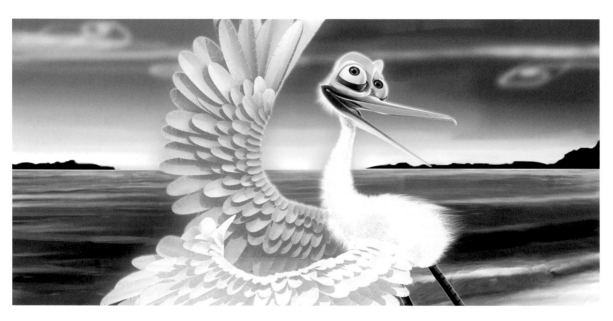

LEFT: Beaulieu's Jacko is ready for his closeup.

That is exactly the situation German animation studio Soulcage Department banked on with its commercial/short film *I'm Walking*. The award-winning short's racing chickens, including the chubby and scatterbrained ones pictured in the still, were designed mainly to get people to buy more packages of organic chicken meat. This was a concept that modern Euro-shoppers could relate to. A dollop of quirky surrealism also helps sell your barnyard character to sophisticated modern audiences. The languorous pigs of Jimmy Maiden's *Sunday_Fluff_XX* are definitely mens' magazine material, if you can make that weird mental jump.

On the other hand, Disney's decision to play it straightly rural with its last 2D-animated feature, *Home on the Range*, was a disaster. The stars, a trio of cute heifers, did not resonate with audiences at the suburban multiplex, and the film struck out at the box office. This no doubt has confirmed studio suits that exotic toon animals will fare better than familiar ones in future. Tropical fish certainly did well for Pixar (*Finding Nemo*), just as extinct Pleistocene mammals like Smilodon and Megatherium put Blue Sky Studios (*Ice Age, Ice Age 2*) on the map.

Or perhaps edgy is the way to go. Canadian animator and character designer Patrick Beaulieu is known for his nervous, unpredictable critters. Like Chris Wedge's Skrat, the proto-squirrel from *Ice Age*, Beaulieu's Arnold the mouse has huge, trembling eyes that twitch at the slightest stimuli. Arnold's generally hopeful, unassuming expression and hands-behind-the-back nonchalance can't hide an underlying anxiety. After all, in the cartoon universe, mice are the prey animal par excellence. Beaulieu's Jacko the bird is likewise oddly high-strung. The elegant ruffle of his feathers and the welcoming wing are belied by a certain theatrical egomania. Like so many cartoon birds, Jacko is, well, full of himself.

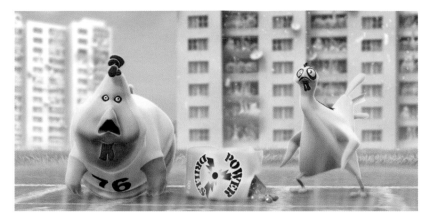

LEFT: These two hens from Soulcage Department's *I'm Walking* helped successfully sell organic chicken.

BELOW: Voluptuous pigs on Astroturf, courtesy of Boring 3D's Jimmy Maidens.

POLITICAL CARICATURE—AN IMAGE IN WHICH THE PECULIARITIES OF THE SUBJECT ARE SO EXAGGERATED THEY APPEAR RIDICULOUS—IS MAINLY THE REALM OF PEN-AND-INK ILLUSTRATORS AND OP-ED CARTOONISTS. THERE'S A QUICK SPONTANEITY TO THE CARICATURIST'S ART THAT IS HARD TO CAPTURE IN THE DELIBERATE, PAINSTAKING PROCESS OF 3D IMAGE CREATION. BUT IN THE HANDS OF A SKILLFUL 3D ARTIST, THE RESULTS CAN BE DEVASTATING.

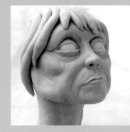

3D CARICATURE

24

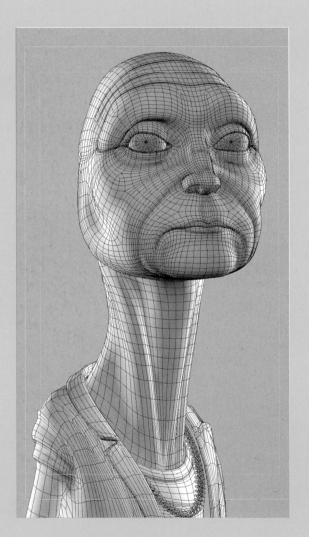

It took artist Fred Bastide about 50 hours to create this spot-on caricature of Swiss political figure Micheline Calmy Rey (known to her detractors as ''Calamity Rey''), currently the minister for foreign affairs. In a process that's not unusual for the creation of feature-film characters, but is rare for illustration, Bastide sketched out his concept first in clay. ''For this work,'' he says, ''I sculpted a plastiline model of about 8 inches (20 cm) in height, in order to determine the main forms of the 3D model. The sketch's front and sides were photographed and brought into Photoshop, where they were cleaned and calibrated. Some distortions due to the lens of the digital camera were also corrected.''

Bastide then imported the reference images into discreet's 3ds max 5.1 and used them as guides for the creation of a temporary spline framework that followed the main lines of the clay model. ''This approach demands a lot of precision,'' adds Bastide, ''but saves precious time later.'' The splines served in turn as guidelines for the creation of a high-resolution subdivision surface that pushed the exaggerations in the clay model to a much higher level.

The final image was rendered with 3ds max's scanline renderer, with three direct spotlights. The skin shader is a translucent material, with a Photoshop-painted map. One point of difficulty was the hair, which—as Calmy Rey usually wears it—is a cross between the signature styles of Louise Brooks and Joan of Arc. ''The hair was painted on after rendering with Photoshop,'' Bastide notes, ''as each hair render attempt wasn't convincing. The hair shape is based on a kind of skullcap that I used as a reference for the colors and light.''

The result of all this care is a 3D caricature of rare insight and refinement.

ABOVE: Artist Fred Bastide used plastiline to sketch out the basic volumes of his caricature of Swiss politician Micheline Calmy Rey.

LEFT: When building the mesh, Bastide introduced even more distortion—the essence of caricature.

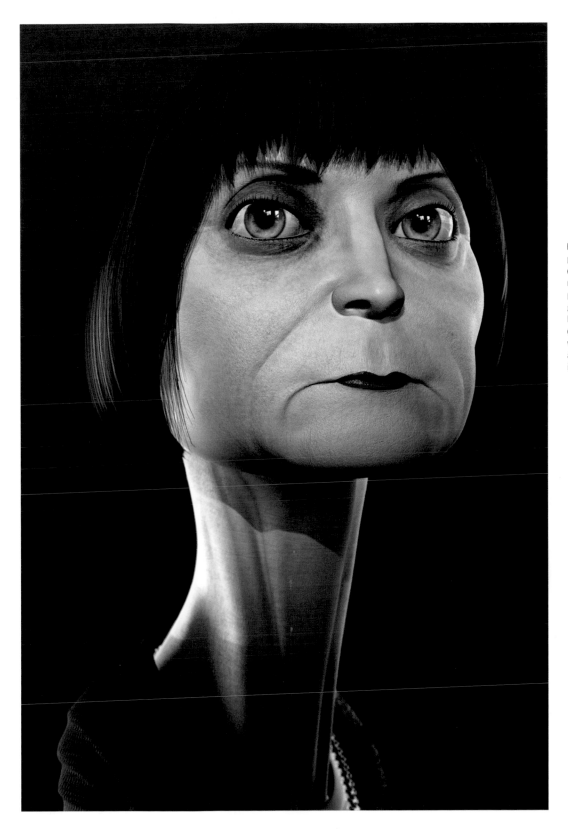

LEFT: Rey's political persona is sharply expressed in the extreme neck extension, tiny pursed mouth, hawk-like gaze, and helmetlike hair. The overall green coloration, contrasted with the carmine lips, adds to the harpylike impression.

ALIENS ARE GREEN. AT LEAST, ALL CARTOON ALIENS ARE GREEN. THEY ALSO LACK ESSENTIAL FACIAL FEATURES, WEAR FUNNY CLOTHES (IF THEY WEAR ANY AT ALL), AND USUALLY HAVE NEFARIOUS PLANS TO DESTROY OR ENSLAVE THE EARTH. HOW EXACTLY THESE FACTS HAVE BEEN ESTABLISHED IS NOT ENTIRELY CLEAR, BUT 3D CARTOONISTS TAKE THEM AS A GIVEN IN DEVISING THEIR CG CREATIONS.

ALIENS

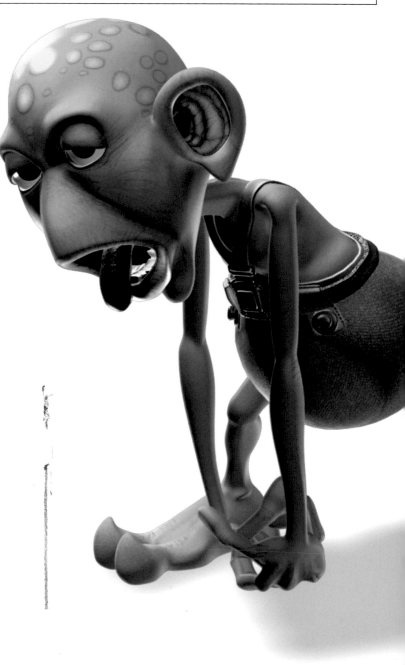

Martians may have started out inky black (as with Chuck Jones's *Marvin the Martian*, who first appeared on-screen in 1948 sporting a push-broom helmet and Roman tutu), but they have certainly been green since Kelly Freas's famous "little green man" illustration for the Fredric Brown story *"Martians, Go Home!"* (1954). And we know they're elusive practical jokers, because they keep shooting down our Mars probes before we can get a good look at them. *Rocky*, the brainchild of Christof Stanits, award-winning director of RABCAT Entertainment Stanits OEG in Vienna, is true to type. He was designed as a technology prototype for an animated TV series in which Martians live on the surface of their planet undetected by human eyes. Like any self-respecting superior being, Rocky delights in mocking the lame preconceptions of a confused earthling. But, as the Rocky character study shows, Mars can be an exhausting place to live, even for a frenetic little green guy.

A certain wacky quality seems common to Martians, but other aliens are downright sophisticated. Richard Rosenman's *Sammy the Intergalactic Troublemaker* has the droop-lidded anti-hero cool of an extraterrestrial Robert Mitchum. All he's missing is the turned-up collar and dangling cigarette. Sure, Sammy may not be as green as some, but he

LEFT: Richard Rosenman's *Sammy the Intergalactic Troublemaker* was modeled and textured with 3ds max and rendered with VRay using traditional lighting techniques with global illumination.

BELOW: This spot-on spoof of Apple's "Think Different" ad campaign features Blit Wizbok, Victor Navone's signature character.

does have several signature alien facial characteristics—long neck, bug eyes, and no nose to speak of. According to Rosenman, who owns a successful Canadian advertising and design agency, Sammy was created over the span of about a week, solely for personal satisfaction. Rosenman is an expert in creature design and has given Sammy his usual high polish. The complex texturing required seven separate layers for background, character, and lighting effects.

We now know that aliens are so advanced that they no longer need two of everything. That's why so many of them have just one eye. *The Simpsons'* drooling Kang and Kodos have one eye each, and so does Pixar animator Victor Navone's Blit Wizbok, probably the world's best-known monocular alien. After Blit's starring turn in the Internet short *Alien Song*, Steve Jobs of Apple Computer approached the self-confident extraterrestrial to appear in its ads featuring great contemporary intellects and artists. In the photo, Blit's arched unibrow unmistakably expresses his superior mentality. After all, who thinks more different than a star-being?

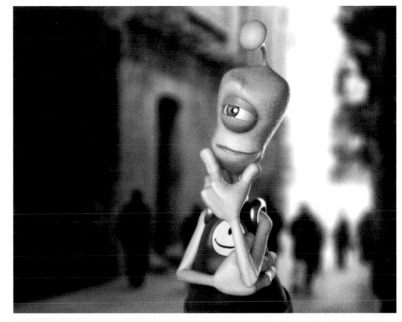

RIGHT: Rocky the Martian, created by Christof Stanits of RABCAT Entertainment for a TV pilot, has a good laugh at human ideas about aliens.

LEFT: Posing Rocky and other aliens was made easier by a flexible internal rig that allows his head and arms to be completely replaced. One base model provided enough variations of Martians to populate the entire planet.

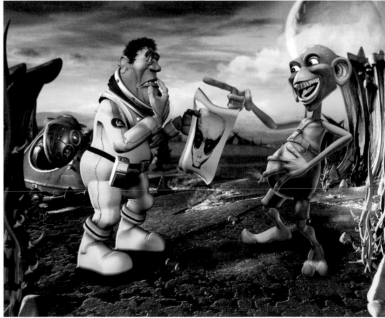

CARTOON STORIES OFTEN NEED A VILLAIN, AND AS EVERY STORYTELLER KNOWS, THE BETTER THE VILLAIN, THE BETTER THE STORY. 3D TOON BUILDERS WORK HARD TO REALIZE ORIGINAL VILLAINS IN ALL THE WELL-KNOWN EVILDOER CATEGORIES. OGRES (AND TROLLS AND GIANTS AND THE LIKE) CAN BE GOOD GUYS, TOO, AS WE'VE ALL LEARNED FROM *SHREK*. BUT THESE MYTHOLOGICAL BEINGS ARE TRADITIONALLY SEEN AS EVIL, OR AT LEAST AS TOUGH-TO-KILL ADVERSARIES WITH NASTY HABITS. AS SUCH, THEY ARE POPULAR SUBJECTS FOR 3D ARTISTS.

OGRES AND VILLAINS

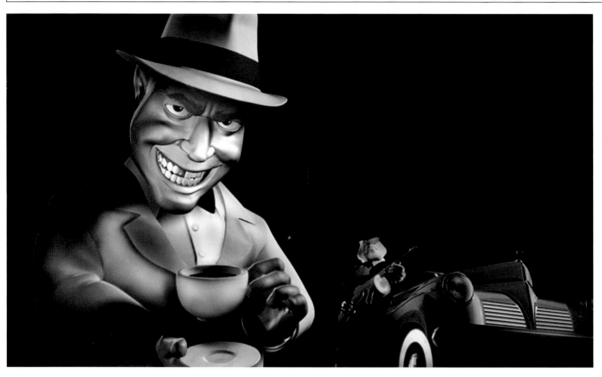

LEFT: Organized crime and java smuggling are the games for this natty mobster from *Java Noir*.

RIGHT: Beware the belly of this bad-tempered bully, created by Avalanche Software for the game *Tak and the Power of Juju*.

Blur Studio's Jérôme Denjean used discreet's 3ds max to adapt his Frost Giant from an original concept by artist Paul Donner. Denjean's 3D treatment brings out lots of character-building detail in the Frost Giant's carefully proportioned head, muscled body, and barbarian get-up. The dangling skulls not only confirm that he's no sweetheart, but also establish his larger-than-human scale. And what is he dragging in that sack?

For the game *Tak and the Power of Juju*, Avalanche Software designed a human with ogreish qualities. This fellow, with his sumo-wrestler's build and bully's sneer, is a type we all recognize—a type that appears often in games as the vicious guardian of sacrifical temples, hidden treasure troves,

and exclusive nightclubs. His conical cranium suggests a potentially fatal lack of brainpower, but game players would be well advised to stay out of his grip anyway. His belly tattoo—a stylized face—is the cool defining detail that Avalanche knows every good villain needs.

Mr. Beanstreet, the mobster from *Java Noir*, is a more suave kind of bad guy. His white suit, bow tie, and fedora hat mark him as a man of style, distinction, and power. But that threatening smile is an unmistakable signal of bad intentions (not to mention the tommy-gun-toting henchman in the background). For *Java Noir*, Raf Anzovin and modeler William Young came up with character designs that graft a high level of detail in the face and hands onto moderately exaggerated

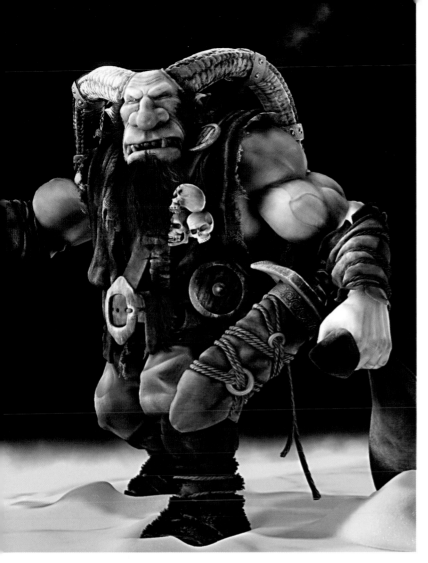

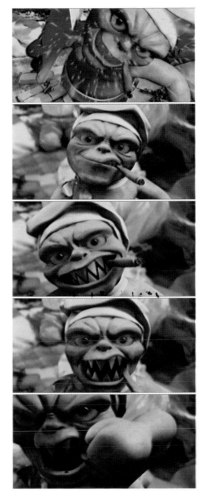

LEFT: Jérôme Denjean's Frost Giant, from original art by Paul Bonner, is a threatening figure out of Norse mythology.

RIGHT: Villainy can also be silly. William Butler's *The GingerDead Man* turns a well-known brandname's spokes-character into a half-baked killer.

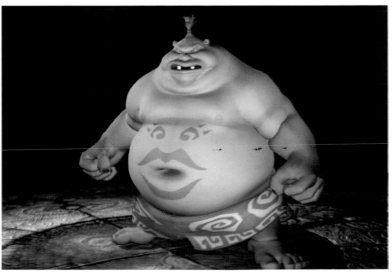

body proportions—a typical strategy for cartoonish characters that need full facial and manual dexterity. Period details (the car, the tommy gun) are authentic and accurate, and backgrounds are 2D graphics hand drawn and applied to 3D backdrops.

But for out-and-out evil, few toon villains can compare with *The GingerDead Man*, from the William Butler horror spoof of the same name. This dangerous doughboy springs out of a cake to wreak havoc on a kid's birthday party, meat cleaver at the ready, and chainsaws a housewife after she unwarily tickles his tummy. In the sequence of frames from the film trailer, he gloats that "I'm gonna kick your a**," and that's exactly what we like about our villains, after all.

A SPECIAL CATEGORY OF STOCK CARTOON CREATURE IS THE "LITTLE MONSTER." UNLIKE FULL-SIZED OGRES, THE PINT-SIZED VERSION IS TROUBLESOME, UNPREDICTABLE, AND MILDLY DISGUSTING RATHER THAN FRIGHTENING—A MINOR DEMON, NOT A MAJOR ONE. LI'L MONSTERS, BEING ALL ID AND NO SUPEREGO, TYPICALLY REPRESENT THE FORCES OF CHILDISH DISORDER AND REBELLION, WHICH IS WHY THEY CAN BE BIZARRELY CUTE AS WELL AS DESTRUCTIVE. IN THE WARNER BROS. PANTHEON, THE RESIDENT LI'L MONSTER IS TAZ, THE TASMANIAN DEVIL; STITCH FROM *LILO AND STITCH* IS THE CANONICAL EXAMPLE IN THE CONTEMPORARY DISNEY UNIVERSE.

LITTLE MONSTERS

3D artists, who like other toon creators employ their art to let their own ids run free, often find li'l monsters especially gratifying to design. Richard Rosenman of Richard Rosenman Advertising & Design Inc. has actually made something of a specialty of them. The "Infosection" character on these pages was created by Rosenman as a host for a game. This fellow, a cross between an orangutan and a goat-devil, has many of the standard li'l monster traits: he's short (we know that because of his stumpy body proportions and his scale measured against the money); big-headed; horned; pointy-eared; warty; paunchy; toothy; hairy; and perhaps not very bright. Rosenman has put these elements together in a tight design with carefully worked-out details and a lot of charm.

The artist began with conceptual character designs, followed by rough character development and a final character model sheet. These were all loosely drawn sketches on paper, which is how he begins all his character designs. The sketch example shown here contains enough ideas for any dozen final concepts. The model geometry was produced by Ben Pilgrim and Rosenman over a two-week period. The texturing was quite complex and the fur even more so. "Because the character was

Richard Rosenman's little Infosection monster, a game mascot, was modeled in 3ds max 4.2 and rendered with VRay 1.09. The fur, which required lots of experimentation, was created with Shag:Hair.

slouched over to such an extent," notes Rosenman, "numerous textures were required for his torso alone, divided into areas such as the belly, chest, back, upper chest, upper back, shoulders, etc. In addition, textures also had to be developed that dictated the color, length, density, and location of the fur." In the end, there were more than 30 unique hand-painted textures. At render time, the artist adds, a conventional three-point lighting system was used for the stylized cartoon look, with the addition of global illumination rendering for photo-realistic shadow synthesis. "This gave the final image a crisp, clean, and bold look."

Under the art direction of Jeff Bunker, U.S. game developer Avalanche Software created a different style of little monster for the video game *Tak and the Power of Juju*. Whereas the Infosection demon is squat, powerful, and a bit dim, this diminutive purple gremlin looks fast, tricky, and malicious. In fact, we seem to have caught him in the midst of some scheme, and he's not happy about it.

Name your web site monster.com and you will sooner or later be looking for a little-monster mascot. Stop-motion and CG artist Webster Colcord was tapped to create one for a couple of TV commercial spots. Colcord's humor is usually very dark, but his chubby green monster.com host is positively jolly and welcoming, despite the sharklike teeth.

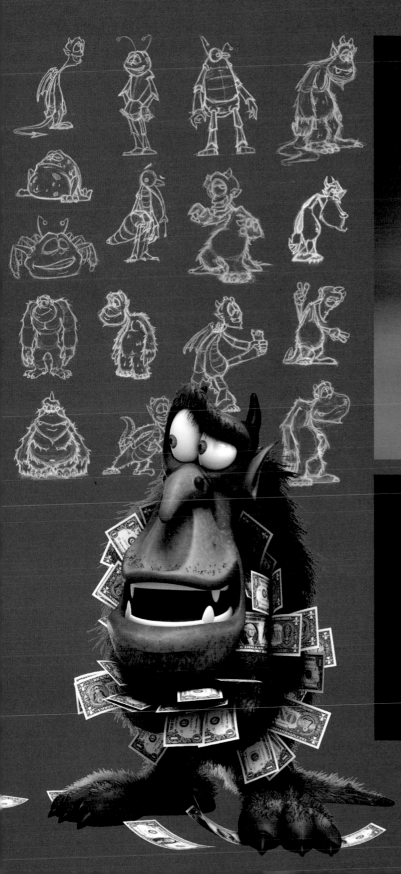

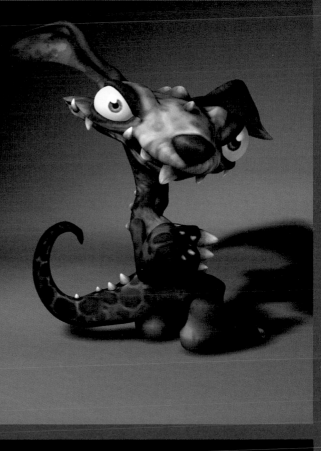

monster®com

ABOVE LEFT: Richard Rosenman sketched out 16 concepts before combining several into the final Infosection design.

ABOVE: Webster Colcord's good-natured green monster was developed for TV spots touting monster.com's job-hunting service.

TOP: This malevolent purple gremlin appears in the hit video game *Tak and the Power of Juju*.

MECHANICAL MEN HAVE BEEN A STAPLE OF FANTASTIC ART SINCE THE AMERICAN SCI-FI PULPS OF THE 1930S. WITH THAT LONG HISTORY, IT'S INSTRUCTIVE TO CHART THE DESIGN CHANGES IN ROBOT ART OVER THE YEARS. THE 1930S BOTS HAVE A DISTINCTIVE ART DECO LOOK, WITH SNAKY ARMS AND CYLINDRICAL BODIES (AND A DEFINITE TASTE FOR SWOONING YOUNG WOMEN). ROBOTS OF THE 1940S AND '50S, BY CONTRAST, ARE MUCH MORE BLOCKY AND HOME-APPLIANCE-LIKE. THE STREAMLINED ROCKET ROBOTS OF THE 1960S, FOLLOWED BY THE VACU-FORMED TRANSFORMING ROBOTS OF THE 1970S AND '80S, HAVE BEEN SUPPLANTED BY TODAY'S ULTRA-DETAILED, HYPERREAL, 3D-RENDERED MECHS BRISTLING WITH GUNS AND ARMOR.

ROBOTS

Cartoon robots rarely get that complicated, however. They tend to stay close to the robot fundamentals of blocky body, big, square head, and clunky walk. Within those limitations, however, there's still plenty for 3D cartoonists to play with. Giant bots are the special province of the Japanese. *Gigantor*, a 1960s TV series adapted from a manga by Mitsuteru Yokoyama, was the first giant robot animation, and it set the parameters for all subsequent good big robot shows, from *Transformers* to *The Iron Giant*. As the *Gigantor* theme song makes clear, "He's bigger than big, taller than tall, quicker than quick, stronger than strong, ready to fight for right against wrong!"

That could also be the creed of American stop-motion artist Webster Colcord's *Underground Robot*, the lead in an animated series pitch to Nickelodeon. Like *Gigantor* (and *The Iron Giant*), *Underground Robot* has a pint-size kid pal who helps him fight evil. But when it comes to clobbering rampaging monsters, *Underground Robot* has enough attitude—judging from his ticked-off expression—to finish the job on his own.

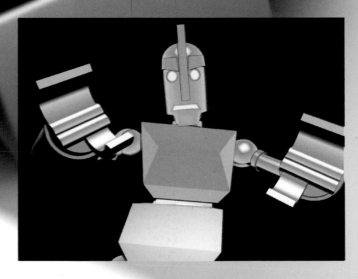

MAIN PICTURE: Jimmy Maidens of Boring3D reminds us that bots need friends, too. Crafted in discreet's 3ds max with custom shaders.

RIGHT: This menacing, cartoon-rendered 3D robot animates a segment of the 1950s radio play *Almost Human* for the *American Pulp* TV series.

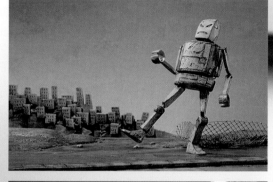

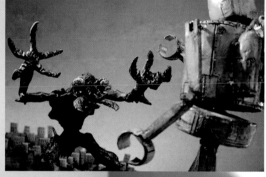

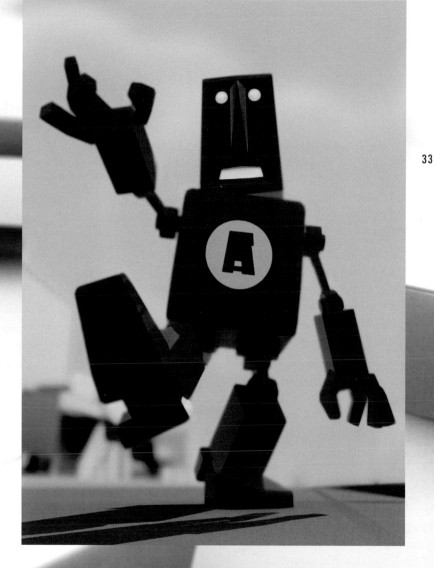

When the French do giant robots, they do them with panache. François Gutherz's big red guy, who appears to be made of snap-together pieces of cycolac, has an almost jaunty, "I-own-the-street" air that is definitely rare in a robot. Gutherz has created an unusually powerful image, with the red of the robot standing out strongly against the yellow background. The shallow depth of field makes the scene look both huge and miniature at the same time.

Everyone projects the inner emotional life of robots—our persistent fantasy is that they will yearn to be just like us—but it takes Jimmy Maidens's particular sideways worldview and compositional genius to make a robot appear positively pathetic. In *Where Are The Other Robots*, the endless field of empty cardboard boxes seems like the

ABOVE RIGHT: François Gutherz's big red bot inhabits the artist's *Mandarine* world. The artist used Newtek's Lightwave 3D to create the shiny plastic look.

ABOVE LEFT: Webster Colcord's *Underground Robot* is the natural descendant of good big robots like *Gigantor*, but filtered through Colcord's funky stop-motion sensibility.

saddest thing in the world, and the robot, apparently made of stuck-together boxes itself, has an inexpressible air of loneliness and dejection.

Of course, depressed or confused robots sooner or later turn on their creators, as Raf Anzovin's silvery monster does in a character test for the in-production TV series *American Pulp*. Harking back to the kitchen appliance designs of 50 years ago, this maniacal mech has that era's requisite lightbulb eyes and glowing mouth. (Early on, animators discovered that flashing a mouth light in synchrony with the robot's voice track was a cheap way to create lip sync. The droids in *Star Wars* do the same thing.) Careful positioning and shaping of these simple face elements give the robot the coldly hostile expression we secretly fear.

SIMPLE SHAPES, BRIGHT COLORS, BOUNCY MOVEMENTS, ZANY MOOD—THESE ARE HALLMARKS OF THE CARTOONY TOON. WE'RE ALL FAMILIAR WITH THE EXTREME, ALMOST FETAL STYLIZATIONS OF CARTOON CHARACTER DESIGN AS SET FORTH BY THE FLEISCHERS, DISNEY, AND WARNER BROS: ROUNDED AND SIMPLIFIED BODY SHAPES, A BIG HEAD WITH BIG OVAL EYES AND HUGE PUPILS, PROMINENT EAR, HAIR, OR HAT SHAPES AS AN IMPORTANT IDENTIFIER OF CHARACTER, OVERSIZED THREE-FINGERED HANDS AND TOELESS FEET.

CARTOONY TOONS

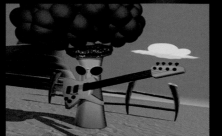

Such stylistic simplifications had a practical purpose—to speed the task of hand drawing thousands of frames—and a psychological one—to appeal to the widest possible audience by using the most basic character signifiers.

Those design principles still apply for 3D toons. The same tools that enable the ultimate in realism can also be used to create extremely simple characters. For some purposes, the simpler the better, to the point where the character is just a face. Case in point: an oncology hospital in France wanted an educational animation to explain cancer therapies to children whose parents were undergoing cancer treatment. The characters had to be appealing and easy to animate. The final designs take the basic toon face conventions and put it on a limbless, featureless body, reducing facial features to one or two unique elements to show which was the father, the mother, and the child. The characters had to emote, but they couldn't look human

otherwise, so kids wouldn't relate them too closely to their own parents. Why add hair? So one of the characters could lose it during chemotherapy.

In a variation on this theme, the animated vegetables in the music video (*see left*) do a lot with minimal bodies. The carrots and pepper put across their dance routine with nothing more than squash and stretch and a lot of bounce. Even the guitar-playing Jimi Broccoli, whose design harks back to the musical trees in Disney's *Silly Symphonies*, rocks without arms.

Toony movement has its own conventions. No need for the subtlety and naturalism that 3D makes possible—classic cartoon poses need to be broad, extended, and dynamic. In this frame from a cartoon cat's run cycle, note that the character has the simplified head shape, prominent ears, tubular body, three-fingered hands, and sassy attitude of the classic toon. The pose is instantly readable.

BELOW RIGHT: A stripped-down cartoon face is all a character needs. These bodiless characters were designed for a medical animation aimed at children of cancer patients.

LEFT: Running toons still have time to mug for the camera.

FAR LEFT: Dancing vegetables need no limbs—they just squash, stretch, and bounce.

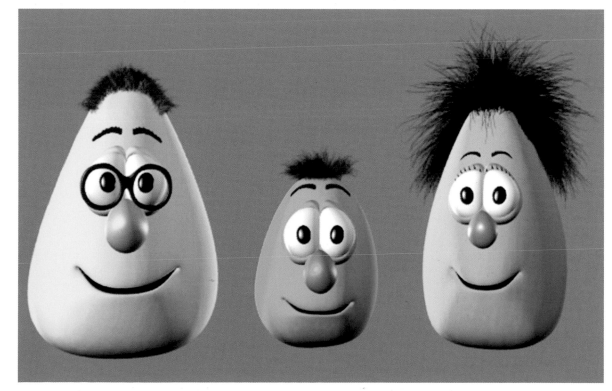

ANIME

ANIME-STYLE 3D, WHICH ORIGINATED IN JAPAN FROM MANGA COMIC-BOOK ART, 1960S TELEVISION JAPANIMATION, AND MODERN CEL-ANIMATED ANIME FILMS, HAS IN THE LAST DECADE DEVELOPED MANY REGIONAL STYLES IN ASIA. IT HAS ALSO BUILT A STRONG CULT FOLLOWING IN THE WEST, INCLUDING THE UNITED STATES. IN JAPAN, AND IN ASIA GENERALLY, MANGA IS IMMENSELY POPULAR AS THE ART FORM OF THE PEOPLE.

Thousands of story lines have been maintained over decades by the major manga publishers, and this does not even begin to tell the story. Loopholes in Japanese copyright law allow a flourishing legion of amateurs and fan artists, called *dojin*, to derive their own works from the worlds and characters created by professional manga artists. Some of these *dojin* are indeed as talented as the pros, but simply prefer to create their art for free.

The look of anime derives primarily from a set of drawing conventions (such as the immense eyes and tiny mouths of most anime characters), elements of which can be traced as far back as premodern Japanese popular arts, notably *ukiyo-e*, but also owes much to Disney cartooning. There are innumerable variations on the basic stylizations, varying from artist to artist and country to country, and also according to the intended audience. To put the aggressively simplistic *Pokemon* in the same category as high-art anime films such as Hayao Miyazaki's *Spirited Away* or Satoshi Kon's *Millennium Actress* seems illogical, but all play with the same graphic conventions and all are indeed anime.

When moving from 2D to 3D, anime and manga artists often try to maintain the hand-drawn look by using cartoon shaders that render the work in outlined areas of flat color. 3D characters have to be designed in a certain way for this to work well; poor design can result in odd distortions or lines in places where no artist would draw them. *Cartoonist Girl* is a polished example of how this approach can succeed. In fact, it is not easy for the untrained eye to see that this is 3D at all. The artist, Hiromoto Akinori, is a dojin who creates CG and comics while

on vacation from his regular job. The pages that *Cartoonist Girl* manages to finish by her deadline are examples of Akinori's own lighthearted manga work, but he is sufficiently skilled in 3D to have won awards in the United States.

Asian games are increasingly designed using anime conventions and localized story lines. A well-regarded example is the Chinese game *Five Lucky Star*, designed by Antony Wong. In the game, the hero Feng and the heroine Yu travel to the southern part of China to confront the evil demon Yulo. Feng and Yu are anime characters designed with a Chinese audience in mind; details of their costumes, the architecture, Feng's sword, and above all their dragon friend are all very Chinese. The rendered look is more obviously 3D as well; offsetting the heavy outlines, there is some modeling and shading to indicate volume, easily seen in Feng's face and hat.

ABOVE: *Five Lucky Star*'s Feng wears anime garb with Chinese detailing.

RIGHT: A Chinese version of anime stylings gives a regional flavor to Antony Wong's *Five Lucky Star* game characters.

LEFT: Artist Hiromoto Akinori created Cartoonist Girl using cartoon-shaded render techniques in Hash's Animation: Master, a low-priced 3D package popular with the Japanese dojin community.

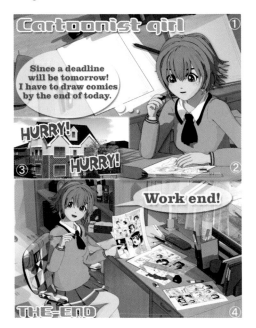

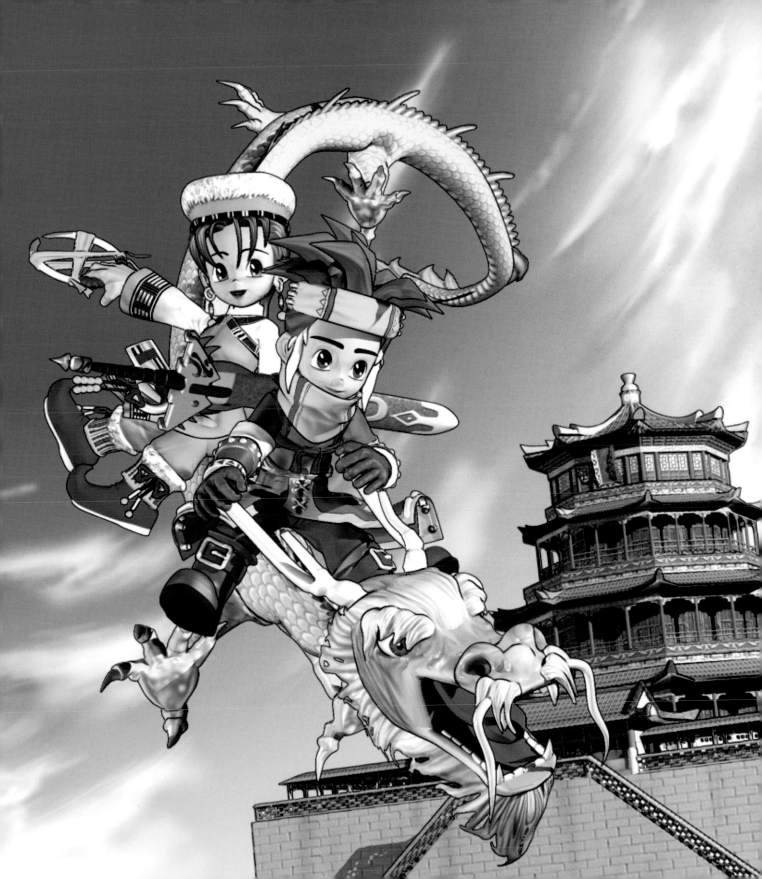

TOONS STARTED CUTE, AND FOR ALL THE SOPHISTICATION, IRONY, AND DARK HUMOR IN TODAY'S 3D TOON ART, CUTENESS STILL RULES, AND NOT ONLY IN CHILDREN'S ANIMATION, FOR IT'S ADULTS WHO ARE MOST SUSCEPTIBLE TO MANIPULATION BY CUTENESS.

CUTE TOONS

The quality of cute is essentially infantile—that is, it's derived from the human infant. A baby's large head, wide, wondering eyes, small, soft, short-limbed body, relatively big hands and feet, and evident helplessness trigger protective and admiring feelings that we are quite willing to transfer to anything with similar characteristics—puppies, kittens, dolls, toon characters, and so on.

Toon artists are well aware that cute proportions help generate instant appeal. For example, Avalanche designed Junior, one of the main characters in the game *Tak and the Power of Juju*, with a young teen's body and a little girl's snub-nosed face and tousled hair. She's a bit of a pest to the hero, Tak, but a help to him also—a mix of bratty little sister and guardian angel.

The popular Japanese cartoon character Alalei is here translated into 3D by Chinese artist deboy. Deboy chooses to use the Lighttracer global illumination renderer in discreet's 3ds max for his fan art rendition because the high-gloss renderer adds surface realism and—to some extent—lowers the inherent sugar content of the characters. Fan art, of which this is a quality

BELOW: Deboy's 3D version of the Japanese comics character Alalei. The model exactly captures the spirit of the drawing.

example, very often focuses on the cuter varieties of manga and anime (which can sometimes seem suffocatingly precious to jaded Westerners), perhaps because fan artists are driven to relive through their art some treasured moment of childhood comics-reading or cartoon-watching experience.

For the quiz game *Amore mio*, a flirting and dating simulator for the Photoplay touch screen device, RABCAT Entertainment (Austria) created a completely new brand and design. Says RABCAT's managing director, Christof Stanits, ''The task was to create cute characters with a little sexual appeal because of the nature of the game, in which you have to answer questions about human relationships. The modeling of the female character started from an already evolved male character; in fact, the female is the same shape as the male with breasts and eyelashes added, plus another hairdo and different clothing. She also is slightly smaller. We used a variation of a velvet shader to give the skin a smooth look.'' The kewpie-doll couple is quintessentially German, especially the female, and so resonated with Middle European players that RABCAT's design won a 2004 Animago award.

Cute does not always have to equal kitsch. Readers with slightly twisted sensibilities might find Webster Colcord's Playdoh bugs button-cute, though they share just about none of the usual cute traits. But cute, or anti-cute, is, after all, in the midbrain of the beholder.

LEFT & BELOW: The cute couple from the love and relationships quiz game *Amore mio* were created in Maya by RABCAT Entertainment. The hyperinfantile body shape was tailored to the resolution of the game screens.

RIGHT: Aren't Webster Colcord's Playdoh bugs cute?

BELOW RIGHT: Juju Junior, from the game *Tak and the Power of Juju*, has most of the qualities of a cute toon.

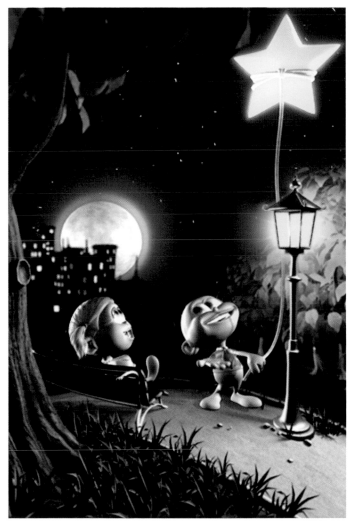

TOON EVOLUTION

IMAGINING AND PLANNING THE 3D TOON

2

SUCCESSFUL CARTOONS HAVE USUALLY BENEFITTED FROM THOROUGH STORY PREPARATION AND PRE-PRODUCTION DESIGN—WORK THAT THE AUDIENCE NEVER SEES AND IS USUALLY NOT AWARE OF. SUCH WAS THE CASE WITH *DAY OFF THE DEAD* (2003), A SHORT CG ANIMATION BY LEE LANIER AND JEFFREY DATES. *DAY OFF THE DEAD* FOLLOWS THE COMIC MISADVENTURES OF TWO DEAD SWEETHEARTS IN THE AFTERLIFE, WHERE THEY TRY TO REANIMATE THEIR LOFTY DREAMS AND EARTHLY DESIRES. THE CO-DIRECTORS SPENT A CONSIDERABLE AMOUNT OF EFFORT REFINING THE STORY LINE AND DESIGNS OF THEIR CHARACTERS TO PULL THIS OFF.

CARTOON PREPARATION

NT. WT.
8 OZ.

$1.99

FOR DEAD ONLY

Dapper Dead

TRADE MARK REG.
U.S. PAT. OFF.

BONE POLISH

DRAWING THE DEAD

The filmmakers had first to answer the question of what the dead should look like. A gruesome or scary appearance was not in keeping with the lighthearted tone of the piece. "Having lived in Texas for the last ten years," says co-director Dates, "it is impossible to ignore the Hispanic influence all around us." November 1 marks "Dia de los Muertos"—The Day of the Dead—when Mexicans honor the dead with processions featuring macabre—but friendly—effigies. "The likenesses created by folk artist José Guadalupe Posada, creator of the Day of the Dead's traditional look, can be seen in the streets. I'd like to think the Calcas (Skeletons) design we ended up using shows a lot of him in it." The Dead are not modeled real skeletons, as one might expect, but, true to their street-art roots, have the appearance of papier-mâché dolls with painted features. Many sketches and test models were created to achieve just the right look.

SCENE SETTING

A well-worked-out backstory gives depth to any tale. Lanier and Dates devised rules for the world of the dead: for example, all props and sets had to be considered "dead" by the living. So Deadworld is inhabited by old junked cars, buildings that have been condemned or demolished, faded supermarket tabloids, ancient black-and-white tube televisions, grimy street corners, even signage and prices (opposite). "We figured there was a forty-year lag from that of the living," says Dates.

STORY DEVELOPMENT

Dates, along with artist Jeremy Dale, drew story ideas directly from the design process. Developing the look and style of the characters and the world of the dead inspired gags that made it into the final production. The writing process was freewheeling, in keeping with the free-form nature of the narrative, a series of short linked scenes. "Lee and I presented each other with about 20 vignette concepts," recalls Dates. "I called it the 'shotgun' effect— shoot everything we have and see what sticks. We took ideas from one, married them with others, until we had what we felt were 10 good vehicles to hold the story arc: two lost souls who find each other and love. Elvis (below left) playing the role of Cupid tied the entire project together."

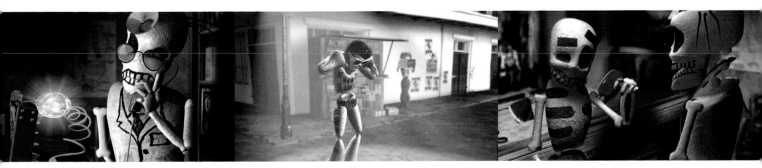

IT'S NOT ALWAYS NECESSARY FOR A 3D TOON ARTIST TO BE A GOOD DRAFTSMAN, BUT IT CAN HELP—AND MOST TOP CARTOONISTS ARE IN FACT TALENTED PENCIL PUSHERS. ESTABLISHING THE KEY LOOK, ATTITUDE, AND POSES FOR A CHARACTER, WHETHER FOR ANIMATION OR STILL ART, IS STILL FAR FASTER IF DONE ON PAPER. THE IDEAS CAN JUST FLOW, WITHOUT ANY WORRIES ABOUT KINEMATICS ISSUES, SCREEN REDRAW, OR THE OTHER IRRITANTS INHERENT IN CG. WALK THROUGH ANY COMPUTER ANIMATION STUDIO, AND YOU CAN SPOT LEADING ANIMATORS BY THE LITTLE POSE DRAWINGS ON STICKY NOTES PASTED TO THEIR MONITORS. THESE THUMBNAILS CAPTURE THE SPONTANEOUS INSPIRATIONS THAT LATER MUST BE LABORIOUSLY TRANSLATED TO 3D.

THE SKETCH

The sketch can serve several functions. For Australian artist Shaun Freeman, the colored-pencil-and-wash drawings of his motherly bird set out character proportions and color scheme. Like many artists, Freeman scans his drawings and uses them as background art in his modeling program. The image serves as a guide for actually creating the model—he lays down the splines (*see page 60*) of his model directly over the drawn outline, preserving as much as possible of his original sketch in the new 3D geometry. This is why he has drawn the bird in front and side views and with arms in the standard T-pose, which most modelers use.

Germany's Soulcage Department studio did extensive drawings for its TV spot *I'm Walking*. In the case of this chicken, one of the competitors in a footrace between organic and ordinary poultry, the aim of the sketch was not so much to define the bird's geometry for modeling as to define a

characteristic aspect of its motion—its kinked neck and goggling, rolling eyeballs. The sketch is quick and loose, like the bird's own movements, and the goofy affect of the finished 3D character is remarkably like that of the sketch.

Drawings can do yet more—they can rapidly define a character's mood. Animator Victor Navone created both quick sketches and finished character studies for his Blit the alien, star of the extremely popular gag short *Alien Song*, which was a sensation on the Internet (and earned Navone his current gig working on features at Pixar). The thumbnail poses of Blit closely match those in the actual film—the pose at lower left is very similar to the animation frame on this page—and they also convey the range of emotions he expresses as he lip-syncs to the Gloria Gaynor song "I Will Survive." The sketches at right detail Blit's design in a more careful manner. It's revealing how much expressivity Navone coaxes from a character with one eye, no nose, and a unibrow.

ABOVE: Shaun Freeman's color sketches of a mother wren served as guides when modeling her in Hash Inc.'s Animation: Master software.

LEFT AND BELOW LEFT: The drawings of this scrawny-necked hen, designed by Soulcage Department for the German TV commercial *I'm Walking*, are very simple but nonetheless define the character's goggling affect.

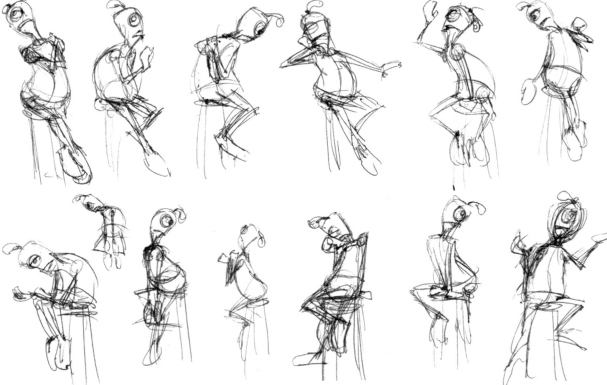

LEFT AND ABOVE: Pixar animator Victor Navone imbues his character Blit with definite attitude in these sketches for his hit short *Alien Song.*

THE MODEL SHEET, SOMETIMES CALLED A CHARACTER SHEET (OR CHARACTER BOOK IF COMPOSED OF MANY SHEETS), IS A DRAWING OR RENDERING THAT SOLIDIFIES THE DESIGN STANDARD FOR A 3D TOON. THE POINT OF A MODEL SHEET IS TO CONTAIN IN ONE REFERENCE SOURCE ALL THE APPROVED VISUAL ELEMENTS THAT GO INTO THE LOOK OF THE CHARACTER, FROM EVERY ANGLE, WITH DETAILS AS NEEDED. THE MODEL SHEET IS ABSOLUTELY ESSENTIAL TO MAINTAIN DESIGN CONSISTENCY AND INTEGRITY IN TRADITIONAL 2D ANIMATION, WHERE MANY ARTISTS MAY BE HAND DRAWING THE SAME CHARACTER.

THE MODEL SHEET

In 3D tooning, the model sheet is not as vital—a 3D model maintains its shape integrity no matter how many artists are working with it—but it is still useful as the step wherein all the complex elements of the character are summed up and communicated to other artists or clients.

The model sheet for Victor Navone's Blit Wizbok is a classic example. It shows the character from front, back, and side; indicates his usual stance, center of balance, and facial expression (at neutral, Blit has a friendly but slightly dopey smile); includes final details of costume (the one-eyed smiley face, the ringed planet on his belt); and nails down the color scheme (pure RGB).

Model sheets may include multiple characters to indicate comparative size and even some relationship among them. In the image of the five heroes of the Chinese console game *Five Lucky Star*, you can see not only their relative heights (the boys are slightly taller), but also some characteristic poses and facial expressions. The slight spacing difference between the characters also clearly shows who is the heroine and indicates which characters may be related to each other.

In *Five Lucky Star*, costume details are extremely important in revealing character. The Chinese audience can easily decode who is good, who is bad, and who is a bit of both just from those details. A lot of attention was also paid in developing original clothing for a Mabinogeon-inspired retelling of the King Arthur legend by animator William Woelbeling. Artist Genevieve Wood worked through several model sheets for Merlyn (a more Aragorn-like version than is usually seen), young Arthur, and an elvish friend. Each

ABOVE: Blit Wizbok; a classic example of a 3D model sheet by Victor Navone.

BELOW LEFT: All of Antony Wong's *Five Lucky Star* heroes can be seen together in this sheet, with characteristic poses and detailed costumes.

ABOVE RIGHT: Perfecting GI Joe's Jinx: an instructive critique by ReelFX Creative Studios.

RIGHT: Artist Genevieve Wood developed this fresh take on characters from the King Arthur legend for a 3D retelling. The model sheets show the unusual costumes in evolution.

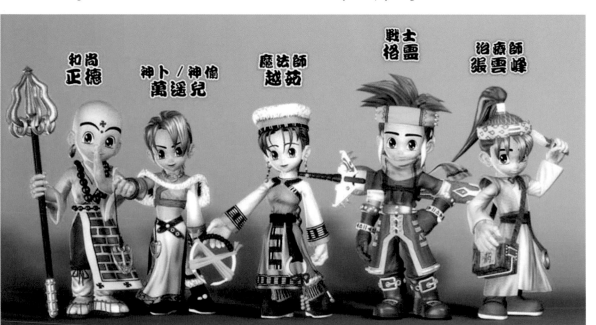

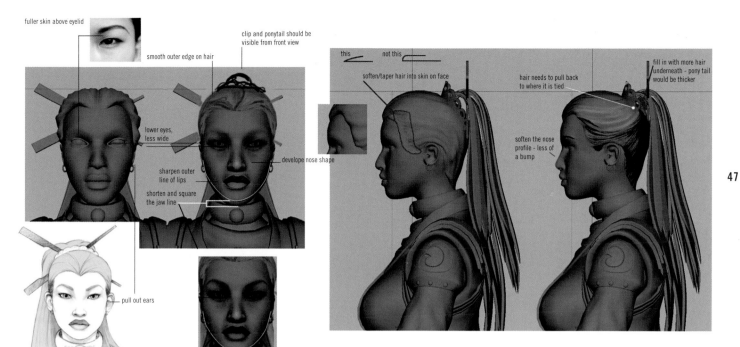

fuller skin above eyelid

smooth outer edge on hair

clip and ponytail should be visible from front view

this not this

soften/taper hair into skin on face

hair needs to pull back to where it is tied

fill in with more hair underneath - pony tail would be thicker

lower eyes, less wide

develope nose shape

soften the nose profile - less of a bump

sharpen outer line of lips

shorten and square the jaw line

pull out ears

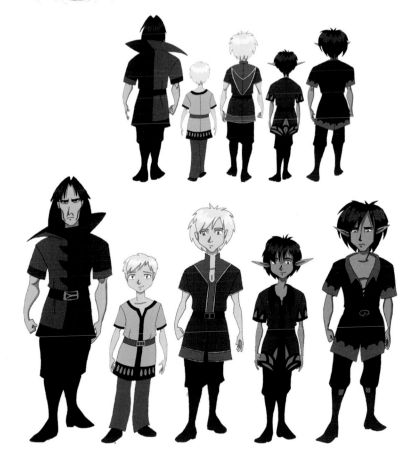

character is shown front and back and to scale. Some elements of these costumes still require tweaking; for example, Merlyn's collar is too wide and will interfere with the animation of his head.

Refining the look of a 3D character for the model sheet can take considerable effort, especially if the design process has to move through several levels of a large corporation, or if the character under construction needs to match already existing designs. Reel FX Creative Studios, a company known for its meticulous approach to design development, went through several approval iterations with the 3D version of the GI Joe character Jinx, who was originally introduced by Hasbro in the 1980s. At issue in this revealing document is how to bring the modeler's first draft of Jinx's head in line with the design sketches. The art director has drawn and annotated modifications to the hairline, jaw, ear, eyes, and ponytail that seem minor, but in fact have a major impact on Jinx's overall look. Photo clips, sketch details, hand-painted elements, and text callouts are all tied together in a clear and unambiguous statement of what needs to be done next.

GIVING PERSONALITY AND LIFE TO A CG CREATION IS ONE OF THE HARDEST TASKS OF THE ARTIST. REAL SKILL IS NEEDED TO CRAFT CHARACTERS THAT AVOID THE USUAL PITFALLS: AWKWARD PROPORTIONS, CLUMSY POSES, LACK OF SPARK IN THE EXPRESSION. MANY ARTISTS TURN TO OTHER MEDIA, SUCH AS COMICS, FOR INSPIRATION. UK ANIMATOR STEPHEN MILLINGEN TAPPED COMICS ARTIST EDWARD BLAKE FOR DESIGN IDEAS WHEN PLANNING AN ANIMATED FANTASY ADVENTURE SOMEWHAT IN THE MOOD OF FRITZ LEIBER'S *FAFHRD AND GRAY MOUSER* TALES.

BUILDING PERSONALITY

"Centered around our main character, Briar Rose, it's a rousing fantasy adventure of courage, friendship, high moral values, gratuitous sexual innuendo, cross-dressing, and a small dog. What more could you ask for!" **EDWARD BLAKE**

COMIC STYLE

From the outset, the artists wanted to capture the style of a comic, not necessarily in terms of the classic heavy use of black and white tones, but mainly in the mannered characterization and strong influence of cinematography in both the look and narrative. After a flurry of preliminary sketches (*below*), they settled on the basic attributes all characters would share: large shoulders, especially for the male actors; relatively small tapering legs with tiny feet; simple, clean textures and forms (with no fussy details like nostrils).

Avoiding the lure of the current desire for hyper-realistic models and texturing in 3D was also important. Excessive detail often works against character expressivity, not to mention making it harder for independent artists to move past the modeling stage and into animated production. The mixed wireframe and shaded view of Gordon Bellows (*below*) shows that his geometry (built in Hash's Animation: Master) has been crafted with considerable economy; this keeps the file size of the models within reasonable bounds and the models themselves easier to load and manipulate.

MOVING PERFORMANCE

In animation, character personality is also expressed through pose and movement. That means installing an effective limb control system for animation—Briar Rose's upper-body controls are shown (*below left*)—crafting good-looking joint deformations, and above all building a well-conceived face setup capable of lively expressions. Control rigging was handled by an automated software utility called The Setup Machine, but deformations and face rigging required careful construction by hand. "Rigging figures with huge, beefy shoulders presented me with a few challenges in terms of mesh deformation," notes Millingen. "Animation: Master's smartskin feature handles this area very well, allowing me to keep the geometry smooth when rotating limbs, but also to easily add details like plausible muscle bulging."

Millingen believes that the personalities of Briar Rose and Gordon Bellows shine through just by looking at the models. "Hopefully," he says, "this will help me animate convincing performances from both."

49

TOONS WITH ATTITUDE
The modeling of toon characters Gordon Bellows and Briar Rose is complex enough to allow realistic movement and facial expressions but economical enough for animation to be reasonably easy.

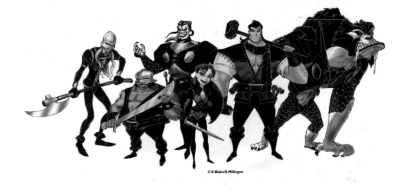

©E.Blake/S.Millingen

IT'S NATURAL FOR THE LOOK OF COMIC CHARACTERS TO EVOLVE OVER TIME AS THEIR ARTISTS DEVELOP, BUT IN THE 3D WORLD, DESIGN CHANGES ARE TYPICALLY DRIVEN BY TECHNOLOGICAL OR MARKETING DEVELOPMENTS, NOT ESTHETIC ONES. SO IT IS RARE TO FIND EXAMPLES OF 3D CHARACTER DESIGN DEVELOPMENT TIED TO THE MATURING OF AN ARTIST'S STYLE AND PHILOSOPHY—RELATIVELY FEW ARTISTS HAVE BEEN USING THE MEDIUM LONG ENOUGH EVEN TO ESTABLISH A DEVELOPMENT HISTORY. HERE IS AN UNUSUAL EXAMPLE OF THE EIGHT-YEAR EVOLUTION OF A 3D CHARACTER DESIGN AS THE ARTIST GREW TO ADULTHOOD.

CHARACTER EVOLUTION

THE AGES OF DENNIS

Dennis the dog, whose evolution is shown below, began life as a drawn character. An initial 3D incarnation was created by the artist at age 12. There are interesting developmental parallels between artist and character. Dennis starts as a small character, almost childlike, and is limited to a seated posture, largely because the software used had few character animation tools— no skinning, no bone system, no IK (Inverse Kinematics, *see page 87*). As the artist grows, gaining more experience and moving to more capable tools, Dennis becomes more complex and sophisticated: he acquires the ability to walk, move his mouth, wear clothes, then to leap, dance, and fight. His body proportions lengthen, his snout recedes, partly to make him easier to animate (especially in the face, where a big snout limits facial expression and workable camera angles), partly because the artist's body image is changing, too.

SEGMENTED CHARACTERS

Limitations in desktop 3D software written before about 1995 meant that articulated characters generally had to be constructed in segments that were then stuck together— analogous to the construction process of toy dolls or action figures, which are assembled from molded plastic parts. This exploded view (*above right*) of an early Dennis, created with Specular's Infini-D software, shows all the shapes used to make him and how they attach to one another. This is still one viable way to construct a character, and works notably well for robots and other characters with a segmented look and little or no deformation. Modern 3D software enables artists to model characters in one major piece, which works best for organic forms. The main advantage here is that the model can be deformed and textured without noticeable discontinuities at places where parts are joined.

HOW DENNIS STARTED
In 1994 Dennis was "Dennis the MicroMutt." He was spline-modeled with extrusions in Stratavision and, with nerd glasses and small bow tie, was classic computer geek material. He didn't yet have a mouth—or, if he did, it was painted on in 2D.

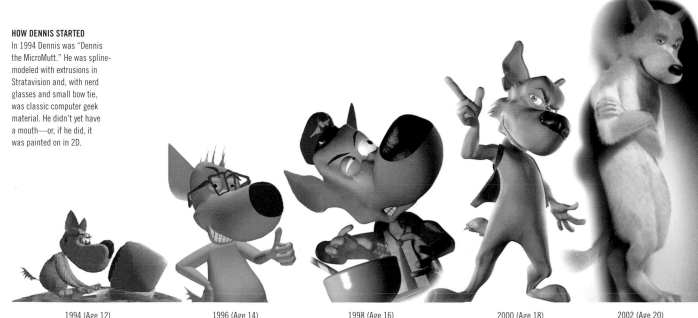

| 1994 (Age 12) | 1996 (Age 14) | 1998 (Age 16) | 2000 (Age 18) | 2002 (Age 20) |

SERIOUS CHANGE

Dennis's persona also matures over time, moving from a simple nerdish character defined by an obsession with computers to an antihero with a darker, animalistic side. The nerd trappings (glasses, bow tie, pocket protector, spiky hair) disappear. Proportion changes make Dennis more wolflike. His body is larger in relation to his head; his snout is much smaller and narrower; he is capable of moving from bipedal to quadrupedal gaits. In this image (*below*), created in Newtek's Lightwave 7, the mouth interior is fully modeled and rigged, allowing full view of the much more imposing, anatomically accurate teeth. Fur (created with Shave and a Haircut for Lightwave) abolishes the remaining cartoonishness of his appearance.

DENNIS'S CURRENT INCARNATION
Now subdivision-surface modeled in Lightwave 3D, Dennis is anatomically much more dog-like. He has convincing fur and lips, five-digit paws, and both bipedal and quadrupedal capabilities. And he has developed a fully authentic personality—a scary one.

51

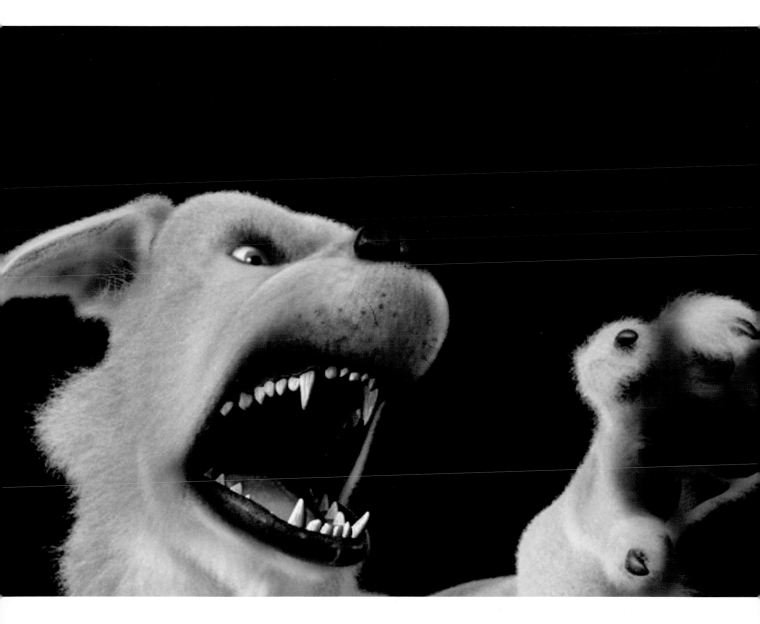

ONCE CHARACTERS FOR A 3D TOON ANIMATION ARE DEVELOPED AND A BASIC BACKGROUND AND STORY LINE ARE DEVISED, THE NEXT STEP IS STORYBOARDING. A STORYBOARD CAN BE THOUGHT OF AS A COMIC STRIP OF THE TOON, WITH EACH DRAWING CORRESPONDING TO A PLOT POINT, BIT OF DIALOG, PUNCH LINE, IMPORTANT CAMERA ANGLE, OR EDIT CUT. THE STORYBOARD IS OFTEN FOLLOWED AND SOMETIMES SUPERSEDED BY AN ANIMATIC, A SEMI-ANIMATED VERSION WITH ROUGH 3D ELEMENTS, TEMPORARY SOUND TRACK, AND PRELIMINARY EDITS, BUT FOR A PRODUCTION OF ANY COMPLEXITY THE BOARDS USUALLY SET THE ORDER OF ACTION.

STORYBOARDS

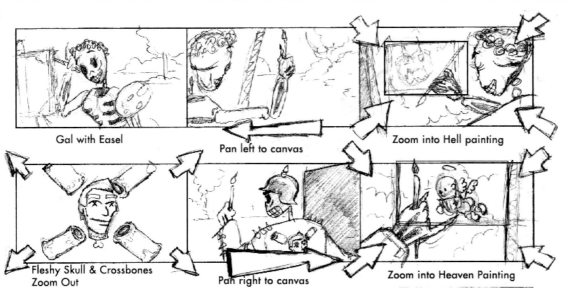

Gal with Easel

Pan left to canvas

Zoom into Hell painting

Fleshy Skull & Crossbones Zoom Out

Pan right to canvas

Zoom into Heaven Painting

LEFT: Storyboard for the opening sequence of *Day Off the Dead*, a short 3D toon by Lee Lanier and Jeffrey Dates. Arrows indicate camera moves.

RIGHT ABOVE: Limiting the viewer's point of view sets up the joke in the *Dog Daze* sequence.

RIGHT: Storyboards should have the concise story and visual punch of a good comic strip.

Day Off the Dead (2003), a short animation co-directed by Lee Lanier and Jeffrey Dates, was thoroughly storyboarded by artist Jeremy Dale. Because of the modularity and loose narrative structure of *Day Off the Dead*—the short is a series of gags on the theme of daily life in the afterlife—each gag was limited in complexity to what could fit on one board. This made it easy to shuffle gags around in the board stage to find the best order, while making sure that laughs came regularly and often. Of all the sequences the co-directors came up with, about half were used in the final piece.

The opening sequence of *Day Off the Dead* contains several standard storyboard graphic elements. Each camera angle and edit gets its own frame. Below, text explains what the frame shows, as well as listing any dialog, effects, or other pertinent information for that frame. Arrows indicate camera movements—pans, zooms, and so on. Arrows may also indicate a line of action for the movement of 3D elements within the scene. Drawing complexity is kept to a minimum—you are shown what's necessary to grasp the scene, but no more. (Storyboards for feature animation may be much more elaborate—works of narrative fine art in themselves.)

The process of storyboarding forces the director to carefully visualize what angles and cuts are needed to carry a particular sequence. In *Dog Daze Afternoon,* the joke is set up by using repetition and carefully limiting what the audience can see—the same gag strategies used constantly in daily comic strips. The Dead Guy is about to toss a stick for his Dead Dog when the Dead Gal passes by. All the frames are the same wide shot on the Dead Guy and Dead Dog except for one of the flirtatious Dead Gal from the Dead Guy's point of view, and one close-up of his love-struck reaction. We return to the "objective" wide camera angle to see the stick being tossed. A tight close-up then shows the Dead Dog fetching a bone rather than the stick. This would seem to be a normal enough mistake, but in the next wide shot we see that the bone is still attached to the now-impatient Dead Gal. Likewise, in the sequence "*You Look Like Death,*" the parallel setup of brushing teeth and buffing skull, each with its own polishing compound, is established by drawing each activity from exactly the same angle. The biggest laugh in the gag—and in the storyboard—is not the sparkling head, but the camera shake when the buffer goes on.

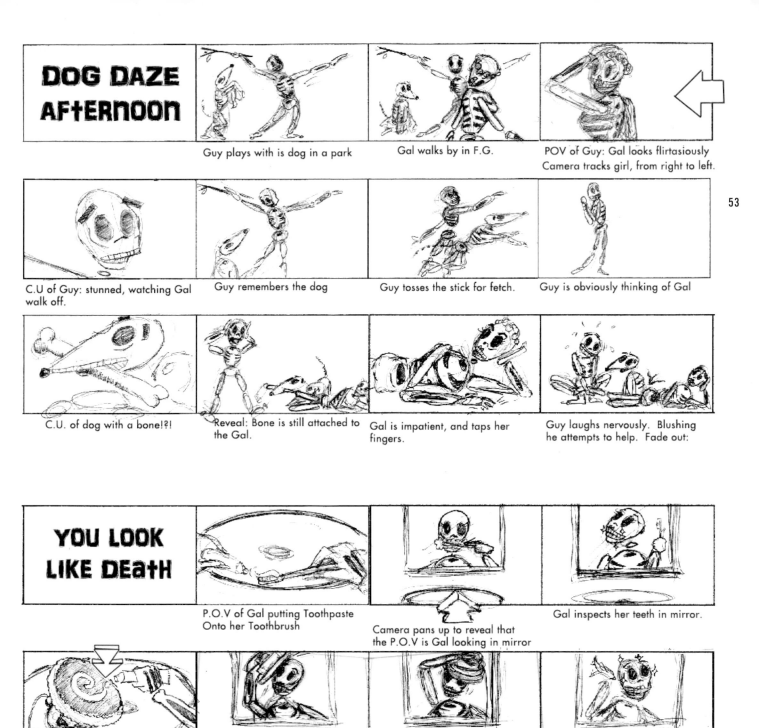

DOG DAZE AFTERNOON

Guy plays with is dog in a park

Gal walks by in F.G.

POV of Guy: Gal looks flirtasiously
Camera tracks girl, from right to left.

C.U of Guy: stunned, watching Gal walk off.

Guy remembers the dog

Guy tosses the stick for fetch.

Guy is obviously thinking of Gal

C.U. of dog with a bone!?!

Reveal: Bone is still attached to the Gal.

Gal is impatient, and taps her fingers.

Guy laughs nervously. Blushing he attempts to help. Fade out:

YOU LOOK LIKE DEATH

P.O.V of Gal putting Toothpaste Onto her Toothbrush

Camera pans up to reveal that the P.O.V is Gal looking in mirror

Gal inspects her teeth in mirror.

Camera pans back to sink to show her Gal applying polish to an industrial buffer.

Camera pans up to mirror: When Gal applies buffer to head introduce: Camera Shake.

Camera Shake cont.

Reveal: Gal forehead sparkles!

THE TIMING AND COMPOSITION OF AN ANIMATION IS OFTEN PLANNED USING AN ANIMATIC, WHICH MIGHT BE THOUGHT OF AS A STORYBOARD IN VIDEO. IT'S A STEP BEYOND THE STORYBOARD, HOWEVER, BECAUSE THE ANIMATIC ADDS TIMING AND CAMERA MOVES AND SOUND. ONE OF THE EASIEST WAYS TO MAKE AN ANIMATIC IS SIMPLY TO SCAN THE STORYBOARD PANELS (IF THEY ARE ON PAPER) AND ASSEMBLE THEM INTO A "MOVIE" USING A VIDEO EDITING PROGRAM, USUALLY ALONG WITH A ROUGH SOUND TRACK. OR ANIMATORS SKETCH KEY POSES OF THE CHARACTERS AND ASSEMBLE THEM INTO A SPECIALIZED TYPE OF ANIMATIC CALLED A POSE REEL.

ANIMATICS

54

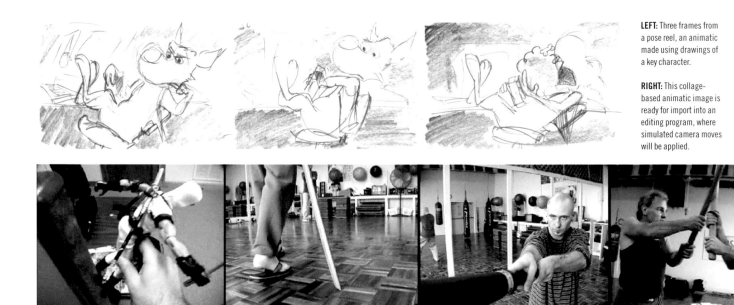

LEFT: Three frames from a pose reel, an animatic made using drawings of a key character.

RIGHT: This collage-based animatic image is ready for import into an editing program, where simulated camera moves will be applied.

C22	×✓	eyes look at box	
	A	**B**	**C**
22		blink	eyes look at box
23			
24			
25			
26			
27			
28			
29			
30			
31			
32			
33			
34			
35		begins reach	
36			
37			
38			
39			chair movement begins
40		Reaches in	
41			
42			
43			
44			
45			
46			chair tilts back
47			
48			
49			
50			
51		(rumage)	
52			
53			
54			
55			
56			
57			
58		hold	
59			

The panels are moved, stretched, and clipped until the right timing is found. This is the best way, visualizing the work as it is assembled in skeletal form, seeing visuals matched with sound for the first time, adjusting the timing and pacing of shots until they build a satisfying rhythm. As Disney animator Shamus Culhane puts it, ''The poses tell the story, but it is the timing that intrigues the audience.'' A dope sheet aids in working out the animatic timing. The example is nothing more than a spreadsheet, with frame numbers down the left and notes about when actions should occur on the right.

Animatics aren't limited to drawings, of course. Collage can add zip to animatic panels. The wide-format collage of a battle sequence between Dennis the dog and a troop of Hell's Monkeys has been assembled from various clip-art images. Tracking and zooming camera moves will be added in the editing program to bring the panel to life.

ABOVE: A sequence from a video ripomatic—an animatic incorporating borrowed footage from other films.

LEFT: The dope sheet aids timing caculations; this dope sheet is a simple spreadsheet.

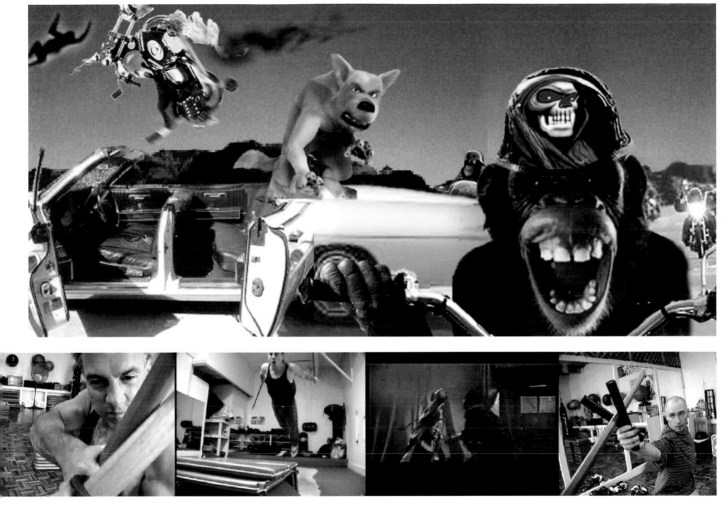

On larger productions, a 3D animatic may be created using proxy versions of the characters and sets. Camera moves are incomplete and characters slide like wooden soldiers to hit their marks, with no motion detail—the point being to produce the animatic as quickly as possible—but the basic pacing of the work can be established. It is also much easier for the director to see in the animatic whether a scene is actually needed or not. This sort of animatic is much the same as the layout phase of a production; in a well-orchestrated pipeline the very same files move right along to be worked on by character animators.

Animators also shoot video versions of the action they will later animate, using whatever is at hand: actors, dolls, toys, or even clips from other movies (especially helpful when, for example, you need a bit of rousing martial arts combat that your feeble crew of pixel pushers is incapable of acting out). The term *ripomatic* has been coined for animatics that borrow lots of Hollywood footage. Fitting the disparate clips together so they flow properly provides some of the same satisfaction as doing a tricky jigsaw puzzle.

With the animatic as a guide, creating the animation itself is more efficient and more fun. The animator can concentrate on the nuances of character performance without worrying that the big shot rhythms might be totally off. It also allows you to make the animation equivalent of Stanley Kubrick's final check: "Is there anything on the screen worth animating?"

ALONG WITH DEVELOPMENT OF CHARACTERS AND STORY, THE 3D CARTOONIST WILL WORK ON CREATING AN ENVIRONMENT FOR THE PIECE. FOR STRIPPED-DOWN CARTOONS, WHERE CHARACTER PERFORMANCE IS EVERYTHING, NOT MUCH OF AN ENVIRONMENT IS NEEDED. THIS IS WHAT YOU SEE IN MOST TV-ORIENTED CARTOONS, WHERE THERE IS NEITHER TIME NOR MONEY (NOR AN ADEQUATE NUMBER OF PIXELS) TO LAVISH ON ELABORATE BACKGROUNDS.

ENVIRONMENTS

Taken to an extreme, you get the "Hanna-Barbera effect," where the same few backgrounds are used over and over again in a series of toons, and, within the toon, a single painting is scrolled behind, say, Yogi and Mr. Ranger as they chase each other around parallel to the picture plane. (Nothing ever moves along the Z-axis in these toons—the motion was just too hard to draw.) There's a certain threadbare charm to this utter simplicity, but not much visual nourishment.

By contrast, creators of long-form CG toons tend to put immense effort into the environment or world being created for the characters. Consider the wealth of scenes in *The Incredibles*, *Shrek 2*, or any other big-budget CG effort, and it's evident that as much if not more effort was put into those cityscapes and magical forests as in the character animation. More modest productions still warrant care in environment creation. With limited resources, Soulcage Department managed to create a credible chicken city and peaceful countryside for their commercial *I'm Walking*. The last shot, where the organic chicken winner strolls off with the trophy, takes place in a landscape that is part 3D (the ground and tree) and part photographic (the sky).

BELOW: Soulcage Department's triumphant fowl from *I'm Walking* heads into a rosy sunset composed of mixed 3D and 2D elements.

Console games often have elaborate environments mixing 3D and 2D elements, if for no other reason than there need to be lots of nooks and crannies where monsters can lurk or magical items can be hidden. For *Tak and the Power of Juju*, matte painters at Avalanche Software created scores of background paintings of locations both peaceful and threatening. The choice of a painterly look for the art helps give Tak a soft and organic feel—appropriate to a family-oriented game—that many other adventure games lack.

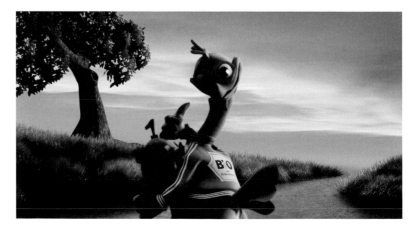

RIGHT: Putting a character in a "real" environment involves lining up a ground plane so feet can be properly positioned, and accurately pointing and adjusting lights so the character appears to be illuminated the same way as the background.

FAR LEFT: This matte-painted environment from the console game *Tak and the Power of Juju* screams danger, from the grim color scheme to the hanging skulls to the Minas Morgul–like green skybeam.

LEFT: A more benevolent Tak background—a homey village with lots of jumping platforms.

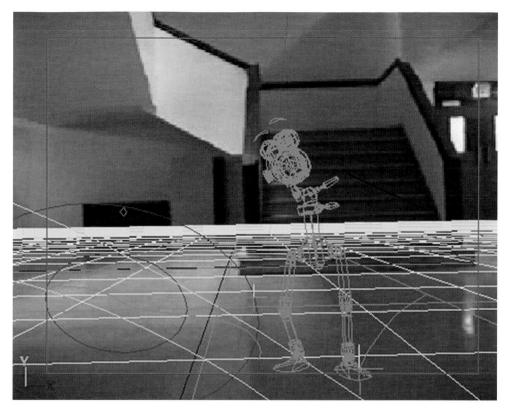

RIGHT: The ultimate environment for any 3D toon character is reality. Compositing a toon into video or film footage takes effort and skill. Well-funded productions use motion markers and light metering on set, and match-moving software in post-production to make the blend as perfect as possible. But it can also be done all by hand, as in this low-budget commercial test for a video-production software company. The trick primarily is to get the ground planes to match so that shadows fall naturally, and to make sure that light sources appear to be coming from the same direction and with the same intensity on both background and character. The gawking passerby only adds believability.

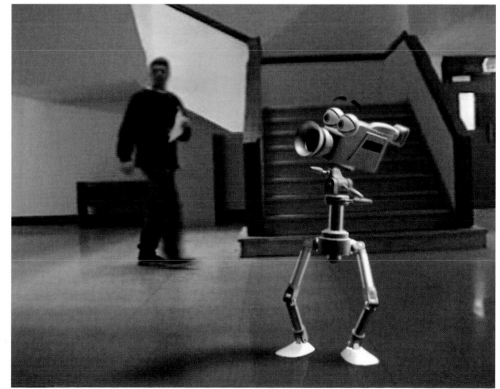

3

ANATOMY OF A TOON

3D CHARACTERS – FROM CONCEPTION TO TOON REALITY

MODELING IS THE PROCESS OF BUILDING A 3D OBJECT USING CG SOFTWARE TOOLS. IT IS THE FIRST AND MOST BASIC STEP OF CG TOON CREATION, COMING AFTER SKETCHING AND DESIGN, AND BEFORE TEXTURING, RIGGING, ANIMATION, AND RENDERING. NEOPHYTE MODELERS OFTEN ASSUME THAT MODELING IS LIKE SCULPTURE, BUT IN FACT, MOST MODELING OPERATIONS ARE MORE LIKE BUILDING WITH A VERY POWERFUL TOY CONSTRUCTION SET. MODELING SOFTWARE IS DESIGNED SO THAT THE ARTIST IS ACTUALLY DEFINING THE SURFACE OF THE MODEL, NOT ITS VOLUME.

MODELING

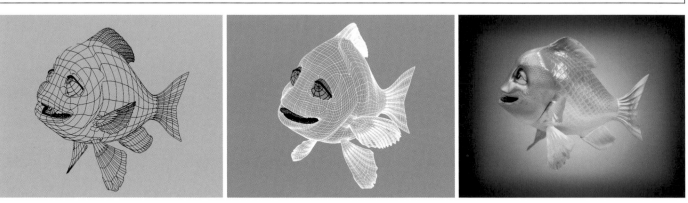

That surface is commonly called the geometry or the mesh; and an image of the mesh is a wireframe. Looking at the illustrations on this page, it's easy to see why—the in-progress characters appear to be made up mainly of simple geometrical shapes, mainly squares or triangles, just as if they were built with Tinkertoys or a Meccano set. The stripped-down look of these wireframes has a spare beauty of its own.

With their organic shapes and many complexities, toon characters pose special challenges for modelers. Three common modeling technologies are used for character building. The most popular is *polygonal modeling*, in which surfaces are defined by triangles or other polygons. The smoothness and detail of the surface depends on how many polygons are used. The more polys, the smoother, but the higher the computational cost. At close range or high resolution, polygonal surfaces can look faceted rather than smooth, so they are rarely used these days for feature animation. However, polys are very efficient for low-resolution game characters, where simplicity of design is paramount. François Gutherz's Smila character was modeled with a few hundred polys, but rendering tricks make her look smooth.

Subdivision modeling is a more advanced form of polygonal modeling in which the modeler starts with a simple geometric object, such as a cube, and subdivides it—like pulling clay or wax—until the desired shape is attained. Subdivision surfaces are smooth at high resolutions and are especially suitable for organic forms. They are the current choice of most character modelers. The fish model, by Israeli animators Oz Adi and Raz Oved, shows a subdivision model (*above left*) and how it looks converted to polys (*middle*).

Spline modeling uses patches made of mathematical curves and is well suited to the creation of precision models at infinite resolution. Some modelers also prefer them for

BELOW: François Gutherz used a minimal number of polygons to create Smila. The textured version is rendered with a very shallow depth of field, characteristic of Gutherz's tooning style.

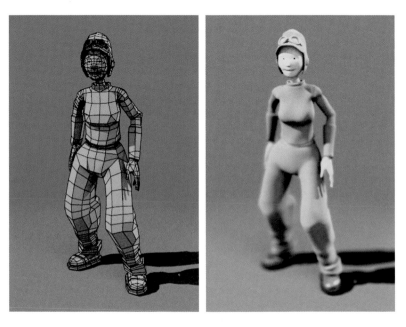

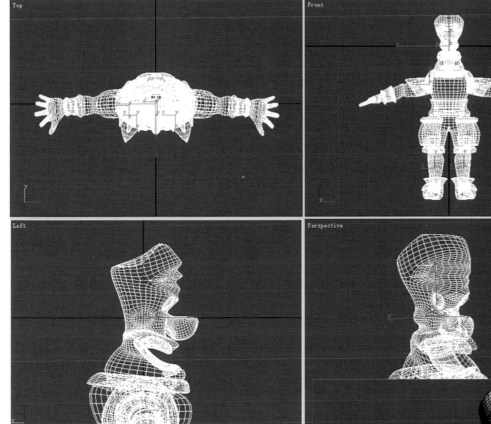

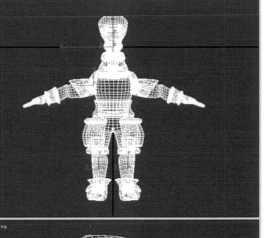

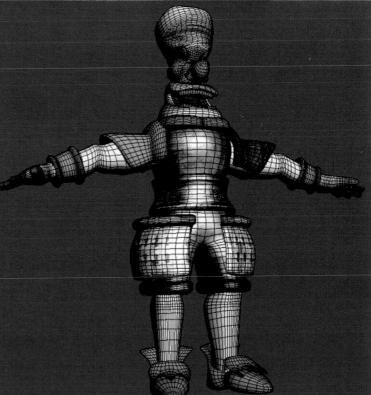

character work. Australian animator Shaun Freeman's cuckoo was created using Hash Inc.'s Animation: Master, which offers well-developed spline-based modeling tools.

CG artists heatedly debate what modeling approach is best, but any of them can work well, as long as the artist understands the limitations of each. To some degree, the artist is constrained by the set of tools provided in the modeling software; not all tool sets are alike, or are equally suited to every modeling task. But nearly all modeling interfaces begin with a quad-view, an isometric representation of the model from top, side, and front, plus a view in natural perspective. Shanghai-based artist deboy built his Guarder character with these standard views. Manipulation tools allow the artist to zoom in and out and examine the model from any angle. Construction tools enable the addition or subtraction of new polygons or patches and aid in higher-level operations like mirroring objects or cutting holes using Boolean operators.

WHEN COMPUTING RESOURCES ARE CONSTRAINED, 3D TOON CREATORS TURN TO LOW-RESOLUTION DESIGNS. THERE ARE NUMEROUS TRICKS—IN FACT, A WHOLE SUBSET OF SKILLS AND A SMALL-IS-BEAUTIFUL DESIGN PHILOSOPHY TO GO WITH THEM—TO CREATING PARSIMONIOUS CARTOONS, AND THEREFORE COAXING THE MOST PERFORMANCE FROM A COMPUTING ENVIRONMENT WITH LIMITED STORAGE OR COMPUTATIONAL CAPABILITIES. SUCH ENVIRONMENTS AREN'T THE NORM IN COMPUTER GAMES ANY LONGER, SO WELL-DESIGNED 3D ANIMATION IS UBIQUITOUS THERE. BUT SCARCITY IS STILL THE RULE IN HANDHELD GAMING AND SUCH BRAVE NEW 3D ANIMATION FRONTIERS AS CELL PHONE DISPLAYS.

LOW-RES DESIGN

Low-res design starts with the creation of geometry that keeps the polygon or spline count as low as possible. In this type of modeling, beauty, or at least complexity, is sacrificed for speed. Using welding, extruding, beveling, and other quick techniques, a skilled modeler can whip out a character of a few hundred polygons in a matter of minutes. Texturing, rigging, and other steps are likewise simplified. The result is a useful toon character, made in a fraction of the time required to build a complex, high-resolution toon, that can be animated in real time by a game engine. The price paid is a general lack of subtlety. For example, low-res characters rarely have much in the way of facial expressivity (the face lacks the needed number of polys for that), so you shouldn't generally put them in stories or situations where realistic acting is required.

Quite a few artists have successfully turned to the low-res approach for purely esthetic reasons. One is Jimmy Maidens, whose droll *Boring 3D* series is all about doing more with less. Another is the French animator and 3D experimentalist François Gutherz. Gutherz uses Newtek's Lightwave 3D, discreet's Combustion compositing and effects software, a strong color sense, and a sack full of lighting and rendering tricks to create his unique minimalist worlds.

Gutherz's Smila character is a good example of low-poly modeling. Smila has only a few hundred polygons, few enough to work well in most real-time game environments. But

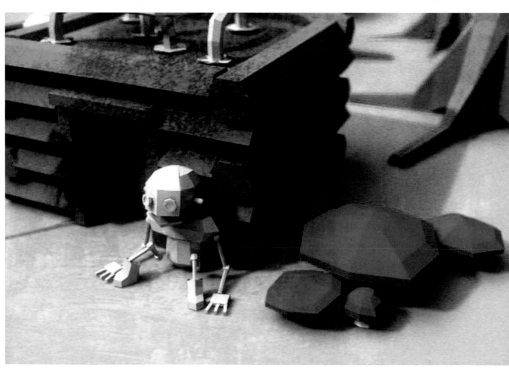

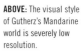

ABOVE: The visual style of Gutherz's Mandarine world is severely low resolution.

LEFT: Careful texturing and lighting adds a unique ambience to the robot's minimalist cabin in the woods.

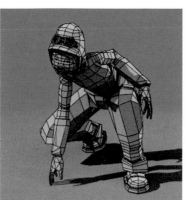

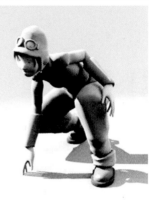

ABOVE: The strong colors, wide-angle view, shallow depth of field, and radiosity renderer give this Mandarine animation test a look both tiny and spacious.

smoothing tricks at the rendering stage make her look rounded, not faceted. The result isn't clearly low-poly at all.

Gutherz likes peering into a miniature alternate reality. The low-detail characters and sets for his enigmatic Mandarine world seem to be from some modern Gallic fable about urban anomie (perhaps a side effect of the fact that these characters are incapable of any facial movement). Intensifying the miniaturizing effect are Gutherz's use of very shallow depth of field and wide-angle lenses, as well as the unusual employment of a radiosity renderer (a renderer which takes light bouncing between surfaces into account). The little fellow, reminiscent of French New Wave star Jean-Paul Belmondo, is made with a radically reduced number of polygons—his torso has about six—as are the train and car that pass him by and the boxy buildings across the street. Such a thrifty universe could be animated entirely in real time.

Texturing can be key to the low-res esthetic. Gutherz has applied what looks like dry-brush painting to the "grass" surface in his Caillou animation test, in which a little monkey-like robot sits open-mouthed outside his log house. The Lincoln logs, trees, and red-capped mushrooms are all made as simply as possible, and have a matte texture that evokes the look of a child's stained and painted wooden toy.

HIGHLY DETAILED CHARACTERS ARE MORE OFTEN THE STUFF OF MOVIE SPECIAL EFFECTS, NOT CARTOONS. DIRECTORS CALL FOR DETAIL AND REALISM WHEN MATCHING ANIMATED ELEMENTS TO REAL-WORLD IMAGERY, BUT THE TOON WORLD RARELY CALLS FOR REALISM. STILL, MANY CG ARTISTS ARE ATTRACTED BY THE COMPUTER'S CAPABILITY TO HOLD ENDLESS DETAIL, TO REALIZE UNREAL VISIONS IN WHATEVER LEVEL OF COMPLEXITY THEY WISH TO APPLY.

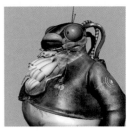

HIGH-RESOLUTION DESIGN

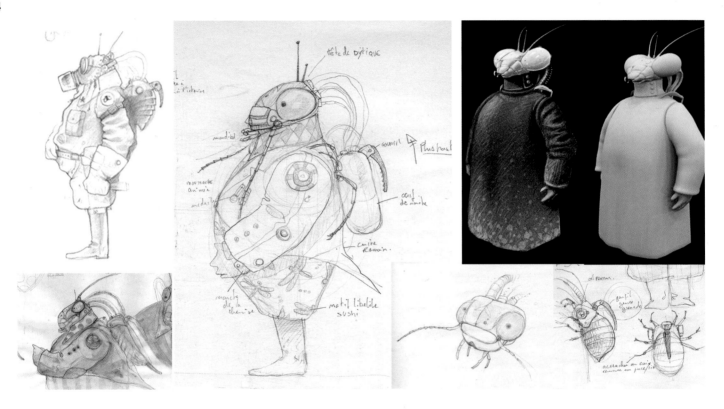

Interestingly, many complex characters begin life as a simple box. Modelers start with a cube primitive in their 3D software, and by a process of sub-division gradually "pull out" the head, arms, and legs, then facial features, fingers, and toes, then such fine details as tear ducts, knuckle bulges, and toenails. Weighting, rigging, and texturing need to be more elaborate as well. Shepherding a complex character from scratch to final is a major creative investment that can easily take weeks, even for a skilled artist.

With no practical upper limit to the amount of 3D detail one can pile on, the temptation is to over-design and over-ramify. One sees frequent examples of this in the fetishized cyborgs posted to online 3D forums (some of which appear to be 3D protests against—or perhaps embraces of—the post-industrialization of modern life). Such hypercomplexity is fatal to the toon esthetic, which in essence is reductive. Artists who resist this strive for visual and formal clarity of character and environment design, and make sure that detail is subordinate to an overall concept that can be easily understood by the human eye.

Laurent Pierlot has designed some very natty high-res bugs for his independent short *Mandibule*. Pierlot incorporates some of the dreaded cyborg elements into his characters, but they are well integrated and relatively restrained. The costumes for these odd creatures are particularly droll and perhaps embody some social commentary as well. Pierlot has carried off the conceit of plump locusts in puce cutaway and caterpillar-green smock,

ABOVE: Pierlot carefully works out all design details before beginning work in 3D.

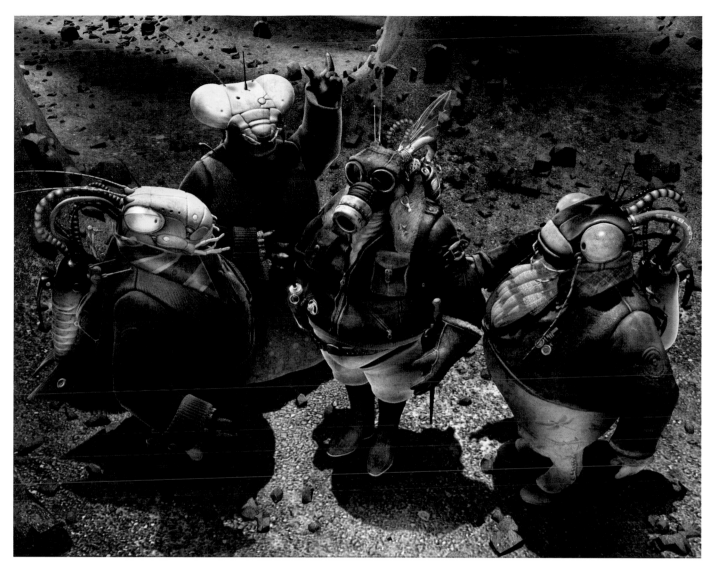

worn leather gas-protection gear, and dandy patterned breeches with real style and attention to detail. (One wonders what they are talking about—a jolly chemical attack on some rival species, perhaps humans?—but Pierlot has not revealed this.)

Work-in-progress images show just how much R & D has gone into these high-resolution characters. The sketches and studies, wireframe and rig shots, and partially textured side views reveal detailed design areas, notably the head and backpack. Tens or hundreds of thousands of polygons were used to make the model; there are at least 500 polys in each eye alone, more than enough for a complete low-res toon. Many layers of textures complete these fully realized and fantastic creatures.

ABOVE: Laurent Pierlot's high-resolution, high-detail *Mandibule* characters. Clever costume detailing does much to individualize these odd insects.

RIGHT: Views of a *Mandibule* character showing wireframe, rig, untextured surface, and partially textured surface. All work was created with Alias's Maya software.

WHEN IT COMES TIME TO POSE OR ANIMATE A CHARACTER, CG ARTISTS GENERALLY DON'T USE THE FULL-RESOLUTION HIGH-POLYGON TEXTURED MODEL. MOST COMPUTER HARDWARE JUST ISN'T UP TO THE COMPUTATIONAL LOAD REQUIRED. IT'S HARD TO MANIPULATE A HI-RES MODEL, BECAUSE OF ALL THE POINTS THAT HAVE TO BE RECALCULATED, AND THE SCREEN REDRAW SLOWS TO A CRAWL, IF THE SYSTEM DOESN'T CRASH ALTOGETHER. AND THIS PROBLEM OF 3D HARDWARE AND SOFTWARE LAGGING IN CAPABILITY BEHIND DESIGN AND ANIMATION REQUIREMENTS IS ONLY GETTING WORSE AS ANIMATORS WORK WITH EVER MORE ELABORATE MODELS, EVEN IN GAMES.

PROXIES

The way to get around the problem is to work with a proxy, a kind of devolved doppelganger of the character. Usually the proxy is built into the full model as an alternate version that can be swapped in or out as needed using a simple button or script. The proxy has the same proportions and shape as the full model—even if it appears to be built of nothing but boxes and cylinders—but it is built of the lowest-possible number of points or splines, to minimize recalculation. It has no or limited texturing, but it does have the same rig and all the same animation controls. Animators can do anything (or almost anything) with the proxy that can be done with the full

model, but in much less time. Animated feature films and other major 3D toon projects would be completely impossible, at the current level of technology, without the use of proxies.

Interestingly, proxies can have an attractive esthetic quality of their own. The orange proxy swinging two swords has a dynamic purity that the full model animation lacked. You see nothing but the pose and the motion. The frames from the short animation starring the blue cat character show how much easier it is to see character motion in a proxy view. The proxy has enough shape detail to be nearly as expressive as the full model.

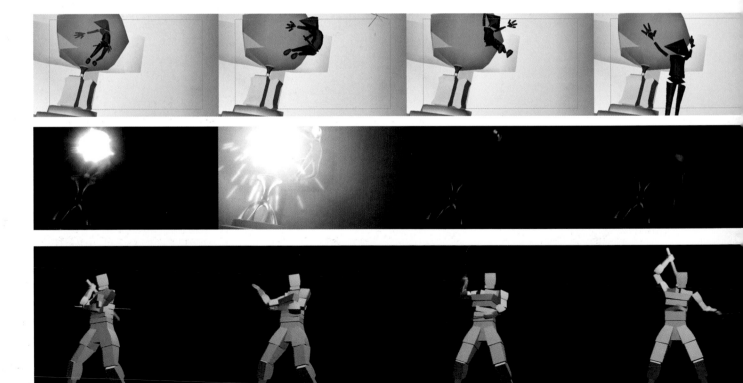

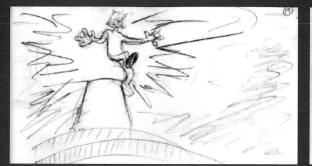
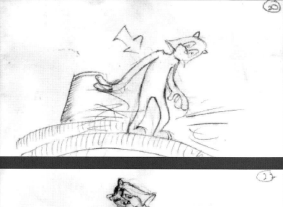

RIGHT: Storyboard frames for an animation of a blue cat popping out of a force field.

BELOW: Proxy animated frames and selected final rendered frames. The motion is easier to see in the proxy frames.

BOTTOM: An orange proxy model swings two samurai swords. Motion blur added to the proxy render increases the sense of dynamism.

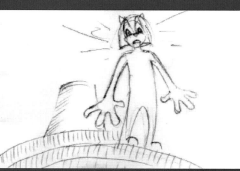

That's not to say that proxies don't have their limits and problems. You can't do facial animation with a proxy unless the full-res face or a good subset of it is grafted onto the clunky body. Putting the full face, with all its thousands of points, on the proxy seriously reduces the proxy's effectiveness in speeding animation, though some animators still take this approach. The alternative is to animate the body using the proxy, then go back and animate the face separately in high resolution. The danger there is that the animator may lose the high degree of face and body motion-integration that is animation's ideal. Another more subtle problem is establishing precise poses with a proxy. The less the proxy looks like a real character, the harder it is for the animator to conceptualize and refine the pose. Tiny modifications of body posture may make a huge difference in a character's performance, but it is difficult to get those just right when you are posing an abstracted mannequin of rectangular prisms.

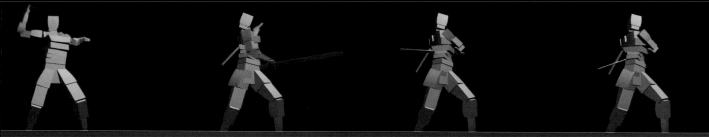

RIGGING, ALSO CALLED SETUP, IS THE PROCESS OF INSTALLING THE SKELETON AND CONTROLS THAT ENABLE EFFICIENT MANIPULATION OF A 3D CHARACTER. LIKE REAL VERTEBRATES, CHARACTERS DESIGNED FOR ANIMATION NEED A SKELETON INSIDE TO CONTROL THE MESH DEFORMATION, AS WELL AS CONTROLS OF VARIOUS TYPES TO MAKE ANIMATION EASIER.

RIGGING

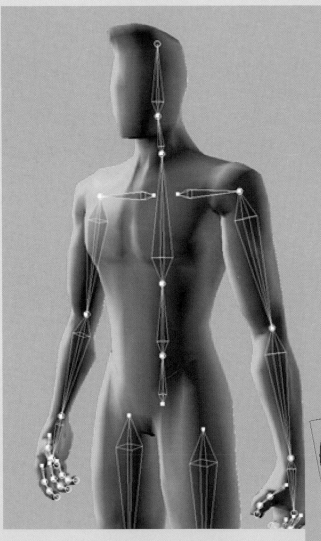

Bones are the fundamentals of any rig; these are special entities that can be positioned inside the character model more or less where real bones might be (at the upper arm, lower arm, etc.). The frame from Jeff Lew's *Learning 3D Character Animation* DVD shows a typical basic arrangement of bones in the upper body. By "attaching" a bone to an adjacent area of the mesh, it influences the deformation of that area. Move the bone, and the mesh flexes to follow it.

The real skill in any rigging process is to link the bones in such a way that they work together like a real skeleton. This involves constraining the motion and rotation of one bone to another using various types of constraints or limits, then adding additional "controller bones" that manage the movement of other bones and thus make moving parts

FAR LEFT: This frame from Jeff Lew's *Learning 3D Character Animation* shows a basic arrangement of bones in the upper body— spine, shoulders, arms, and hands.

ABOVE & LEFT: Using an automated rigging program like The Setup Machine makes it easier to rig characters like this six-legged lizard. The red boxes are rig controls for moving body and limbs.

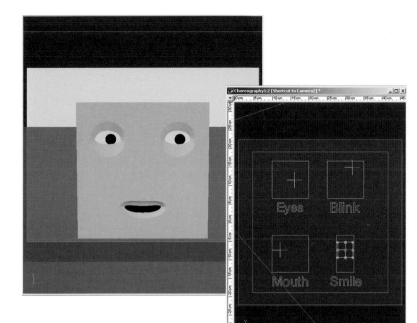

body are representations of controls linked to hidden bones. To move her limbs, you just drag on the controls.

Faces also must be rigged so they can produce all the varied expressions needed for animation. Most face rigs are collections of morphs with slider controls—one slider might control the deformation of the right corner of the mouth, another slider the left eyebrow. Clever riggers can devise more intuitive rig interfaces. For his short animation *Riba*, the young French animator Yves Dalbiez created a face rig in the shape of a cat's face. The little face, available right above the character during animation, is a graphic representation of the controls for the full character's facial rig. Drag on the mouth of the little cat, and the mouth in the actual model also moves. Another kind of simple face rig is shown in the example by William Young. Expressions on the simple toon head are created by dragging the labeled controls on the right.

of the body easier. For example, a good rig might designate one control in the foot to move many leg bones. Riggers also strive to isolate parts of the body from each other, so that, say, moving the arm does not affect the pose of the head unless the animator chooses to have it do so. Advanced rigs take care of these things, making sure the elbows and knees always point in the proper direction, no matter how the arms or legs are posed. A master rigger can devise systems that actually do some of the animation, such as having a character's tail wag as it walks.

In fact, efficient and accurate skeletal control systems are essential for successful 3D animation; they aid the animator and make animation a pleasure. A poorly designed rig makes animation tedious and leads to awkward character movement—floaty arms, feet that slip on the ground, jerky movement caused by the need to counterrotate limbs. Much second-rate 3D animation isn't the animator's fault; it can be blamed on rigs that are too complex or lack proper isolation.

Unfortunately, constructing a high-quality rig and control system is complex and time consuming—it can take days for a single character, possibly weeks for a show with many diverse characters. Large studios can pay people to do nothing but rig, but many independent animators—and pro riggers as well—turn to automated rigging software that does much of the work for them.

The Setup Machine for Maya, shown left rigging a simple six-legged character called Lizardo, is one such tool. The red boxes and circles around various parts of Lizardo's

ABOVE: Simple but effective facial animation controls developed in Animation: Master by William Young.

RIGHT: French animator Yves Dalbiez created clever facial rig controls for the feline hero of his short film *Riba*.

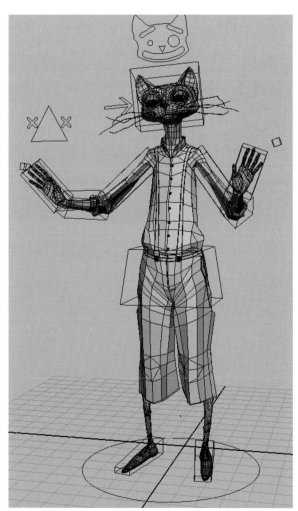

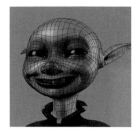

AN IMPORTANT PART OF THE RIGGING OF A 3D CHARACTER IS DETERMINING WHICH BONES AFFECT WHICH AREAS OF THE MODEL'S GEOMETRY. THE BASIC FUNCTION OF A BONE IS TO DEFORM THE MESH, BUT CG ARTISTS CAN'T JUST ASSUME THAT POSITIONING A BONE IN MORE OR LESS THE RIGHT PLACE WILL MEAN THAT, WHEN THE BONE IS MOVED, THE MESH WILL CHANGE SHAPE IN THE DESIRED WAY.

WEIGHTING AND UV MAPPING

For all but the simplest cartoon characters, modelers must specify the exact areas of the model that are deformed by each bone. Moreover, to avoid unwanted crimping and twisting in complex areas, especially the shoulders, modelers must also determine the degree of influence each bone should have over its associated points. This process is called weighting.

Most 3D applications for character creation include a general-purpose automated weighting function that assigns a proportional area of influence around each bone. But no automated solution is perfect, because no two models or skeletons are the same. So artists tweak the standard weighting using weighting tools that usually are quite similar to paint tools. Painting an area of the mesh with the color associated with a particular bone assigns all those points to that bone. In the illustration, it's easy to see the areas of

BELOW: A weighted human torso created in Hash's Animation: Master. Points are assigned and weighted to bones of the same color, and therefore deform smoothly.

BELOW RIGHT: Sebastian Schoellhammer of Lionhead Studios created a UV map of just the head, neck, hands, and ears of his pixie, which was also modeled in discreet's 3ds max.

influence of each bone. The more saturated the color, the more influence the bone has on the mesh of that color. Colors overlap and blend because areas of the mesh between adjacent bones are influenced by both; getting those blends just right is the key to a smooth deformation. Taking the time to paint weights results in a model that deforms predictably, with no ugly surprises.

Another process in character creation is *UV mapping*. In practical terms, UV mapping (which draws its name from a tensor function of the two vector spaces U and V) is nothing more than an unwrapping of the model surface into a flat plane. A texture artist can paint on this flat plane using a paint program, then rewrap the UV and have all the textures applied accurately to the right areas of the mesh. The UV positional data is stored in the model. This is of prime

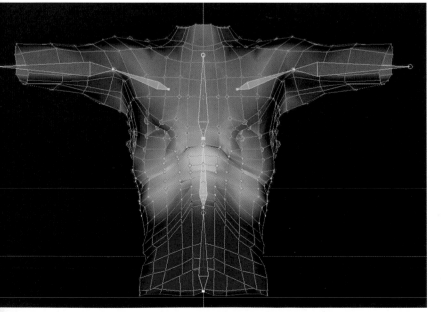

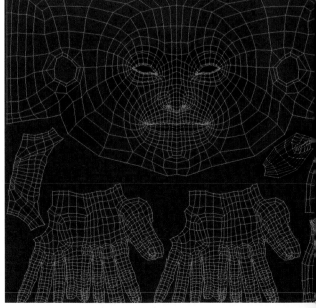

LEFT: From this shaded view, the mesh of the Pixie head can be seen and related to the UV map.

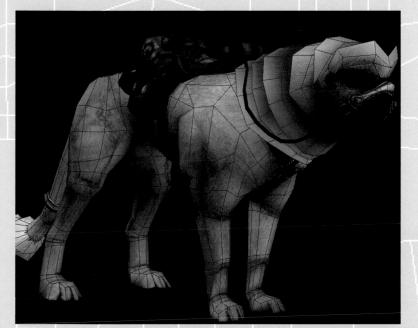

BACKGROUND: A basic UV map for texturing expert Ely Cannon's Dharzi Hound game character, modeled in discreet's 3ds max.

RIGHT: Color textures used to surface the Dharzi Hound model.

ABOVE: The Dharzi Hound model with polygons visible. Locating each poly on the UV map is part of the challenge for the artist.

importance for game characters, where painted (bitmap) textures are all the surfacing the character has. High-resolution models for feature animation also use UV maps, but are less dependent on them, because they can be textured in other ways as well.

Conceptualizing the 3D model as a flat plane, and juggling the various parts of the UV map for maximum efficiency on that plane, can be a significant puzzle-solving challenge for the artist. The art of UV mapping is in hand adjusting the unwrapping process so the flattened parts are laid out efficiently on a single plane of limited size. Automatic mapping tools tend to lay out pieces of the map somewhat at random; it's up to the artist to rearrange and resize them in a visually logical order for painting. Areas of the UV that need more detailed textures, such as the face, must occupy a larger area of the map, and areas that will hold a texture of a particular shape (perhaps a logo decal) must fit that shape as closely as possible. Often this means tweaking the location of individual points on the map to keep the painted textures from pinching or distorting.

SURFACING IS CG PARLANCE FOR "PAINTING" THE 3D MODEL, GIVING THE BARE WIREFRAME OR BLAND GRAY MESH SURFACE COLOR AND TEXTURE. AS WITH ALL THINGS 3D, THE PROCESS CAN BE QUITE COMPLEX. TOON ARTISTS MAY CHOOSE TO USE PAINTED TEXTURES, ALSO REFERRED TO AS BITMAPS, OR TO CREATE *PROCEDURAL* TEXTURES, ALSO CALLED *MATERIALS*. BITMAPPED SURFACES ARE LIKE THIN LAYERS OF PAINT APPLIED TO THE MODEL SURFACE, WHEREAS PROCEDURALS ARE GENERATED ALGORITHMICALLY AND "PERMEATE" THE ENTIRE MODEL.

SURFACES

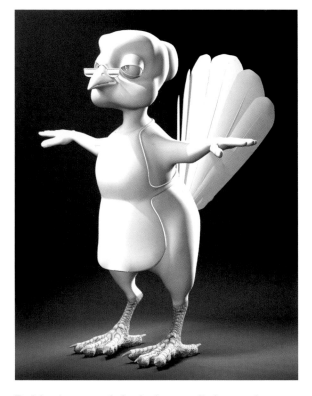

Each has its uses and often both are applied to one character. For example, a character may have a general procedural skin texture overlaid by bitmapped layers for specific skin details on the face, hands, and so on. (Game characters rarely have procedural surfaces, as they are not supported by most game engines.)

There's also the question of whether surfaces can be painted directly on the 3D model using a 3D painting system, which not all 3D software supports, or whether they must be created in a separate 2D paint program and mapped (that is, projected) onto the model. Most artists prefer the relative immediacy of a direct 3D painting environment, but the tool sets for 3D painting have not yet evolved fully and so resorting to mapping is still common.

Beyond that, there are the many qualities of 3D surface that must be taken into account, and that often cannot be arrived at without considerable trial and error. The shiny highlight that takes the painter on canvas just a flick of the brush to apply requires careful analysis of an index of specularity by the 3D artist and probably quite a bit of experimentation, too. Surface qualities may include color, image, shininess, diffuseness, displacement, bumpiness, and dirtiness. Each quality is captured in its own mapping layer and applied to the model in a specific order to arrive at the final texture. Maps may and usually do affect one another; for example, a diffusion map is typically used specifically to modify the color map.

Australian animator Shaun Freeman's mother bird character, created and surfaced using Hash Inc.'s Animation: Master, provides a good example of how a final bitmapped surface is assembled. The bird feet alone require at least nine separate maps, mainly to bring out the texture of the scales in different areas. Color maps determine the main color of each area. Bump maps are used to indicate the raised areas of the scales without actually having to create the geometry for them. Diffuse maps (also called diffusion maps) control how much light is absorbed by the surface; they affect how intense the color is. And specular maps control the shininess or reflectivity of an area. The claws, which are somewhat shiny, are the only areas on the foot that require specular maps.

LEFT: Australian animator Shaun Freeman required nine surface maps to texture the feet of his mother wren character.

ABOVE (LEFT TO RIGHT):
The bump map for the calf scales, the color map for the calf scales, and the diffusion map for the calf scales.

LEFT (LEFT TO RIGHT):
The toe scale bump map, the toe scale color map, and the toe scale diffusion map.

RIGHT: A close-up of the finished foot.

BELOW (LEFT TO RIGHT):
The toenail bump map, the toenail color map, and the toenail specularity map.

EVEN A CARTOONY OR FANTASTICAL MODEL MAY NEED REALISTIC SURFACING. OFTEN THIS INVOLVES LOCATING PHOTOGRAPHIC IMAGES THAT CAN BE USED AS SURFACING MAPS. THE IMAGES IN DIGITAL FORM ARE COLOR TWEAKED AS NEEDED IN AN IMAGE-EDITING PROGRAM LIKE ADOBE PHOTOSHOP, PERHAPS CROPPED, SIZED, AND DISTORTED TO BETTER FIT THE SURFACE, THEN APPLIED USING THE 3D SOFTWARE'S MAPPING TOOLS. IMAGE MAPS MAY BE MODIFIED TO TILE OR REPEAT SEAMLESSLY OVER THE SURFACE, SO THAT A SINGLE MAP CAN COVER A LARGE AREA. OR THEY MAY BE IMPORTED AS BUMP MAPS TO ADD APPARENT RELIEF TO THE SURFACE.

IMAGE MAPS

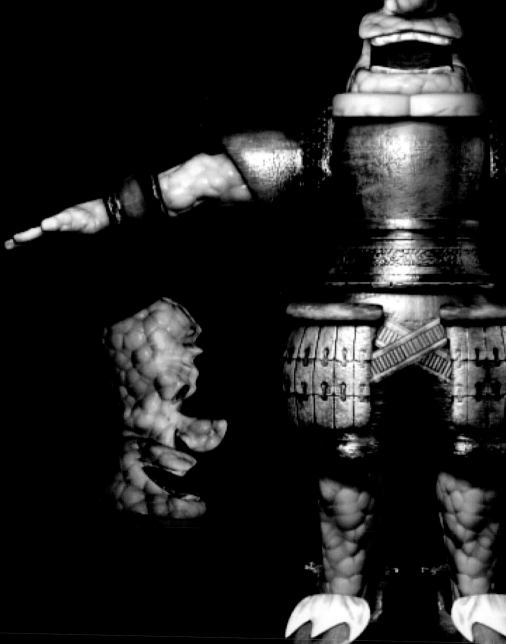

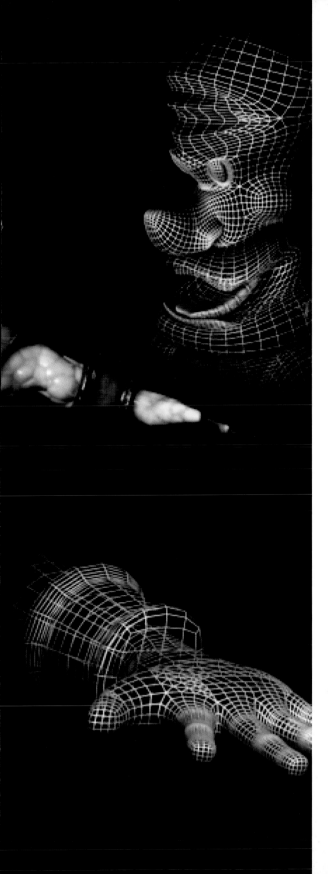

LEFT: A multiple view of the Guarder character by the artist deboy, with details of the head and hands. Guarder was modeled and textured in just five hours. Several image maps were used to speed character creation while achieving a good level of detailing.

FAR LEFT (TOP DOWN): Image of linked metal plates of traditional Asian design applied to the hip armor.

A photograph of floral relief mapped around Guarder's waist.

Wire-stitched leather or hide for the upper arms.

The advent of Internet-based clip-art collections has made high-quality image mapping for characters immensely easier. The artist merely searches an online visual database and orders the desired images for instant acquisition and application. Image collections geared especially to the 3D texture artist are readily available. With digital cameras, it's nearly as easy to go out into the field and capture original, texture-ready photos. In either case, the trick is to start with the highest-resolution image the artist can get, and "res it down" as needed from there. Starting with a low-resolution image with too few pixels will mean a low-quality result, as the 3D program stretches and distorts the image to cover a surface too large for it. Image maps for feature-film characters may measure 2,000 by 2,000 pixels (four million pixels in total), or more, so that the camera can zoom in on the character without seeing individual image dots. Low-res images are nonetheless essential for the handheld gaming world, where every byte of storage is precious and there's no elbow room for big bitmaps.

The Shanghai-based 3D artist deboy used a number of image maps, some of which are shown here, for his Guarder character. Guarder was a fast-modeling project requiring just five hours to model and surface in discreet's 3ds max. What deboy did not add in the geometry, he has created using maps. Details of Guarder's armor, such as the elaborate floral pattern at his waist (apparently a cropped photo of ancient relief-work in ceramic or metal), are applied as tiling image maps. Another tiling image application is in the armor on his hips; a third is what appears to be wire-stitched leather on his upper-arm plate. A notable use of bump mapping is for this character's very warty skin. Looking at the mesh, it is obvious that the bumps are not actually modeled at all, but have been applied later with mapping.

ONE AREA WHERE TRADITIONAL 2D ART SKILLS AFFECT 3D TOONING IS THE CREATION OF FACE TEXTURES. IRONICALLY, AFTER SEEING THEIR SKILLS DENIGRATED DURING THE ENTIRE MODERNIST PERIOD OF ART, PORTRAIT PAINTERS ARE ONCE AGAIN MUCH IN DEMAND, BUT THIS TIME FOR HIGH-END 3D GAMES AND FEATURE ANIMATION. ARTISTS WIELDING TABLET AND STYLUS RATHER THAN CANVAS AND BRUSH CAN ONCE AGAIN MAKE A PROFESSIONAL CAREER OUT OF DEPICTING SKIN PORES, LIP SHINE, EYEBROW HAIR, AND OTHER FACE ELEMENTS.

FACE PAINTING

Face textures can be highly complex, depending on the needs of the character, incorporating layers of shaders (software-generated textures) as well as hand-painted maps and doctored photographic imagery. Maps are generally painted or assembled on a flattened projection of the face using a paint program such as Adobe Photoshop, then re-wrapped onto the face model using the 3D software's mapping tools. Conceptually, this is one of the hardest things for artists to master—how to judge the positioning and blending of painted elements so that they look right when mapped back onto the mesh.

For his highly detailed caricature of Swiss politician Micheline Calmy Rey, Fred Bastide needed a highly detailed face map. Bastide hand painted this in Photoshop with reference to photographs of the subject. The map was applied along with a translucent skin shader (to give depth to the skin). Eyes were separate models, textured separately. In the painted map is all the personality that skin can contain;

the thin red lips (which are less distorted than any other element of the map because they are in the center of the face) are perhaps even more chilling in the map than in the final caricature.

The face of Seattle artist Ely Cannon's Dharzi Warlord—a real-time game character—was also painted by hand. The low-polygon model was projected onto a flat image, which Cannon then worked using Photoshop. Shaders were not used because real-time games do not usually support procedural textures. In this case, the eyes and facial expression are painted directly into the map and therefore cannot be animated. Although Cannon did not use any specific photographic reference, he clearly was influenced by medieval Islamic and Indian art; there is a motif of Arabian domes in the Dharzi Warlord's leather chest piece.

Creating eye textures is a specialist subcategory all its own. Shader artist William Young uses procedural methods rather than painted maps to create complex eyes. These don't

RIGHT: Eyeballs can be textured using shaders or painted maps or a combination of the two. Here, William Young uses shaders only to create an eye suitable for a cartoon character (you can see the finished texture on the right).

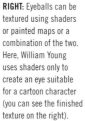

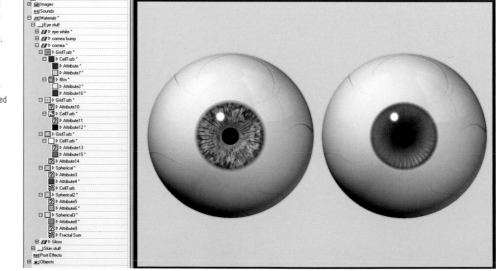

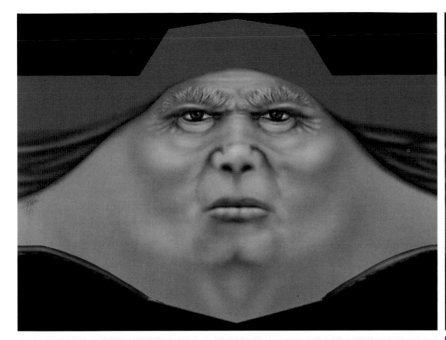

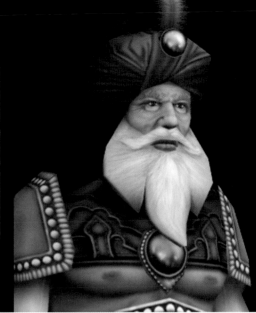

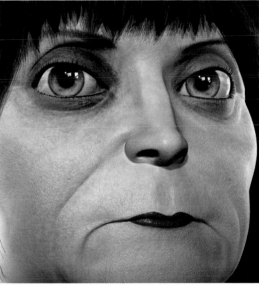

look entirely realistic, but they work very well for cartoony characters. Using the shader editor in Hash's Animation: Master, he layers colors to create depth in the cornea (left-hand eye), using obviously different tints to see more clearly how the various shader layers interact. When he finalizes the texture (right-hand eye), he substitutes the appropriate colors. Another noticeable difference between the two versions is at the corneal rim. Tinted green in the preliminary version, it is white in the final version so the cornea softens and blends smoothly into the white (sclera) of the eye.

ABOVE: Fred Bastide painted a detailed face texture map in Photoshop for his caricature of Swiss political figure Micheline Calmy Rey. Areas farthest from the face centerline are the most distorted.

IN THE CG WORLD, SOME HARD THINGS ARE EASY, AND SOME EASY THINGS ARE VERY HARD. ONE THING THAT HAS BEEN PARTICULARLY HARD IS THE CREATION AND ANIMATION OF HAIRY, FURRY, OR FEATHERED CHARACTERS. WHAT MIGHT TAKE ONLY A FEW PENCIL OR BRUSH MARKS FOR A DRAWN CHARACTER MAY REQUIRE BILLIONS OF 3D CALCULATIONS AND SOME QUITE TRICKY PROGRAMMING. SO TRICKY, IN FACT, THAT IT'S ONLY IN THE LAST COUPLE OF YEARS THAT 3D APPLICATIONS COULD OFFER HAIR SOLUTIONS THAT WOULD EVEN RUN ON A DESKTOP WORKSTATION.

HAIR

But strong demand for hairy beasts and wavy locks in CG entertainment has driven the technology out of the university labs and major animation houses and into commercial software, so that now you can purchase a powerful hair system for a few hundred dollars.

What exactly is so hard about hair? The essential problem is that, to make hair or fur or feathers look at all believable, the software must calculate a whole host of variables for each hair—and there can be hundreds of thousands of hairs on a character. Individual hairs have length, thickness, taper, cross-sectional shape, direction, curve, opacity, color, anisotropic qualities (changing color, opacity, or other surface features depending on the angle the hair is viewed from) and various possible surface maps. In some systems you can assign any 3D object to be a "hair," which is one way to create feathers or scales. When you take hairs in aggregate, they must interact, so there are lots of new

variables: density per area of surface, the ability to stick together in wads or clumps (often called "clumpiness"), combing (the direction that clumps of hair take on the surface), and the ability to cast shadows on each other (and other things). Hair patterns—where the hair is long or short or nonexistent—are determined with maps. If you want the hair to move naturally for animation, then the software must deal with dynamic factors such as hair collision detection, hair stiffness, hair velocity, and hair preroll (getting the hair dynamics up to speed before animation actually begins).

With all that, hair system interfaces tend to be extremely complex, and it can take quite a long time to develop a "look" that is satisfactory, even for a relatively simple 3D toon character. So designers sometimes opt for simpler approaches. David Maas, an advertising creative and lecturer on organic modeling at the German Film School, and his wife, designer Tatjana Herrmann-Maas, developed the CG pals Jasmin (a little girl) and Grizzel (a teddy bear) for a German television project. Early in the development of Grizzel's hair, David played with wider, more graphic hair strokes. But Grizzel's design was too realistic to support this, so the final hair design is much more like the hair on an actual bear, and thus required lengthy experimentation with a hair system.

On the other hand, the development of Jasmin's hair was much more a matter of styling than naturalism. Her initial design was found to be too bland to suit her personality, and her hair was the most obvious place to give her the sassy edge that had been missing. In the end, a simplified hairdo was chosen and a hair system was not used.

A broad and cartoony use of hair can be seen in the orangutan created for the console game *Tak and the Power of Juju* by U.S. developer Avalanche Software. The ape's overgrown shag-style fur, created with Hash Inc.'s hair system in Animation: Master 2004, suits him perfectly—as well as matching the over-the-top style of the game.

ABOVE: In this early version of the character Grizzel, designers David Maas and Tatjana Herrmann-Maas thought the hair strokes looked too much like boa feathers.

LEFT: Grizzel's final fur, before eyes and other elements were added to the model. This example shows development using Worley Lab's Sasquatch hair rendering system.

RIGHT: The ape's shaggy orange fur defines his character in Avalanche's console game *Tak and the Power of Juju.*

BELOW RIGHT & CENTER: Rejected hair styles for the character of Jasmin.

BELOW FAR RIGHT: Jasmin's final hairstyle, using modeled hair elements rather than a hair system.

TIME WAS, CARTOON CHARACTERS EITHER DID NOT WEAR CLOTHES (MOST OF THE WARNERS STABLE IS BUCK NAKED, THOUGH ALL THE CLASSIC TALKING ANIMALS IN THE DISNEY UNIVERSE AT LEAST HAVE SHORTS ON), OR, IF THEY NEEDED CLOTHES, THE CLOTHES ACTUALLY CONSTITUTED THEIR BODIES. (CONSIDER YOSEMITE SAM'S COWBOY GARB OR FRED FLINTSTONE'S SKIN TUNIC). THAT KEPT THINGS SIMPLE, AND IN CARTOONS, SIMPLE IS USUALLY BEST.

CLOTHING

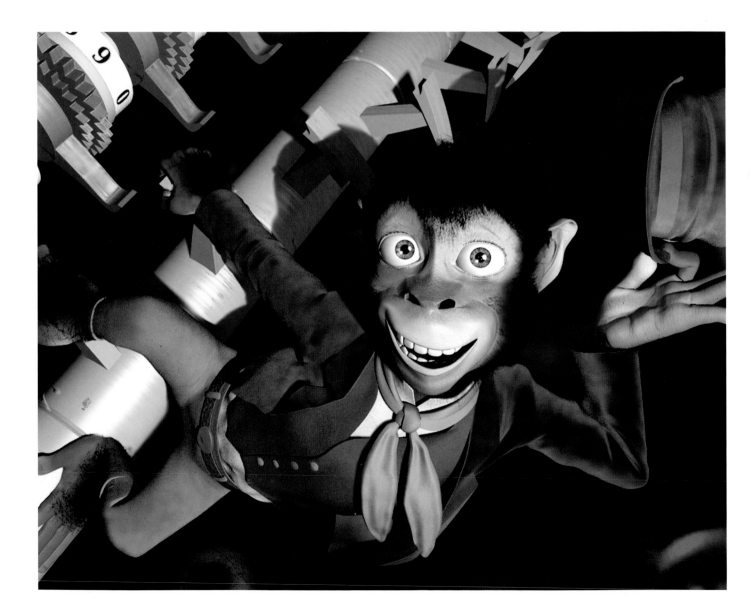

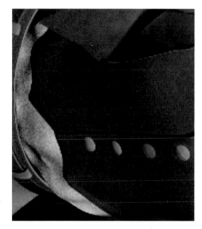

FAR LEFT: The vest has been rigged to provide enough control to wrap it around a character's body and animate for motion detailing.

LEFT: This monkey model shows details of clothing geometry before texturing is added.

LEFT: Layers of clothing call for various texture treatments. Research was required on proper colors for the mid-Victorian period, as well as what types of cloth might be available. None of the clothing is simulated.

ABOVE, LEFT TO RIGHT: The scarf has a silken texture. An anisotropic shader (which changes color according to the angle of incident light) was used to simulate velveteen. A light fractal bump sufficed for the vest.

However, in the endless quest for cartoon realism, software engineers have devised exceedingly clever solutions for simulating clothing. This was indeed a hard technical problem—or complex of technical problems—to solve, involving major R&D on issues of 3D surfaces passing through each other, the behavior of thick cloth versus thin, how to simulate wrinkles, how to "tailor" clothing to characters, how to get cloth to fit tightly at some spots and flap loosely at others, how to impart believable weaves and textures to cloth and so on. But things have gotten to the point where, nowadays, 3D toons at the feature-film level usually have clothing that behaves more or less like real cloth. Good examples can be found in the *Shrek* films, Pixar's *The Incredibles*, and others.

When budgets are lower and good cloth simulation software is not affordable, clothing is often animated by hand. Animating clothing this way is challenging and time consuming. Not only must the cloth appear to move in a believable way, taking into account gravity, the character's momentum, any wind or other external forces, and the cloth's own characteristics (thick or thin, stiff or flimsy), but it also has to appear to fit closely around the character without ever going through the surface. On the other hand, you don't have to deal with the often arcane problems presented by simulation software, and if you want to cheat and move the cloth in a way that obeys cartoon physics and not Newton's physics, you are free to do so.

Clothing movement can to some degree be handled by conventional rigging. You place bones in the clothing that help you move it as a unit. Lag and secondary action can be automated with a rig as well. In the case of a character with multiple layers of clothing, as in the Dickensian monkey pictured on these pages, each clothing layer may have its own rig elements. Layers of cloth also call for varying texture treatments. The monkey's coat and hat have a velvety texture created with the use of an anisotropic shader. The weave in his vest is a simple high-frequency fractal bump. No need for high-resolution image maps of wool weave or velveteen.

HOW MUCH OF THE TYPICAL FEATURE FILM IS ZEROED IN ON THE FACES OF THE ACTORS? FOR A DRAMA (NOT, SAY, AN EPIC TRAVELOGUE LIKE *LAWRENCE OF ARABIA*) IT MIGHT BE 50-60 PERCENT FOR SHOTS OF SHOULDERS AND ABOVE. FOR TV, WITH ITS SMALLER SCREEN AND MORE INTIMATE SCALE, YOU COULD BE SEEING FACE SHOTS AS MUCH AS 75 PERCENT OF THE TIME FOR A COMEDY OR LEGAL DRAMA, OR 100 PERCENT OF THE TIME FOR NEWS. BUT FOR THE TRADITIONAL CARTOON, IT'S…? NO STATISTICS EXIST, BUT WE CAN SAFELY SAY THAT THE PERCENTAGE IS MUCH LOWER, GIVEN THE TYPICAL CARTOON'S LOW-DETAIL FACIAL DESIGNS AND RELIANCE ON FULL-BODY SLAPSTICK.

FACE POSES

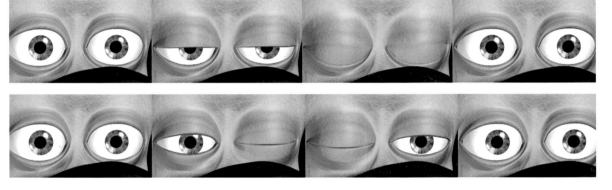

ABOVE: Head tilt and gaze direction do a lot to define the expressions of RABCAT Entertainment's Rocky the Martian.

LEFT: Different sorts of blinks are key to lifelike eye animation—which in turn is the key to lively facial animation as a whole.

RIGHT: Tak's puckish side comes out in this dynamic series of facial poses by Avalanche Software for *Tak and the Power of Juju*.

But as 3D cartoons become more cinematic, face animation has become more important, and animators spend more time on it than ever before. 3D characters now are often required to emote just like real actors, with the subtlety of a Tom Hanks or Holly Hunter. Video footage of the real actors delivering their lines is pored over by animators seeking to capture every nuance of eyebrow, lip, and dimple. To make this possible, animators and face riggers devote endless time to crafting 3D characters capable of all the thousands of human expressions. There is no one way to achieve this, and much disagreement about which of many ways is best.

Competing rigging styles have their advocates; you can rig the face primarily with bones, or you can rig it with morphs and blendshapes (used to smooth the shift between facial poses), or some combination thereof. You can actually build 3D simulacra of the facial muscles underneath the 3D skin, though this is more common for ultra-realistic visual effects creatures than cartoon characters. You can set up facial animation controls in all kinds of ways, with sliders to control each twitch of the mouth corner, or with a simplified graphic representation of a face, each facial icon acting as a control, floating off somewhere on the animator's screen. Or you can dispense with animators altogether and use facial motion capture (taking face movement data off a real human

being) or rule-based software that generates mouth movements and facial expressions through analysis of the voice track audio waveform (a popular if low-quality solution favored by game developers). Animators often create face-pose model sheets to test whether the character is capable of making the desired expressions, and to obtain approval from clients and studio executives. The examples on this page show expert examples of facial posing.

No matter what approach is taken, the risk is that the 3D character will still have the expression of an animated corpse, as has been seen in some ill-conceived 3D features. Animators will tell you that it's all in the eyes; if the eyes don't convey a thinking, feeling, anticipating mind, it doesn't matter what else the face (or body) is doing. Surprisingly, blinks are key to lifelike eye animation. Flirts bat their eyelashes; an exaggerated blink suggests disbelief; lengthy blinks indicate drowsiness. In normal blinks, the upper lid moves down to the bottom of the eye. Blinks of disbelief and sleepiness involve the lower lid, too, and are to the center of the eye. A technique often used in cartoony forms of animation is the offset blink, in which the eyes are made to blink a frame or two apart. This produces the effect of a goofy or drunken or goggly-eyed character. Offset blinks are used so often in Pixar films that they've become a part of the Pixar style.

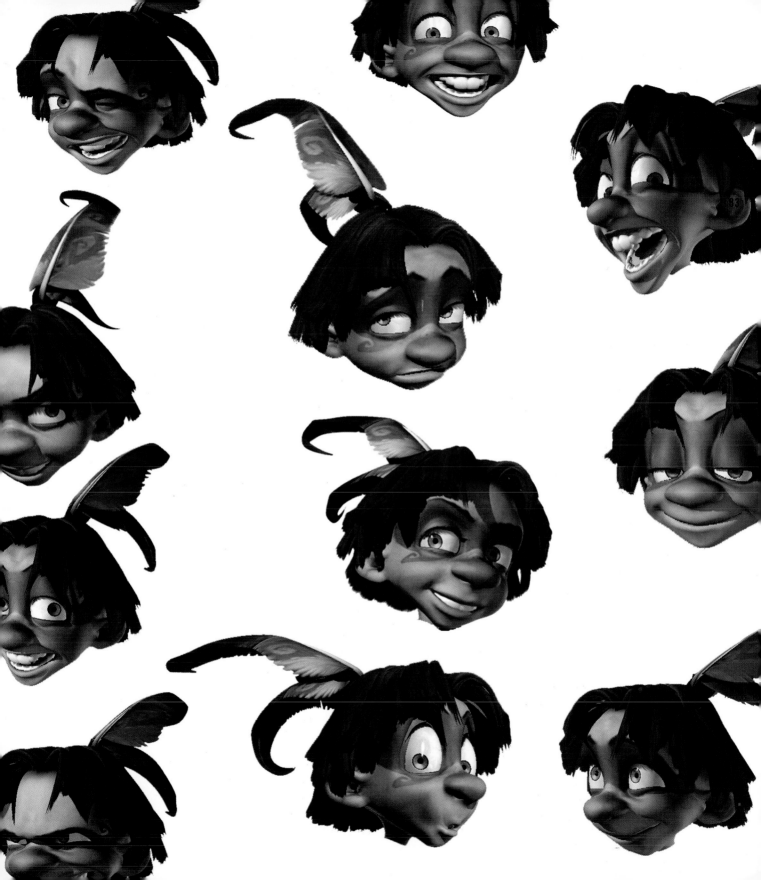

ANIMATED TOONS

MASTERING THE TOON MOVING IMAGE

4

JUST AS THERE ARE AS MANY WAYS TO PAINT A PICTURE AS THERE ARE PAINTERS, THERE ARE AS MANY ANIMATION STYLES—THE PARTICULAR METHODS AND TECHNIQUES AN ANIMATOR USES TO *KEYFRAME* (THAT IS, SET KEY OR IMPORTANT POSES) A CHARACTER'S PERFORMANCE—AS THERE ARE ANIMATORS. MOST ANIMATORS ARE INFLUENCED BY THE STYLE PRACTICED IN A PARTICULAR STUDIO OR BY A PARTICULAR TEACHER, BUT ALMOST EVERYONE EVENTUALLY DEVELOPS A UNIQUE STYLE TO MATCH HIS OR HER TEMPERAMENT, PHILOSOPHY, AND TECHNICAL ABILITY.

ANIMATION BASICS 1

That said, there are nonetheless a number of fundamental techniques—rules or laws, actually—that follow both from classic 2D animation practice and from the unique characteristics and limitations of 3D animation software—that underlie all effective animation.

One ironbound fact of 3D life is simply that every CG character is made up of individual pieces, such as arms, legs, head, finger joints, and so on. The character may look one-piece and smoothly skinned, but from the point of view of the animation software, each part of the character is separate. The animator must set keyframes for each part, or find ways to group parts together for keying (most animation software now allows this, but you must divide the character into specific groups before animation). So to move a character's arm in a simple arc (as shown in these images from animator Jeff Lew's *Learning 3D Character Animation* instructional DVD), animators have to pay attention to all kinds of controls and issues no 2D animator ever encounters.

One thing that usually drives 2D animators nuts when they first move to 3D is the need to play with points on graphs to obtain nice-looking motion. The computer is the world's stupidest in-betweener; when it calculates the movements needed between keyframes set by the animator, it has no idea whether the movement should start fast and end slow, or vice versa. If left alone, movements may look "spliney" or "floaty." To adjust the timing of the in-betweens, the animator typically opens a special software window called a motion graph and tugs on splines called function curves to get the interpolation to look right. Understanding how the precise curves in the motion graph affect the movement of the character is one of the most abstract, and sometimes maddening, of the tasks of the 3D animator.

Animation software offers some partial solutions to the problem of having to keyframe every little thing. For example, a real aid to animation of limbs is the ability to switch easily between two modes of *kinematics* (direction of

ABOVE: In pose-to-pose animation, the key poses are created first, then the in-betweens (shown partially transparent) are filled in.

BELOW: A dynamic sequence animated using the pose-to-pose approach.

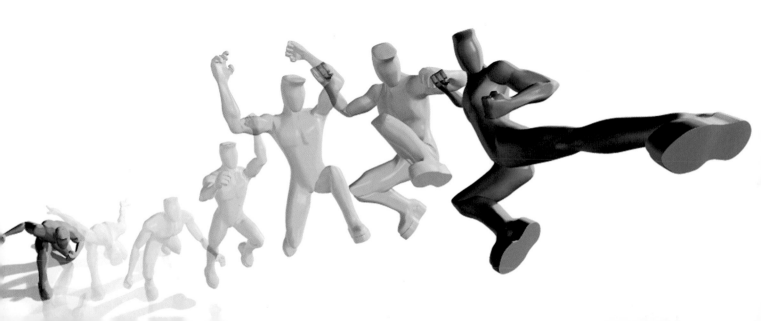

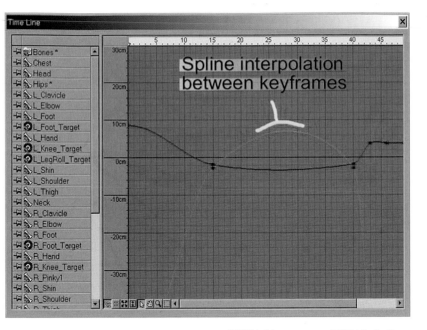

Time Line

Bones *
Chest
Head
Hips *
L_Clavicle
L_Elbow
L_Foot
L_Foot_Target
L_Hand
L_Knee_Target
L_LegRoll_Target
L_Shin
L_Shoulder
L_Thigh
Neck
R_Clavicle
R_Elbow
R_Foot
R_Foot_Target
R_Hand
R_Knee_Target
R_Pinky1
R_Shin
R_Shoulder

Spline interpolation
between keyframes

BELOW: In this illustration from Jeff Lew's *Learning 3D Character Animation*, a simple arc is created when a CG character bends his arm.

ABOVE: Adjusting the timing of a movement by modifying the curves in a motion graph.

RIGHT: The difference between forward kinematics (above) and inverse kinematics (below) as applied to an arm.

articulation), *forward kinematics* (FK) and *inverse kinematics* (IK). It is easiest to understand the difference between the two by example. The parts of the arm of a CG character are arranged in a hierarchy, parent to child. The upper arm is parent to the lower arm, the lower arm is parent to the hand, and so on. In forward kinematics, the direction of articulation runs down the arm, from parent to child. Move the upper arm, and everything below it in the hierarchy moves along with it. But pull on the hand, and nothing above it moves. In inverse kinematics, the situation is reversed—the direction of articulation runs up the arm, child to parent. Place the finger on an object, and the entire arm articulates to follow along. Move the upper arm (within limits), however, and the finger stays put. Sometimes you want to use FK, and sometimes you want to use IK, but—until very recently—it was quite difficult to easily switch between the two.

Once a CG animator has mastered the basic operations, he or she will start to develop a keyframing style. Most use a modification of the pose-to-pose style first developed in the early days of drawn animation. Using the pose-to-pose method, the animator drafts a set of "key poses" that define important states in the character's motion; this makes it possible to see the movement in full, albeit in an unfinished form, very quickly.

When an animator uses a pose-to-pose style, he or she is thinking primarily about how strong and expressive the character's poses can be. Cartoony motion, with its emphasis on extreme poses, is particularly suited to the pose-to-pose style. The transition period between two poses is deemphasized; movement has to look good, but it's the poses that tell the story.

ANTICIPATION, LEADING AND FOLLOW-THROUGH, ACTION AND REACTION, OFFSETS, WHIPS AND STAGGERS, WEIGHT— ALL THESE REFER TO BASIC CONCEPTS IN CARTOON ANIMATION, WHETHER IN CLASSIC 2D OR IN CG 3D. AS DORON MEIR, THE DEAN OF THE ISRAELI ANIMATION SCENE, HAS SAID, "CHARACTER ANIMATION IS AN ART OF MOTION AND ACTING, THE PRINCIPLES OF WHICH ARE INDEPENDENT OF TECHNIQUE"—AND, ONE MIGHT ADD, OF TECHNOLOGY. NO MATTER HOW DIFFICULT THEY ARE TO ACHIEVE WITH THE EVOLVING TOOLS OF 3D, THESE CARTOON ANIMATION PRINCIPLES VERY MUCH STILL APPLY.

ANIMATION BASICS 2

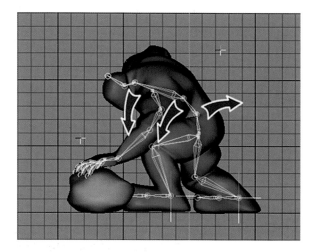

Jeff Lew's sequence showing one character throwing a punch at another illustrates several animation basics, including anticipation, follow-through, action and reaction, and whips and staggers. In a perfect example of anticipation, the green guy pulls back his arm to gain room to swing more powerfully. His upper body pivots in anticipation of the forward whip of his arm (you can tell the fist is moving fast by its blurred motion). The follow-through is relatively simple—his arm stays rigid and extended even after the impact. The head of his stolid blue opponent, who is doing nothing to get out of the way (no anticipation), snaps back (action and reaction) with the impact of the punch (at the same speed as the green guy's fist moved forward). The rest of the blue guy's body follows the head, but not all at the same time; his upper body is close-coupled to the head, but his left arm lingers behind, just as a real arm would. A more developed sequence would probably add even more elements to the animation, such as anticipation by the blue guy of the blow about to come, and more reaction in the green guy's arm and body to the impact-shock of his fist.

LIFT

GRAVITY

ABOVE: Anticipation captured in a single pose: you can play the rest of the sequence in your mind's eye.

LEFT: Animating weight and lift requires an understanding of the forces involved.

FAR LEFT: This blue giant will not lift the rock in exactly the same way as the normal-sized green fellow.

RIGHT: A sequence from Jeff Lew's *Learning 3D Character Animation* illustrates several cartoon fundamentals, including anticipation and follow-through.

Animating characters to show weight is one of the harder tricks to get right. Much depends on the judgment of anticipation and follow-through. A heavy character moves deliberately, and that means more of a windup for any movement as well as a longer, more extreme follow-up (caused by the increased inertia from the character's greater mass). Normal-sized characters also encounter and move heavy objects—in fact, this is a classic assignment in basic character animation courses. Making a character look like he is really lifting a heavy weight involves an understanding of the forces at work—gravity versus muscle lift, modified by mass and shape of object, character body structure, and desired line of action. The blue giant above will need less follow-through after lifting the rock, as it's not as much of a challenge for him as for the normal-strength green guy.

Finally, the image in which the blue giant is about to crunch a sports car provides a perfect example of anticipation. You hardly need to see the subsequent frames——you can play the Hulk-stomping, car-flipping action quite well right in your head.

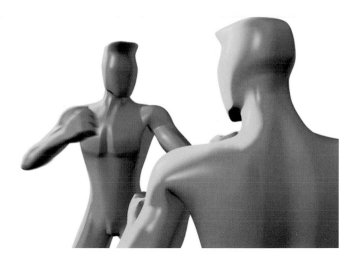

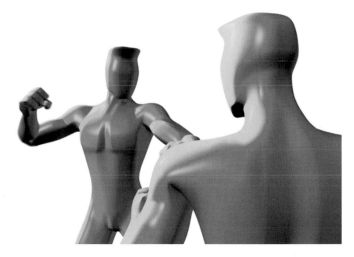

BEFORE MOVEMENT, THERE MUST BE POSE. ESTABLISHING THE CHARACTERISTIC POSES FOR A TOON, WHETHER HUMAN OR ANIMAL, IS THE ESSENTIAL FIRST STEP IN DEFINING CHARACTER AND CONVEYING EMOTION. CLASSIC ANIMATION BEGAN WITH THE "POSE-TO-POSE" APPROACH, WHICH GOES BACK TO THE EARLY DAYS WHEN THE DISNEY STUDIO WAS INVENTING THE PRINCIPLES OF CEL ANIMATION. A LEAD ANIMATOR DRAFTED A SET OF "KEY POSES," WHICH DEFINED IMPORTANT STATES IN THE CHARACTER'S MOTION AND ALLOWED THE DIRECTOR TO QUICKLY GET A LOOK AT THE MOVEMENT IN FULL, ALBEIT IN AN UNFINISHED FORM.

KEY POSES

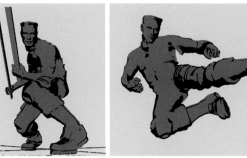

ABOVE: The Duke proxy model from a recent Hasbro GI Joe movie, in typical superhero action poses. Note the use of wide-angle views and extreme camera placements to achieve foreshortening and exaggeration.

TOP & FAR RIGHT BELOW: A good pose is facilitated by a good rig, which makes it easy to position the limbs and torso of a 3D character in exactly the desired pose.

RIGHT: The smart, evil shaman Tlaloc (of the console game *Tak and the Power of Juju*) has just the supercilious body posture and facial expression you expect of a superior villain.

Those key poses had to read instantly, with no visual ambiguity, and convey exactly the action and emotion desired at that moment in the scene. When the poses were approved, the animator or an assistant went back and drew the in-betweens.

Nowadays, 3D animation software takes care of the in-betweens, but the basic idea of describing the character's acting by a set of important poses and then developing the rest of the motion from those poses is still the most common animation methodology. Movement has to look good, but ultimately it's the poses that tell the story.

When creating character poses for action, the artist thinks primarily about how to make them strong and exciting, how to use poses to drive the scene forward. Poses that move aggressively into the viewer's space, or have multiple vectors of emphasis, as in the diagram from Jeff Lew's *Learning 3D Character Animation* DVD, are more dynamic than poses oriented parallel to the picture plane. Comics-influenced 3D art in particular is distinguished by exaggerated, almost animalistic poses. In the example showing a proxy model of Duke, one of Hasbro's GI Joe characters, he adopts action

poses with impossible extensions. Angled orientation to the camera, placement of the point of view very close to one part of the figure (often the leading foot), and the use of wide-angle lenses distorts the body proportions to add even more superhero-style foreshortening. The greater the distortion (within limits), the greater the visual punch.

Pose also defines character. In the cartoon world, heroes and villains have very different body postures. Those postures tend to be of very ancient lineage, easy to find in the history of Western art from the Greeks onward. In animation, archetypal poses also derive from the conventional personifications of theater and film. Tlaloc, a character in Avalanche's console game *Tak and the Power of Juju*, is instantly recognizable as a suave, self-confident villain, the sort of character Basil Rathbone used to play.

And pose need have no greater purpose than to sell a gag. Richard Rosenman's hairy little demon has plainly committed a faux pas. Perhaps he's pointing to an accident on the floor, or maybe he has pressed the wrong button. The body posture and facial expression reinforce each other so strongly that you can almost hear him say, "Oops."

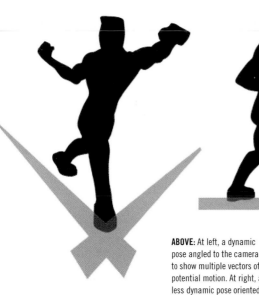

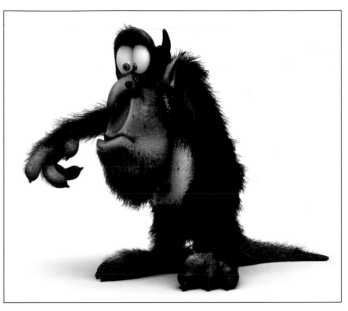

ABOVE: At left, a dynamic pose angled to the camera to show multiple vectors of potential motion. At right, a less dynamic pose oriented parallel to the picture plane.

RIGHT: A simple pose conveys the gag moment, as proved by Richard Rosenman's hairy little monster.

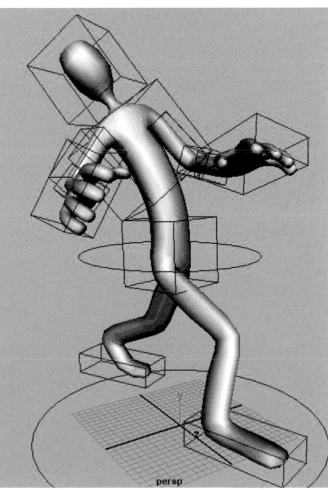

persp

TO BE MOST EXPRESSIVE, THE POSE OF A CARTOON CHARACTER SHOULD BE SUPPORTED BY OR REFLECTED IN OTHER ASPECTS OF THE SCENE, INCLUDING OVERALL COMPOSITION; COLOR SCHEME; LIGHTING; CAMERA ANGLE, MOTION AND LENS; AND SOUND, IF ANY. IN THE AWARD-WINNING SHORT ANIMATION *PUPPET* (2001), DIRECTOR RAF ANZOVIN SOUGHT A HIGH DEGREE OF INTEGRATION BETWEEN POSE AND PERFORMANCE.

POSE AND PERFORMANCE

The setup of *Puppet* is minimal. A version of Dennis the dog plays both marionette and puppeteer. The puppeteer has the magical ability to imbue his tiny puppet with real emotion, and delights in tormenting him with one strong emotional state after another. One sequence of rapid changes exhausts the puppet and it collapses, to the puppeteer's intense satisfaction. That satisfaction turns to fear and ultimately to submission as the puppet "wakes up" and binds the puppeteer with his strings. There is no voice track or sound effects, only music from *Funeral March of a Marionette* by Gounod.

Several rather simple devices were used to emphasize pose and marry action and scene. The short takes place on a completely empty and featureless stage; there are no props of any kind except the puppeteer's hand controllers. Lighting consists mainly of one volumetric spotlight trained directly down on the puppet from above, but the light is animated and moves with the character. It widens and narrows and changes color to signal the changes in the puppet's emotional state—white for neutral, golden for joy, blue for despair, red for anger, yellow for terror, and so on. The puppeteer is always bathed in a greenish light from below. The camera approaches the puppet from a low angle when he threatens violence and uncaringly pulls up and away when he is fearful and isolated. The score has been heavily remixed to vary pitch and tempo with the changes.

The poses themselves are meant to be as pure and unambiguous as possible. When the puppet has not yet been given an emotion, he is motivated only by pulls on the strings and moves in the unsteady, broken-jointed manner of a real marionette, his limbs at all angles. When the puppet is happy, he twirls in the air, arms strongly extended, fingers hyperextended, head thrown back in joy. In despair, his shoulders are slumped and he holds his head in his hands. In anger, his hands curl into claws and he furiously beats an imagined victim. Fearing retribution, he hunches down and draws his limbs in tight as he shivers. Even the strings have poses. They are taut when emotional tension is at its highest, slack when tension is released, and sway in aimless parabolas when the puppet's motivation is withdrawn.

BELOW LEFT: The puppet normally moves with the awkwardness of a real marionette.

BELOW RIGHT: Extended arms and fingers and a weightless, upward-yearning pose signal joy.

ABOVE: The puppet is now aware—and truly furious.

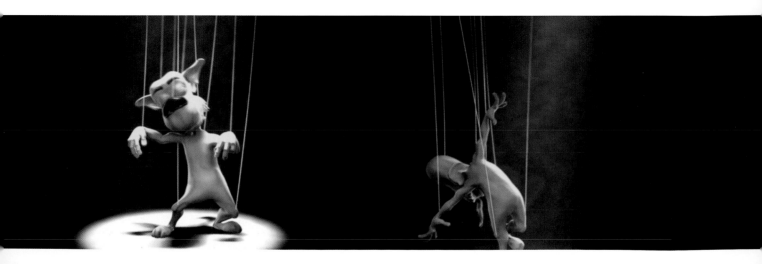

93

ABOVE: The puppeteer gleefully torments his tiny alter ego.

BELOW LEFT: The violent puppet's clawlike fingers appear ready to seize the camera.

BELOW RIGHT: The puppet despairs, as shown by his heavy posture, slumped shoulders, and head in hand.

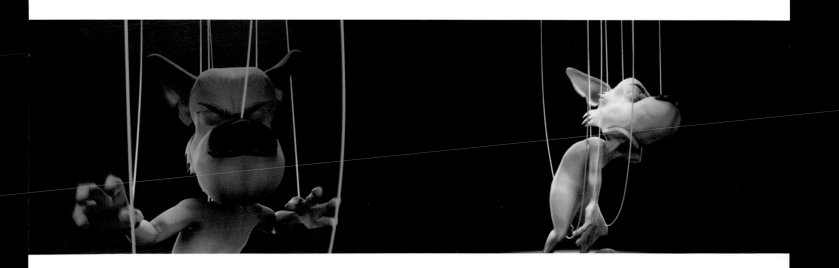

HOMO SAPIENS ENJOYS THE DUBIOUS DISTINCTION OF BEING THE ONLY CREATURE ON EARTH WITH A VERTICAL SPINE AND LOCKING KNEES. GIVEN THIS ODD ANATOMY, THE STRANGE AND COUNTERINTUITIVE METHODS THAT HUMANS HAVE DEVISED FOR GETTING AROUND WITHOUT FALLING FLAT ON THEIR FACES HAVE CAUSED ANIMATORS NO END OF TROUBLE (NOT THE LEAST OF WHICH IS LOWER-BACK PAIN CAUSED BY LONG NIGHTS IN FRONT OF A MONITOR OR LIGHT TABLE).

WALKS AND RUNS

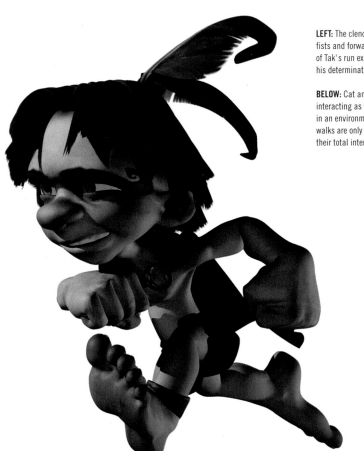

LEFT: The clenched fists and forward lean of Tak's run expresses his determination.

BELOW: Cat and dog interacting as they walk in an environment; the walks are only part of their total interaction.

That's why mastering the simple mechanics of a walk, seemingly one of the easiest but in fact one of the subtlest and most difficult motions to get right, has always been the essential rite of passage for any journeyman animator, CG or traditional. In 3D, tricky aspects of kinematics ("Hmm, should I use forward kinematics on the legs, or inverse kinematics?") can make it even harder to achieve a good walk or run.

There are two essential poses in a walk cycle. In the "strike pose," the weight of the character is evenly distributed between the front foot, which has just struck the ground, and the back foot, which is about to leave it. In the "passing pose," the weight is balanced exactly over one foot while the other foot passes by off the ground. Transitioning between these two poses gives you the basic foot motion for a walk, but more work is needed to make it convincing. For example, the path that each foot takes, whether arclike or saddle shaped, can make the walk look either mechanical or fluid.

Many characters have what's called a "footfall." Heavy characters usually pause perceptibly between steps, as they absorb the impact from the previous step and work up the energy needed to move their bulk forward for the next. The footfall is the dip in the pelvis movement that occurs as the character brings itself to a stop and starts on the next step. Huge characters can have tremendous footfalls that last as long as a step or longer, complete with secondary action on blubbery bellies. Lighter characters may have barely noticeable footfalls that help convey a minimal sense of weight.

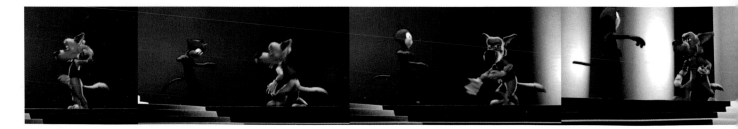

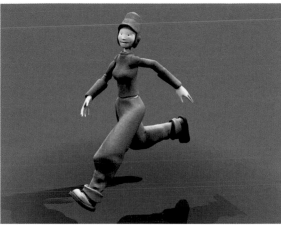

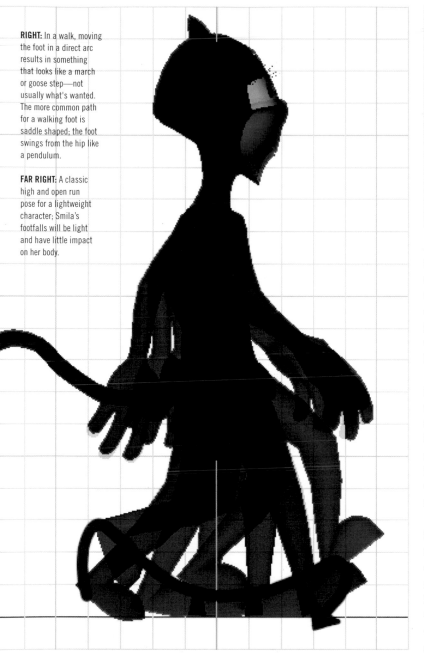

RIGHT: In a walk, moving the foot in a direct arc results in something that looks like a march or goose step—not usually what's wanted. The more common path for a walking foot is saddle shaped; the foot swings from the hip like a pendulum.

FAR RIGHT: A classic high and open run pose for a lightweight character; Smila's footfalls will be light and have little impact on her body.

A walk is a signature motion for a character, and can be used to express personality and mood. Think of the difference between the relaxed stroll of Bugs Bunny and the obsessed, angry bursts of Daffy Duck. Art Babbit, one of the old Disney master animators, often added little defining flourishes to the walks of his characters. For example, Babbit would make Goofy stick his feet out sideways just before hitting the strike pose.

Of course, getting the walk mechanics right is only the beginning. The walk must also reflect a wide variety of other factors, notably the physical environment, the emotional state of the character, and the dramatic situation of the scene. Moreover, walks are often mixed with other forms of motion, such as talking, gesticulating, or running. In the sequence of frames featuring the dog and cat, the dog walks backward while using his hands to direct the actions of the cat, while the cat struggles to gain control of her newly active limbs.

A run is really a series of jumps rather than a controlled fall. In many situations, animators combine what is basically a fast walk with small jumps/run cycles; in others, the run is an entirely separate action with its own dynamic. Runs, too, can be character defining; for example, a predatory character may bound forward, crouched low, arms out and ready to clutch, whereas a prey character skitters left and right, head turned to watch his pursuer. The run pose for Avalanche's Tak character expresses much of his plucky, determined personality.

AMONG THE MANY ANIMATION PRINCIPLES, SQUASH AND STRETCH IS THE ONE THAT APPLIES MOST CHARACTERISTICALLY TO CARTOONS. AS A TERM, *SQUASH AND STRETCH* IS REALLY SHORTHAND FOR THE COMPLETE MORPHOLOGICAL PLASTICITY OF TOON REALITY.

SQUASH AND STRETCH

When a real person jumps in the air and lands on the ground, her body crouches, becomes compact for the leap, springs up and stretches during the jump, then absorbs the impact of the landing by going back into a compact pose. This is the classic squash and stretch situation, but of course in the real world, there are all kinds of real-world restrictions: human bodies need to maintain volume and shape and have only a very limited amount of squashability and stretchiness. Animator Jeff Lew obeys these limitations, albeit with a cartoon character, in an example from his *Learning 3D Character Animation* DVD.

However, toons are in no way required to follow the dictates of reality. Toons can not only compress and extend just as far as the animator desires, but can also deform in any other way imaginable. That's been a prime source for some of the funniest (and cruelest) gags in 2D toons all along: Tex Avery's wolf getting flattened by a safe or piano, then popping up again, no harm done. Porky inflated with an air hose until he floats into the air. Tom Cat screeching as his hand is turned into a waffle when Jerry toasts it in a hot waffle iron. And so on. (Toon invulnerability is one of the key wish-fulfillment aspects of animation, as playfully exploited in *Who Framed Roger Rabbit?*) Of course, there are more subtle uses for squash and stretch as well, as in creating muscle bulging or fat jiggling, or just to be able to reach the arm a little farther than it normally would go.

BELOW: A bounding, highly active 3D human character like this swordsman can benefit greatly from limb and spine squash and stretch. He was designed to look deliberately cartoonish so his exaggerated deformations would not seem out of place.

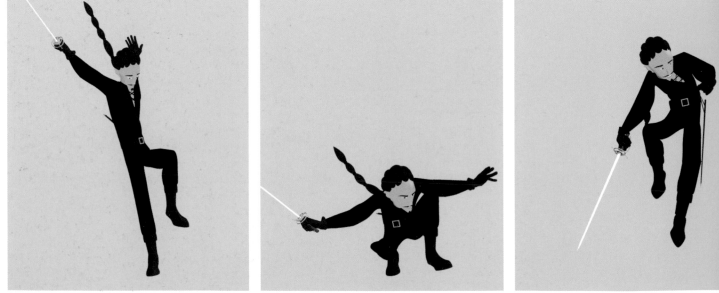

In 3D cartooning, squash and stretch requires a rig to support the desired deformations. Many free and commercial rigs offer the basic ability to stretch the limbs and spine, which takes care of the majority of situations for more human, realistic characters. The swashbuckler provides a good example of this level of 3D squash and stretch. In the first image, his body is very elongated, much more so than a real human is capable of. As he lands, his legs and spine actually get shorter so he can fold up compactly. From that low pose, he springs up, extending again (though not as much as before) and ready for his opponent.

When it comes to exaggerated, Tex Avery–style deformation, no off-the shelf rig offers everything you might want, so custom rigging is required. Disney's rule-breaking rig approach on the CG feature *Chicken Little*—where animators were encouraged to actually break the rigs to achieve squash and stretch extremes—points the way toward the ultimate goal of complete 3D character plasticity.

ABOVE: In this image from Jeff Lew's *Learning 3D Character Animation* DVD, the little yellow guy winds up and leaps in a more or less realistic fashion; little squash and stretch is needed.

RIGHT: A simple arm rig designed to allow squash and stretch.

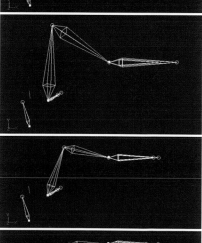

TALKING (LIP SYNC, IN ANIMATION JARGON) IS SOMETIMES CONSIDERED THE MOST DIFFICULT ASPECT OF ANIMATION TO GET RIGHT. IN FACT, IT ISN'T THAT HARD, BUT IT DOES REQUIRE FINE JUDGMENT AND TRADE-OFFS TO LOOK CONVINCING. PRESTON BLAIR'S CLASSIC REFERENCE *CARTOON ANIMATION* CONTAINS WHAT IS GENERALLY CONSIDERED THE BEST EXPLANATION OF LIP SYNC AS IT APPLIES TO ANY FORM OF ANIMATION.

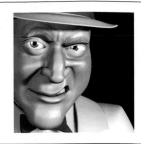

TALKING

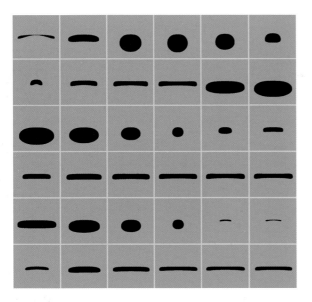

As Blair describes it, the lip-sync process involves breaking down the voice track into phonemes (the several dozen fundamental sounds that make up all spoken languages); animating the character's mouth to synchronize with the sounds; and then animating the rest of the character to coordinate with and reinforce what's being said (a process sometimes called face and body sync).

The animator really works not with phonemes but with visemes—visual phonemes. It's the mouth shapes, not the sounds themselves, that concern them. It's perfectly possible for an animator to do good lip sync for a character speaking a foreign language, or even complete gibberish. Luckily, animators don't need as many mouth-shape visemes as there are speech phonemes, because many phonemes involve movements inside the mouth and throat that can't be seen. Blair drew up a 12-viseme system that many animators swear by, but others use eight mouth positions, or even four, depending on the style and complexity of the character.

The temptation with 3D talking toons is for the animator to do too much—to animate too many mouth positions—just because the software makes it easy to add endless complexity. The result is a busy, flapping mouth and nervous, gesticulating body sync to boot. Visemes must often be left out for the sake of visual clarity. Judging which visemes to use comes with practice and observation, but even then there's usually some degree of trial and error. Viseme triage is even more important when animating at low frame rates and with cartoony characters.

For all the work put into lip sync, mouth movements are in the end less important in communicating the meaning of a character's speech than body pantomime (in a wide shot) and face pantomime (in a close-up). All the motions of face and body must reinforce and extend the meaning of the words. If expertly done, gestures can almost take the place of speech. Expert animators find a rhythm of movement in which broad and subtle facial and body movements accent the important points of the speech.

RIGHT: A selection of frames from an animation in which the character is saying, "Now now, Mr. Mutt, you can't be as dumb as you look." Head tilts, gaze direction, and eyelid animation amplify the lip sync.

LEFT: Simplified mouth visemes for the phrase "four thousand Cubans." The mouth forms, animated by Justin Barrett at 30 frames per second, are created by a nearly flat black 3D shape on the face of a blue rectangular prism.

BELOW: This animation interface shows the voice-track waveform along with the head model. At upper left are sliders for various facial controls.

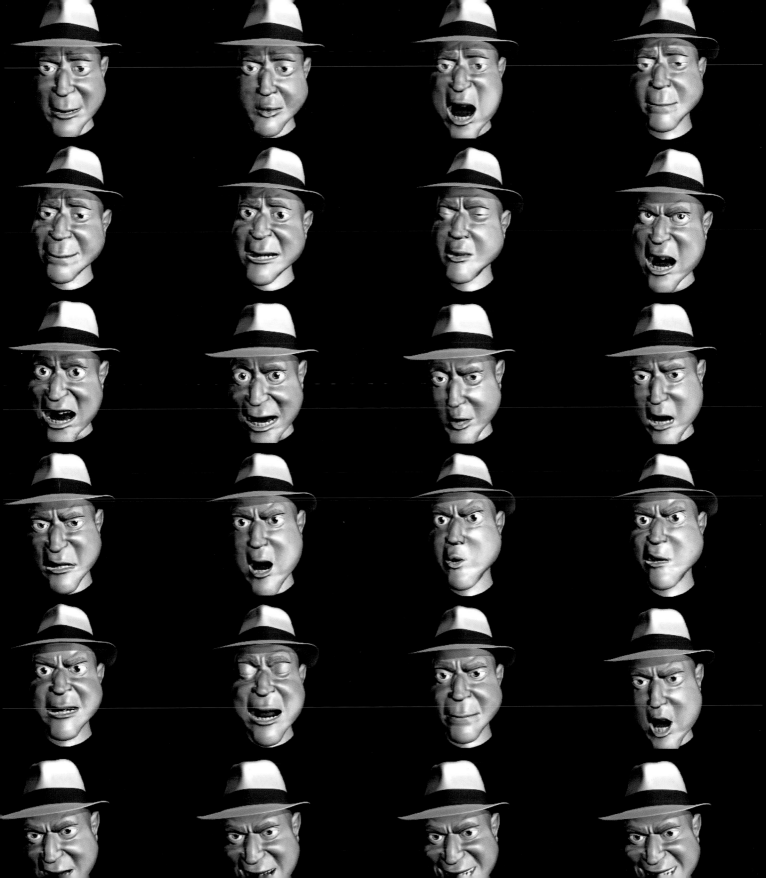

GREAT CHARACTER ANIMATION IS ALL ABOUT INTEGRATION—THE INTEGRATION OF SOUND TRACK, VOICE TRACK, AND VISUALS, THE SEAMLESS MESHING OF POSE, GESTURE, FACIAL EXPRESSION, AND LIP SYNC. BODY SYNC, AS THIS INTEGRATIVE QUALITY IS CALLED, MAY WELL BE THE HARDEST ANIMATION SKILL TO MASTER, BECAUSE IT REQUIRES THE ANIMATOR TO DEVELOP AN ACUTE SENSE OF TIMING FOR EVERY ASPECT OF MOTION.

BODY SYNC

Part of the difficulty is that different sorts of motion may require subtle timing offsets to look natural. One well-known principle, which applies to lip sync, says that the mouth must start to move before the sound of the word begins. But by how many frames? Two? Four? Much depends on the actions and expressions of the character; the same solution does not work every time, which is why you regularly see animators sliding the speech track back and forth, trying this, trying that. The sync is ultimately a matter of feel, not science.

Another standard principle is that motions of face and body should reinforce and extend the meaning of the words. But what if your character has no face? This was the challenge for Reel FX and Anzovin Studio when animating the Cobra Commander for the CG feature *GI Joe: Valor vs. Venom*. Cobra Commander's face is completely covered by a shiny helmet. The effect of his performance depends on the perfect synchronization of hammy voice acting and second-hand fascistic gestures. In fact, though Cobra Commander is supposedly the locus of pure global evil, he is actually the funniest character in the film. His performance is so campily over-the-top that even kids get it.

Gestures should also begin well before the sound they accompany. As the great Disney animator Shamus Culhane notes, many public speakers (Culhane gives Nixon as an example) don't understand this principle and gesture simultaneously with their words, or even after. The result is

ABOVE: What to do with a faceless character? Theatrical overacting helps drive home Cobra Commander's fiendish performance.

simultaneously with their words, or even after. The result is out-of-sync body language that undercuts the verbal message. On the other hand, a practiced performer like Ronald Reagan knows how to time gestures with words to create the appearance of naturalness, sincerity, and spontaneity (even if those gestures are in fact the exact opposite of spontaneous).

If you are looking for an example of the perfect melding of voice and gesture, it can be found in Victor Navone's short *Alien Song*. You can actually accept that Blit

BELOW: Perfect body and voice sync sell Blit the alien's impersonation of disco singer Gloria Gaynor in Victor Navone's short *Alien Song*.

BOTTOM: Dennis the dog dances to the strains of "The Sorcerer's Apprentice"— an example of purely gestural body sync.

the alien is singing with the voice of Gloria Gaynor, so precisely has Navone copied, timed, and exaggerated her gestures.

Taking that a step further, some animations have no voice track at all; the character's body is synchronized to sounds or music. In the sequence below, Dennis the dog is power dancing to the well-known sounds of "The Sorcerer's Apprentice" by Paul Dukas. Each down gesture either hits a beat or maintains a rhythm of movement that plays off the building intensity of the score.

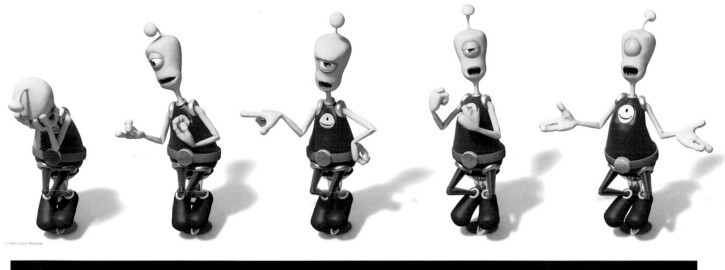

©1999 Victor Navone

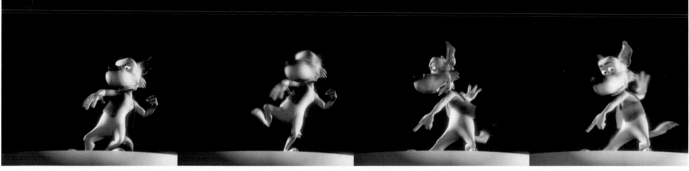

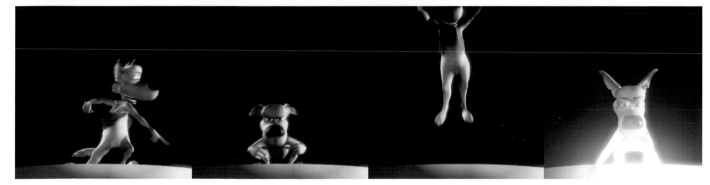

MOTION DETAILING, ALSO CALLED SECONDARY ACTION, REFERS TO MOVEMENT THAT RESULTS INDIRECTLY FROM A CHARACTER'S MAIN ACTIONS. THAT INCLUDES THE MOVEMENTS OF HAIR, CLOTHING, FLOPPY EARS, AND OTHER INANIMATE OR PASSIVE OBJECTS THAT ARE HANGING OFF OR DRAPED ONTO THE CHARACTER. BECAUSE FLOPPY EARS AND LONG HAIR AND CAPES AND THE LIKE ARE NOT RIGID OR ARE NOT RIGIDLY FIXED TO THE CHARACTER, THEY WILL OF NECESSITY MOVE ONLY IN REACTION TO THE MAIN LINE OF MOVEMENT. THAT IS, THEY WILL TEND TO 1) LAG BEHIND THE MAIN ACTION; 2) KEEP GOING FOR A WHILE AFTER THE MAIN ACTION STOPS; AND 3) OTHERWISE ACT LIKE OBJECTS GOVERNED BY REAL OR CARTOON PHYSICS.

MOTION DETAILING

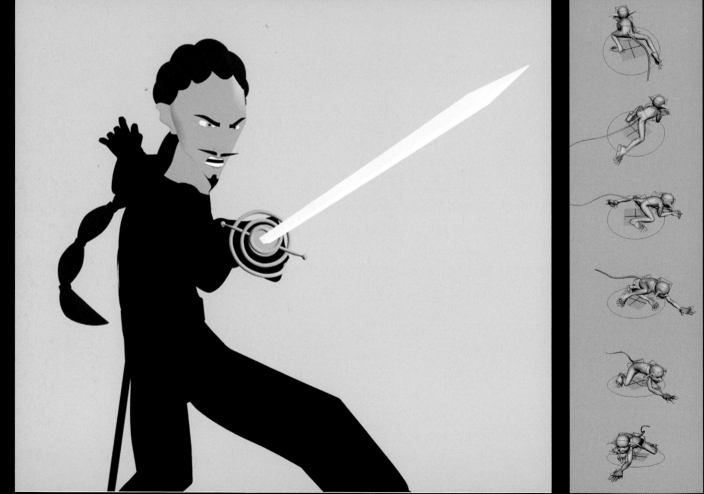

ABOVE: A simple whip motion for a cat tail. The base moves only slightly, whereas the tip lags and overshoots.

LEFT: Careful motion detailing of the hands, feet, and tail enhance the believability of this character's crawl.

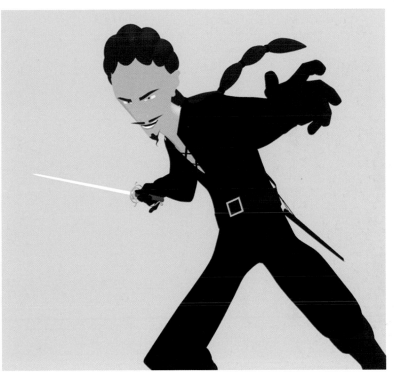

FAR LEFT & ABOVE: The swordsman's ponytail, which is animated much like a cat's tail, lags behind his main line of action, providing both important motion cues and a visual counterweight to the linearity of his sword.

Motion detailing also applies to parts of a character—arms, fingers, tails, fins, and so on—that are influenced by the main action while being under the character's conscious control. For instance, the hand may trail behind the line of action of the arm but still have a motivated, nonpassive motion—it may, for example, culminate in a deliberate snapping of the forefinger. Clothing isn't necessarily passive either; its secondary motion can be used to good effect as an extension of the character's personality, especially in cartoony styles of animation; superhero capes, for example, typically have something of a personality of their own.

Procedural dynamics tools and various rigging tricks can be used to automate motion detailing, especially in the case of clothing, but what you gain in automation you lose in expressiveness—no procedural system can convey motivation and individuality. So most toon animators prefer to apply motion details mainly by hand. This can be made easier by thrifty toon character design that minimizes the need for keyframed detailing; clothes, belt items, and most hair will be fixed to the character and not dangling off, thus requiring no secondary animation. With toons, detailing should be saved for major character-defining elements such as a distinctive tail.

In the frame sequence showing a crawling character, the animator has applied detailing in several areas to add believability to the motion. The head tracks back and forth with the shift in mass of the body. The ears are fairly rigid and react only slightly as the body moves. The long fingers and toes snap and hyperextend as they reach forward, and they curl up at the end of their push. The whiplike tail wags back and forth with the movement of the hips, but also expresses personality by a catlike twitching motion.

The exact timing and extent of a whip motion has a lot to do with the length, rigidity, and tensility of the object being animated. The swordsman's ponytail is extremely flexible almost all the way along its length, and thus can curl and whip in any direction. Its sinuousity acts as an essential balance to the character's stabbing, linear sword thrusts and quick arm extensions.

WHEN STAGING SCENES FOR MULTIPLE CARTOON CHARACTERS, THE ANIMATOR SEEKS TO GIVE EACH TOON AN INDEPENDENT LIFE OF ITS OWN—AND THAT USUALLY MEANS ALSO CREATING PLAUSIBLE, AFFECTING CHARACTER INTERACTION. JUST AS A STAGE PRODUCTION OR LIVE-ACTION FILM BENEFITS FROM THE INTERPLAY OF THE CAST'S PERSONALITIES AND MOTIVATIONS, SO AN ANIMATION GAINS COMPLEXITY AND DEPTH FROM THE BYPLAY OF ITS CHARACTERS. FOR SUPERLATIVE EXAMPLES OF ENSEMBLE TOON ACTING, YOU NEED LOOK NO FURTHER THAN THE SCENES IN THE FISH TANK IN PIXAR'S *FINDING NEMO*.

CHARACTER INTERACTION

Although the voice talent always provides an essential element for the creation of toon personality, most of the character differentiation has to come from the animator, and it must mainly derive from physical action, not the voice track. (Even more so if the animation has no voice track—then the animator must fall back on vaudevillian slapstick or the stagey techniques of silent film acting. This is why top studios often ask animators to take acting and film literacy classes.) The job of animating multiple characters, and getting them to interact consistently together, can be particularly difficult in large productions where many animators work on each scene and there's often no continuity in how shots are assigned.

Fight scenes are eagerly sought assignments because they offer an opportunity to animate fast-paced, purely physical character interaction—a chance to prove one's chops as a crafter of exciting motion. But combat moves are complex and liable to critique from an audience increasingly sophisticated in martial arts, so it can be helpful to acquire reference footage as a guide. In the examples, video frames of two fight sequences in which a small-statured martial artist

is pitted against a much larger opponent have been used as reference for keyframed animation (the two were chosen to match the relative sizes of the animated characters). Some animation directors might choose to capture movement data directly from martial artists wearing motion capture (mocap) suits, and then apply that data to the 3D character models. However, this works well only when the 3D characters have the same proportions and motion capabilities as the human actors. When the animated character is not built like a human, using human motion data can cause endless trouble.

Note one more tricky aspect of character interaction—areas where characters "touch." Unlike real-world objects, 3D characters can easily interpenetrate each other, so animators spend time and effort avoiding this by carefully positioning any points of contact. The job becomes more complicated with furry characters, because fur should react to pressure from another object, but not pass through it.

Like fight choreography, dance choreography is an exercise in pure motion. The sequence of images of Dennis the dog and the blue cat dancing was inspired by a Fred

RIGHT ABOVE: The size disparity of the two martial artists, one small, one large, helps the animator correctly judge the relative actions of the two animated characters, who also differ in size.

BELOW: Video of two human martial artists used to guide the physical interaction of animated characters.

RIGHT: A low-res test render of two dancing characters. The sequence was conceived as one long take, with no cuts, to give the well-rehearsed feel of a classic Fred Astaire dance routine.

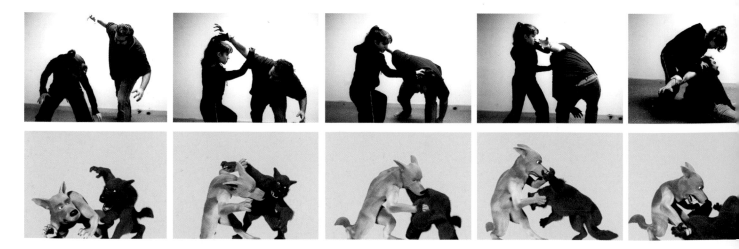

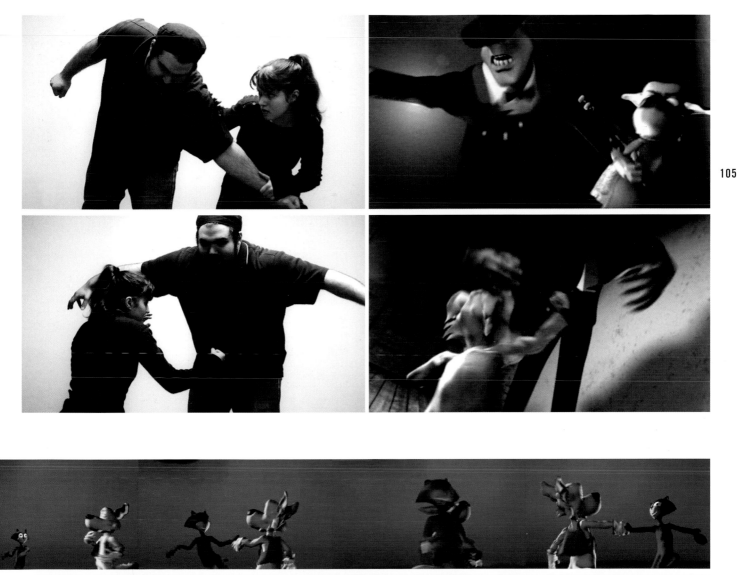

Astaire–Ginger Rogers dance routine in *Flying Down to Rio*. The sequence immediately makes plain what is perhaps the key feature of dance interaction: a carefully worked-out rhythm of bodies coming close and moving away, clutching and letting go, tension and release. Their hands are the locus of the centrifugal force pulling them apart, with gravity working to keep them together. (This sequence does not show it, but after the blue cat is released, she spins up and into the air, completely free.) In coordination with the limb and body motion, gaze direction indicates the emotional involvement of the characters in the dance and with each other. The whole sequence comprises one very long take—rare in animation, but necessary to preserve the integrity of the dance choreography.

PIXELS AND LEAD 1

FOREWORD

The last few years have seen a rapid growth in 3D animation. Stronger computers, more sophisticated software, greater accessibility, and the possibility of hyperrealism helped the computer animation technique to take classic animation's place as the most popular and profitable medium of animation.

Character animation is an art of motion and acting, the principles of which are independent of technique. In addition, knowledge plays very little role in animation—what makes a good animator is talent, and mainly experience. The conversion of seasoned classic character animators to CG (computer generated) animation was, therefore, only natural.

Since the principles of motion and acting don't change, I expected the work methods to be similar. I was wrong: the different technique requires a different way of work. I adapted. Slowly, I got used to a new way of working, a new way of thinking. I began to practice 3D animation.

Meanwhile, I continued to draw and teach classic animation, and became interested in the way these two mediums relate to each other. What is the difference? Why does the computer force me to think and work differently? And most of all, how can I combine the advantages of classic animation with those of CG animation?

A FEW NOTES

Because some of the animation terminology is rather vague, and I want to prevent possible misunderstanding, here are my definitions for a few problematic terms:

ANIMATION, ANIMATOR

There are quite a few forms of graphic arts that can be called animation. This essay refers only to "manual" character animation (not rotoscoping or motion capture).

CLASSIC ANIMATION

Hand-drawn animation.

CG ANIMATION OR 3D ANIMATION

Animation that was created using 3D software.

CARTOON

A style of animation in which the animator may "bend" the laws of physics.

The essay is written from the point of view of a classic animator who turned to CG animation. Classic animation is my native language, so to speak, and it is therefore only natural that the problems analyzed here are those of CG animation and not classical animation. I suppose a CG animator trying to understand classic animation would analyze it the other way around. In any case, I do not intend to claim that one medium of animation is superior to the other.

THE CLASSIC ANIMATION WORK METHOD

For those who are not classic animators (99.99999% of the world's population), I should describe first the general work method. Generally, the procedure is for a lead animator to draw "key poses" or "keyframes," the most important character poses, and for assistant animators to fill in the "in-between" poses. On special (and quite rare) occasions, the animator can choose to animate purely straight ahead—just start with the first drawing, finish with the last, make a test, and check what happened.

Before beginning work, the animator receives the following:
* Storyboard and sound analysis (the sound at each frame when the scene contains music or dialog)
* Layout: the layout is essentially the storyboard enlarged and much more specific, usually including the background and the characters in the important poses of the scene.
* Model sheet: the characters as they look from several angles. For main characters, the model sheet usually also includes various poses and expressions.

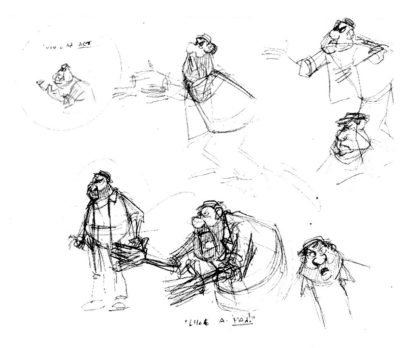

TOP: Thumbnails for a sample scene. The dialog is, "You can act like a man!!!"

ABOVE: Extremes. The third drawing was the first to be made, and the whole scene is "drawn" from it.

BELOW: Added in-betweens and moving holds. Some breakdown drawings may be half drawn—the in-betweener (a specialist who does just the in-between poses) puts in the rest.

Equipped with all this information, the animator can start working. These are the typical phases that the work goes through:

PHASE 1: THUMBNAILS

A "research" test done with small, very spontaneous drawings, searching for a few poses that "tell the story" and suggestions for interesting poses that can be used in the scene. Often the timing is also generally planned at this early stage.

PHASE 2: EXTREMES

A small number of poses that tell the story. The poses must be clear, but they don't need to be clean.

PHASE 3: BREAKDOWNS

Less important, intermediate poses that add character to the motion, define arcs, and enhance the timing.

PHASE 4: OPTIONAL

Going through the whole animation in a straight-ahead fashion, with the initial poses serving as waypoints, but usually not actually used in the final animation.

PHASE 5: PENCIL TEST

The drawings are scanned or shot by camera and edited in the right timing. The animator checks that the animation actually works the way he meant it to. The classic animation test is "fragmented," since there are no in-betweens yet, and may have partially drawn frames—sometimes just a mouth or a hand.

PHASE 6: IMPROVING THE ANIMATION

Adding special keys (such as the eighth drawing in the sample on page 108), improving problematic drawings, fiddling with the timing, making a new test, and so on, until the director approves the result.

PHASE 7: ADDING OVERLAPPING ACTION

On hair, clothing, and so on, in a straight-ahead fashion.

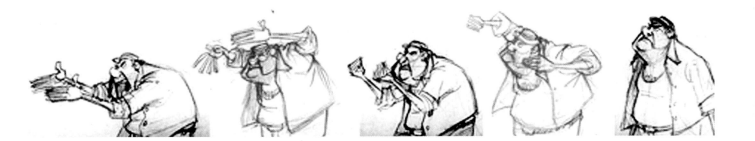

PIXELS AND LEAD 2 BY DORON A. MEIR

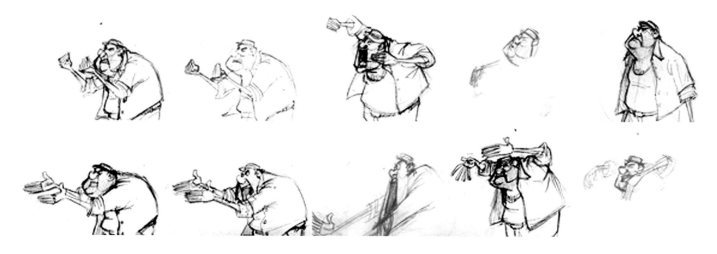

PHASE 8: IB (IN-BETWEEN) CHARTS

These are quick diagrammatic instructions for the assistant animators who draw the in-betweens. Essentially, these instructions have to do with slow "ins" and "outs" and other exceptional parts.

ANIMATING IN CG

We've explained the methods of working in classic 2D animation. So what is the difference between this process and the method of animation used in CG? Well, the answer is: none. I work in quite the same way in both. The difference lies elsewhere: classic animators use paper.

ABOVE: Filling in additional key drawings to improve the animation.

CHARACTERISTICS OF ANIMATING ON PAPER

The differences between CG and classic animation are quite evident in the way that animating on paper works:

✱ Constantly flipping the drawings—all the time, even while drawing—with the previous drawing (checking proportions and motion), the two previous drawings (checking flow and arcs), or the three or four previous ones (not as often—this is a deeper checking of flow). With in-between drawings you flip between the previous and the next drawing. All it takes to get back to the current drawing is a small movement of the fingers.

✱ Occasionally you change the order of the papers. It's very easy. The animator sets up a sequence of drawings he would like to examine, and flips them or turns on the light table to see them overlap. The order of the papers in the work process is entirely unrelated, of course, to their final order in the film (contrary to CG animation, in which the work is done directly on the time line [a software feature that allows editing of the order and timing of frames]).

✱ You can easily get the "onion-skin effect" (several transparent, overlapping drawings)—you just have to turn on the light table.

Some of these characteristics, such as working independently of the time line, don't exist in any of the currently available 3D software. Other features (like onion-skin effect) can be found in some programs, but it's never as simple as pushing a button. Why is this relevant to CG animation? Because the classic way of work, especially the flipping, is the very thing that develops the famous "sense of motion"—that feeling that guides the animator and tells him whether a certain motion "works." A classic animator would usually flip to previous drawings before he even starts drawing the next keyframe, to feel and imagine roughly how it's supposed to look. These issues are solvable. They can be programmed into 3D software. I hope someday, someone will actually program it. But these are differences that, important as they are in my view, are still superficial. The deeper differences are still ahead.

FUNDAMENTAL DIFFERENCES BETWEEN CLASSIC AND CG ANIMATION

Very early in my CG experience, I encountered some of the basic differences between the two:

INDIRECT ANIMATION

I felt, and I still do, that in CG animation I wasn't actually animating: I was explaining to the software, through its user interface, how I wanted it to animate. In other words, the work is indirect—contrary to classic animation (as well as puppet animation, for instance). Every animator who ever yelled at his computer, "But I asked you to do it like that!" will understand what I mean.

INTUITION

In classic animation one can create quickly, with a few lines, a rough pose. This allows a simple, flowing, harmonious animation process, in which the artist concentrates on acting and motion without being distracted by details. The drawings can then be carefully redrawn, with all the necessary details, keeping the original flow of the free, intuitive animation. This is impossible with 3D animation: each pose includes tedious picking, moving, and rotating of different objects. In classic animation, you think of the pose, then analyze its parts; in CG animation, you have a multitude of parts from which you assemble a harmonious pose. A hand is perhaps the ultimate example: a few seconds of pencil time, a lot more digital time.

RIGGING

Every CG character requires an internal skeleton—called a rig—plus controls to manipulate it. Each rig has a sort of user interface, with its own features, missing features, and bugs. Thus another thick layer is added to separate the animator from his animation. And on top of that, the rigging issue is very much responsible for the intuition problem.

A classic animator thinks less about bones and more about the forces working within his character. The character is trying to reach something high? The animator visualizes a power that supposedly pulls the character up, stretching it through its fingers and influencing the whole body. The character reaches to scratch its head? The animator doesn't move the arm: he moves the hand. The character hits the floor after a jump? In the mind of the classic animator, there is a squashed mass, along with a sense of weight and the strength of impact. There is nothing similar in the current rig technology.

ILLUSION OF MOTION

This is, I think, the most fundamental difference between classic and CG animation, and it's so simple that it gets completely overlooked. I noticed it for the first time while working on this essay. Classic animation is an illusion of motion. CG animation really moves. In other words: in 10 frames of classic animation there are 10 static characters, but they are drawn and arranged in such a way that it seems to be one character moving. In 10 frames of CG animation, there is only one character.

BELOW: In 10 frames of classic animation, 10 static characters are drawn so they seem to be one character moving. In CG, only one character is moving.

PIXELS AND LEAD 3 BY DORON A. MEIR

This simple but unobvious difference has significant consequences. In classic animation, I can do whatever I like. If, all of a sudden, just for a single frame, I want my character to stretch, or completely distort, or turn into a messy scribble or a tomato—anything—and I think it fits the action, I do it like that. In CG animation, by contrast, I am limited to the existing character and to the "laws" made by the rigger—that is, unless I model something entirely new, just for that single frame, and also the in-betweens (which is of course not practical, at least for regular commercial projects).

This draws us to the conclusion that, compared with classic animation, CG animation is inescapably a restrained medium, simply because it's harder to distort and exaggerate when you are trapped in a web of software-based constraints and laws that are completely absent in classic animation.

Some other important differences between CG and classic animation:

* Classic animation is done from a single point of view—that of the camera. 3D animation is done simultaneously from every point of view.
* The classic in-betweener is human, and has human intelligence (usually). The computer understands nothing, and has no common sense at all.
* The result in CG animation can be viewed instantly and altered at any point, whereas in classic animation it's impractical to test every minor adjustment. When the in-between is done the animation is usually not changed. Therefore classic animation demands more imagination and planning.
* In CG animation each object—arm, hand, leg, and so on—has its own keys, whereas in classic animation the keys are generally set for the character as a whole.

GENERAL CONCLUSIONS

* The spontaneous nature of drawing is irreplaceable. CG animators, too, will gain from a solid quick-sketching and drawing ability, which will enable them to create appealing, interesting, flowing thumbnails that can be used as reference for the actual animation.
* Animation is tough enough even without technical complications, but the 3D animator is working with double gloves on—the interface and the limitations of the software, and those of the rig. Precisely because their work is less comfortable and intuitive, 3D animators have to better understand what they are doing, whereas classic animators can use their intuition.
* Because in CG animation you can immediately view the results, you have a better chance of getting exactly what you are after. Classic animators must be extremely experienced to achieve this goal, especially when it comes to timing. CG animation can shorten the learning process—

BELOW: In 3D animation, you can pose and view the results immediately.

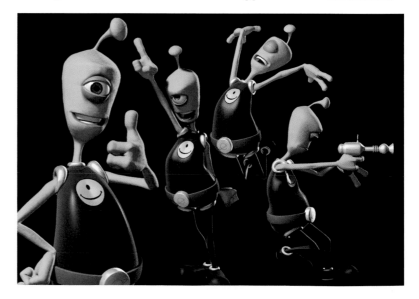

but, on the other hand, may cause the animator to neglect the planning and visualizing stage, which in my opinion is dangerous.

✱ Working in 3D space—animating from all angles simultaneously—can contribute to a better understanding of pose, weight, and anatomy. Nevertheless, because a holographic medium is yet to be invented, the final result is two-dimensional when seen from a single angle. Therefore, the camera has to be set before animation, and the animator should take specific care of the pose from that point of view.

IMPROVING THE SOFTWARE

✱ The rig technology is still not fully formed. I think the animator should be given the option to use not just his rationality but also his intuition. The objective I would suggest is for the rig to enable work on forces (weight, squash, stretch, line of action), leaving the work on bones for fine tuning. Also, the entire IK scheme is problematic and should significantly improve to be really intuitive.

✱ Several features can be added to let the CG animator work similarly to the classic way of working with paper. For example: an option to set a few poses that can easily be flipped with the current frame. There should be a hot key that toggles ghosting (onion skin effect) for these poses. Also it should be easy to rearrange the selected poses without influencing the time-line arrangement.

✱ There should be a simple option of setting the nature of in-betweens (slow in, slow out, smooth) for all the character's objects at once. Most of the major programs now include such a feature, but it's not simple enough, and when the character is very complicated (includes many objects) it may be time consuming and cause technical problems.

ABOVE LEFT: Posing a hand in 3D requires using up to 20 objects (three bones for each finger, four in the palm itself and one for the wrist). This example is somewhat more efficient.

ABOVE: A whole pose in less than half a minute, including character design. Drawing is much more intuitive than 3D posing.

CG WORK METHODS

✱ Keep the keys for all the objects of a character grouped together as much as possible. It simplifies the animation process, gives the animator greater control over the final result, and prevents some technical complications. Once the animation generally works, you can fine-tune by changing and altering the keys for specific elements.

✱ Sometimes it is more practical and convenient to animate more freely, i.e., to work on each object separately. When the animation is essentially finished, you can group the keys by creating grouped keys (i.e., on all objects at once) in the important frames and deleting the rest of the keys. When correctly done, the animation will stay almost the same and you can refine timing and poses without getting all tangled up.

Where cartoon animation is needed, you may also want to consider the following:

✱ Simple, flowing, and graphic characters, without too much detail in model or texture

✱ Make the rig as flexible as possible, thinking ahead of possible distortions (wildly open mouth, violent stretch/squash, and so on).

✱ Animators with a classic background should draw sketches of the animation before and while they work, to better feel the flow and the distortions needed.

✱ Once the animation is done, the model (mesh) itself can be animated where distortions are needed.

✱ Don't be afraid to hold the character [keep it nearly still for a range of frames]. The conventional CG way of thinking says that a hold doesn't look good in 3D, the reason being (I think) that—contrary to drawn animation, which is perceived as an icon or caricature—CG animation is seen as a simulation of reality, and in reality holds don't exist. I think cartoon will be seen as caricature in CG as well, and therefore holds will hold (so to speak).

PIXELS AND LEAD 4 BY DORON A. MEIR

POINTING FINGER: AN EXAMPLE OF THE "CLASSIC" WAY OF WORKING TRANSLATED TO CG

The following is a somewhat technical explanation of the creation of a very simple CG animation with methods adapted from classic animation. I've skipped the usual thumbnail phase and have gone straight to the extremes. After planning the desired timing, I set the two main poses: initial and final. Then I set the anticipation. I watched the animation and made sure that the timing I planned roughly works. In every keyframe there is a key for all objects (upper arm, forearm, fingers).

Now it was time for some breakdowns. To see the arcs I worked with ghosting (to simulate the onion-skin effect) and set options for the trajectory of the arm and fingers. I set two breakdowns to make sure I would get the arc I wanted (in classic animation one breakdown would usually be enough, and I would add a drawn arc that the in-betweener can follow). The second breakdown pose is quite close to the anticipation extreme, but it's not as close in the time line, which makes a slow in. Between the anticipation extreme and the final pose I added another breakdown, defining a very flat arc and adding a "drag" on the hand and the index finger. After the "pointing" extreme

I added a recoil pose that also serves as a moving hold. Finally, I went through the important objects, making sure the different arcs work.

The animation already works, even though there are still no in-betweens—just like in the classic test in the beginning of the article. Now I turned to some specific adjustments: I stretched the bones in the pointing extreme to get some more elasticity, and added a key for one frame in which the hand is stretched, to simulate a blur. (This is an old 2D cartoon trick, and a fine example of this can be seen in Eric Goldberg's animation for the genie in Disney's *Aladdin*.)

It's time to add in-betweens. I selected all the objects (as you may remember, every keyframe contains keys for all objects), and changed the curves: accelerate from the first to the second key, smooth to the third, then slowing in to the fourth (anticipation extreme). Slow out toward the pointing, no in-betweens between the stretched key and the pointing itself, and then slow in toward the recoil, final pose. After a test render, I made some timing corrections here and there (very easy, as the keys are grouped), and the animation is done. No tedious work adjusting motion curves (software tools in which the animator can change the timing of motion

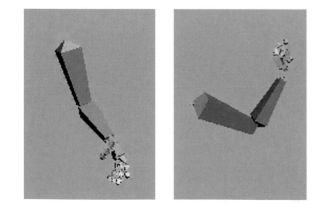

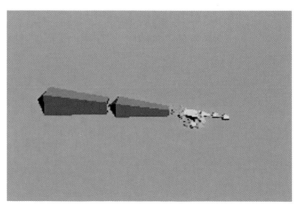

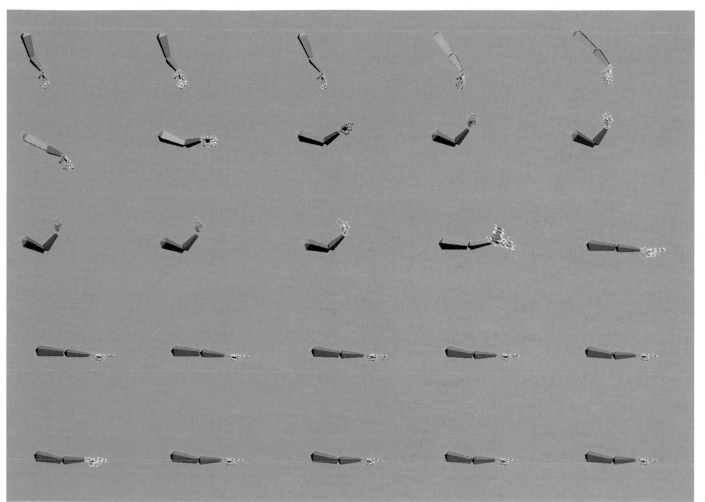

by adjusting spline values on a graph) has been required, and yet the animation is smooth, elastic, and also somewhat cartoony. More important, this method does not destroy creativity and may even improve it: instead of investing a lot of time in curves and motion, most of the time was spent on the initial extremes, the important ones, those that tell the story; a little less time was put into the secondary poses, the ones that make the motion; and the shortest time was spent on the in-betweens, whose sole function is to smooth out the motion. Furthermore, since every keyframe is set for the whole character (the whole hand, in this case) and not parts of it, I was able to maintain a high level of control over the final result.

I chose not to go over the animation and clean up redundant keys, or smooth the arcs by using the graph editor, because I wanted to keep the more natural timing that you get when the arcs are not completely mathematical and "correct." It is important to emphasize

FAR LEFT: Frames of the extremes test of a CG arm animation.

ABOVE: Final frames for the CG arm animation.

that I don't claim that this is "the right way to work in CG animation," but merely a possible example of how classic cartoon animation methods may be put to work in the CG world.

AND FINALLY...

Finally, animation is animation. This essay examined through a magnifying glass—no, through a microscope—the differences between classic and CG animation. But, when all is said and done, it's more of the same thing, and the goal is always the same: nice motion and interesting, convincing acting. And so all animators, in all techniques, are sitting in the same boat, trying to understand where the hell we're paddling to.

I'd like to thank Kfir Ram from Asifa Israel, Tal Flint and Nir Hermoni, and also the guys at Tapuz animation forum, for their help with this essay.

114

5

SHOOTING TOONS

STYLE IN THE 3D TOON

SHOT FRAMING

For the simplest toons, shot framing solutions are also pretty simple: you show the entire character foursquare in the center of the frame and let them do their thing. (Standard TV's 3:4 aspect ratio tends to encourage this sort of static framing.) It's cheap, easy, and if you fudge the lip sync. you can repurpose the shot endlessly no matter what the action or plot. This might be called the Hanna-Barbera solution. Most modern low-budget anime does much the same, only the compositions are off-kilter a bit, from low or high angles, to look modern and add variety. But mainly, it's toons in the middle.

Cartoons with more filmic sensibilities are going to stretch the dynamic possibilities. Raf Anzovin's in-production short *Java Noir 2* is composed in wide screen and shot like a noir film, with all the twisted, off-center visual framing that implies. In the series of frames from one segment of the short, Dennis the dog, tormented by his addiction to coffee, breaks free and attacks the mobsters controlling the java trade. The fight shots are framed so action is heavily weighted to the left or right, with light areas compositionally balancing the characters and the camera moving to keep the framing off-center. Other shots employ the CG equivalent of telephoto lenses to keep foreground and background elements equally in focus, as in the image of the cat inspecting her claws. Even in the head shots of the mobster,

he is never exactly in the center of the frame. A publicity still from *Java Noir 2* is framed as a two-layer, two-element composition, with a sharply focused foreground and a soft-focus background. The spilling coffee is not a fluid simulation, but simply modeled geometry in the form of a stream of liquid, with an appropriately coffeelike shader. The tightly compressed, claustrophobic space reflects Dennis's horror at the waste of his treasured beverage, and the "V" composition draws the viewer's gaze irresistibly to the spill. Dennis's head is cropped so that all you really see are his eyes—but they convey everything you need to know about his stark emotional state. No other background or foreground detail is required.

In the two-shot of Dennis and the cat, there's an interesting and complex emotional dynamic between the two—the cat's cool, amused appraisal against Dennis's slightly anxious stare. The cat's left eye, which conveys most of her expression, is carefully placed at the center of the composition. The S-shaped negative space between them continues the visual rhythms of the outlines of their heads. Most striking is the fact that the entire composition is in the shape of a heart. This was not originally planned but was instead a serendipitous discovery: a light placed to illuminate the cat's face just happened to create the right shadow shape against the wall, pulling the whole image together.

ABOVE: This heart-shaped composition looks deliberately framed but was in fact a happy accident created by the placement of a single light.

RIGHT: A series of frames from *Java Noir 2* shows a variety of shot framing possibilities, from telephoto-style compositions to off-kilter action sequences.

THIS PAGE: Sharp foreground, soft background, tied together in a V-composition.

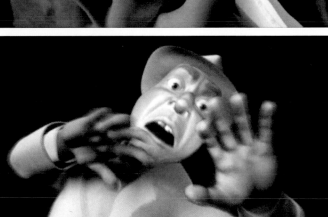

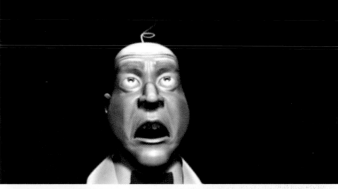
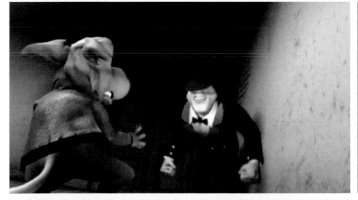
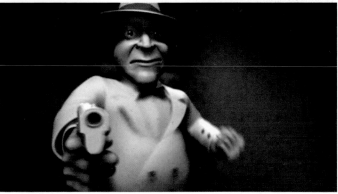
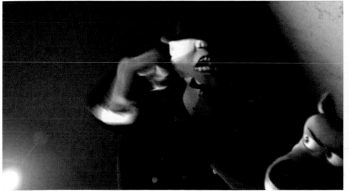

THE EMOTIONAL AND ESTHETIC EFFECT OF 3D ART, LIKE PHOTOGRAPHY AND CINEMATOGRAPHY, IS STRONGLY DEPENDENT ON COMPETENT AND IMAGINATIVE LIGHTING. THE RULES OF LIGHTING IN THE 3D REALM ARE MUCH THE SAME AS—IN FACT, ARE LARGELY DERIVED FROM—THOSE GOVERNING PHOTO, STAGE, AND FILM LIGHTING, BUT IT IS AN INTERESTING FACT THAT MANY 3D ARTISTS NEVER FULLY MASTER MORE THAN THE LIGHTING BASICS OF KEY AND FILL LIGHTS. PARTLY THIS IS BECAUSE LIGHTING TOOLS PROVIDED IN MOST ADVANCED SOFTWARE ARE IMMENSELY DIVERSE AND POWERFUL; CREATORS HAVE AT THEIR DISPOSAL MORE LIGHT TYPES AND MORE WAYS TO VARY THOSE LIGHTS THAN ANY LIGHTING DIRECTOR WORKING ON A MAJOR MOTION PICTURE.

LIGHTING AND MOOD 1

LEFT: Lowering the ambient light level and adding a strong light brings out the sinister side of this otherwise emotionally neutral image by François Gutherz.

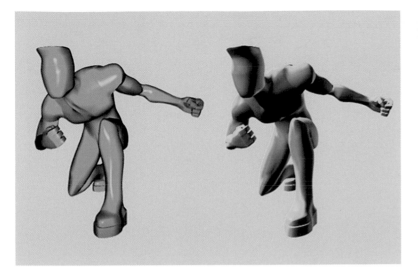

Fully understanding these tools and how to use them to full advantage typically involves a lengthy period of basic experimentation plus careful analysis of existing lighting setups. (The set-lighting maps published in filmmaker magazines such as *American Cinematographer* can be an important source of expert knowledge for students of 3D lighting.)

A simple lighting comparison created by *Matrix* animator Jeff Lew shows how lighting is instrumental in defining 3D form. Lew's case for proper lighting is airtight. At left, the figure is surfaced with a simple plastic texture and is uniformly lit. The body shapes are undefined, there are no shadows to add drama and mood, and funky deformations at the neck and upper chest are clearly visible. At right, the same figure

ABOVE: In this image from Jeff Lew's *Learning 3D Character Animation*, the figure on the right benefits from the simple application of a few spotlights that help define 3D forms.

is given a matte texture and is lit with several carefully positioned spotlights. The body forms can be read clearly, shadows add further definition and a sense of drama, and the less-than-perfect deformations are much harder to see.

The French animator François Gutherz is a dedicated experimenter with 3D lighting. His two studies of Smila show the dramatic effect of a single strong light. One image is lit with ambient light plus three spotlights (the shadows indicate their positions), and rendered with global illumination techniques. The mood is neutral, lacking in any strong drama or emotion. In the second image, the ambient light is removed and a light placed within the naked lightbulb provides powerful illumination. The second image is dark, moody, even sinister, although the content of the image is identical in every other way.

Another set of work-in-progress images from Gutherz provides a revealing perspective on light positioning. In his toons, Gutherz often seeks to create a sense of despair and isolation. His little *Mandarine World* character lies uncaring on his bed, in his cell-like room, illuminated by a single naked bulb. It is possible to see in both images a set of lines that define a cone spreading out from a light situated near the top of the bulb wire. This cone indicates the area affected by the light. Illumination is brightest near the center of the cone and falls off at the edges. The effect is to create harsh overhead lighting on the character and objects in his little cell, while leaving the upper corners of the room swathed in relative darkness. A simple light and precise placement does everything to define the scene's dark mood.

RIGHT: Illumination by a single overhead light creates a feeling of anomie and isolation for this Mandarine character, also by Gutherz.

LIGHTING IS KEY TO SETTING THE MOOD OF AN IMAGE, BUT IT ALSO CAN DELINEATE ASPECTS OF CHARACTER AND EVEN CREATE SURPRISINGLY DRAMATIC NARRATIVE ON ITS OWN. THE PROPER LIGHT SETUP CAN IMBUE A SCENE WITH A FEELING OF JOY, ISOLATION, STRENGTH, AND SO ON, ALL BY VARYING THE LIGHTS' ANGLE, INTENSITY, COLOR, AND FALLOFF (EDGE SOFTNESS). LIGHTS CAN BE SHAPED BY THE USE OF A GOBO (A "LIGHTING STENCIL"); FOR EXAMPLE, A GOBO THAT CREATES BARS OF LIGHT FALLING ACROSS A CHARACTER SUGGESTS IMPRISONMENT.

LIGHTING AND MOOD 2

Conflicts within a character can be externalized by the proper use of conflicting light sources. In animation, cross-fading lights can indicate a change in situation or scene. Keeping an area dark and then suddenly bathing it in light—a grand reveal—is the most dramatic way to unveil a major plot point. Lights can follow or precede the action as if they were characters themselves, lurking or prancing, commenting on the action, and giving the viewer information the actors do not have.

Despite the current emphasis on realism in CG lighting—many artists strive to reproduce as closely as possible the most subtle variations of natural illumination—for 3D toons it often pays to look at earlier sources of lighting technique. A simple theatrical light kit, just two spotlights, was used for magazine cover art featuring Dennis the dog. Dennis as puppet is strongly lit by a single pure white spotlight from above. Not only is he "on stage" and about to perform, but he also is under the control of a higher power, and the lighting dramatizes this. Dennis as puppeteer receives greenish underlighting, the traditional illumination for dominant or evil characters. The bright oval of light at puppet Dennis's feet serves to indicate his constrained range of movement, as do the parabolas formed by his wires; he is literally on strings of light.

Some story genres are closely identified with certain tricks of lighting. Noir, whether in comics, graphic novels, or animation, depends heavily on lighting shapes and shadows to produce its secretive, foreboding atmosphere. Simone the cat, from the *Java Noir* short films, is effectively highlighted by just one spotlight. Her shadow cuts suggestively into the spot's soft oval. A small additional spot emphasizes her

RIGHT: In this magazine cover, single spotlights provide uplighting and downlighting for Dennis and his self-puppet.

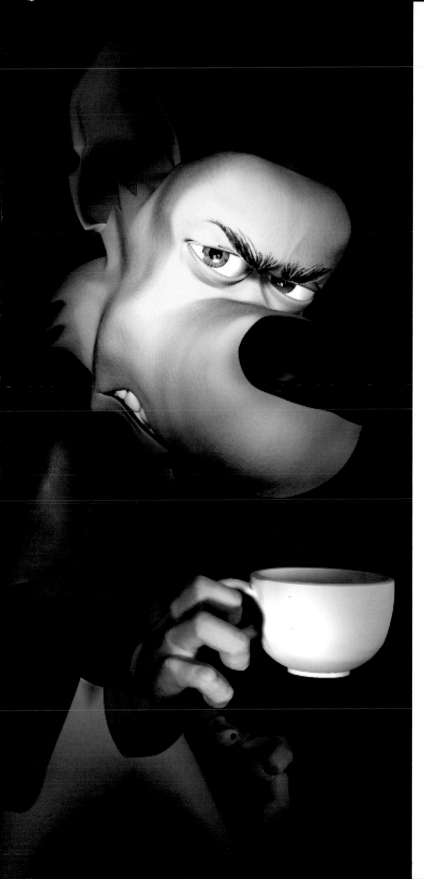

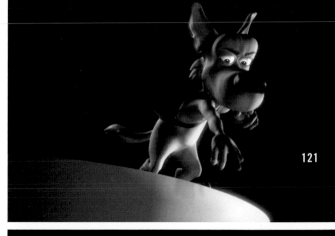

LEFT: The head-on lighting in this image emphasizes the character's harsh and confrontational expression.

ABOVE: A soft spot at a 3/4 angle gives Simone the cat a look both glamorous and noirish.

TOP: Rim lighting picks out Dennis from the black background. The glow was added in post-production with a simple Gaussian blur.

preternaturally long claws. In another *Java Noir* still, a strong revealing light picks out Dennis from the surrounding black. He casts no shadow, but the harsh contrasty illumination, which could be from a cop's headlights or the flash from a reporter's camera, is quintessentially noir.

Rim lighting is another theatrical and cinematic lighting technique that comes in quite handy in 3D cartooning. In rim lighting, a light is positioned behind the character so that the character's edge is illuminated. This is especially effective when the character is against a dark background. For animation, the light can be rigged so that it always automatically points at the camera but from the other side of the character. For this image, a glow was added in post-production to emphasize the rim effect even more.

IN CG, RENDERING IS THE REPRESENTATION OF A HIGH-LEVEL OBJECT—A MODEL—AS AN IMAGE FOR DISPLAY. TO ACCOMPLISH THIS, THE SOFTWARE REQUIRES A GEOMETRIC DESCRIPTION OF THE MODEL AND ITS SURFACE QUALITIES, A FULL DESCRIPTION OF THE LIGHT SOURCES AND THEIR LIGHT-SCATTERING PROPERTIES, AND THE LOCATION OF AN OBSERVER—A CAMERA VIEW.

RENDER STYLES 1

What that representation actually looks like is, nowadays, primarily a matter of artistic choice versus computing power, with more realism requiring more processor cycles. You can pretty much make your toon look any way you want, as long as you are willing to pay the computation price. A super-high-detailed look like that developed for Blue Sky Studios' feature *Robots* requires thousands of processors working day and night for months to crank out all the frames in the film. A simplified flat-shaded toon look that takes only a few seconds per frame allows all the frames of a feature to be rendered with many fewer processors, at much lower cost. Real-time rendering, made possible with high-end graphics hardware, eliminates the render-time issue altogether, as long as you are willing to live within the look restrictions imposed by the RT code.

CG rendering tech is evolving quickly, and because artists are always seeking an original visual style for their work, nearly all 3D toons produced to date have a unique render look. Even animations that ostensibly take place in the same story universe, with the same characters, will differ depending on when they were made. A canonical example of this inexorable evolution of render capabilities is the differences visible in Pixar's two *Toy Story* features. The second film looks distinctly more advanced and detailed, despite Pixar's deliberate efforts not to stray too far from the visual appearance of the first film.

With all the tweakability built into the standard 3D renderers in the major animation packages—these complex settings and tools guarantee job security for armies of technical directors and shader experts—and the availability of specialized plug-in renderers tailored to various looks (hard-edged ray traced, soft-edged global illumination, hand-drawn cel shaders), the options for artists are endless. (And the pitfalls, too; WYGIWYNTYH, or What You Get Is What You Never Thought You Had, is endemic in render development.) Only a few of the possibilities are included on these pages.

At the simple end is a series of stills from a low-budget educational video (*see right*). The look was meant to be like a drawing, with outlines around cheerful, flat colors, so a cel shader was used. Mike Sanderson also used a cel shader for his image of three menacing gunmen, rendered with heavy outlines and harsh illumination. The motorcyclist by François Gutherz occupies an interesting middle ground in render realism; a high-quality global illumination renderer, usually applied to architectural interiors and such, has been used to render exceedingly simple models, with intriguing results. This is much the same GI renderer as is used to image a mechanical dragon by the artist deboy. The dragon is so hard edged and hard surfaced that it could be a photographed plastic toy. No long-form animation has yet been attempted using this computationally expensive render technique, but it is only a matter of time.

ABOVE: These brutal killers, created by Mike Sanderson, are appropriately cel rendered in black and white with heavy outlines and harsh lighting.

RIGHT: Global illumination rendering can also generate a super-high-gloss look, as in this dragon by artist deboy.

RIGHT: Low-budget toons are well suited to cel-shaded rendering. The process saves on rendering time, and the results have a strong visual clarity.

RIGHT: An unusual example by François Gutherz of the use of a high-end global illumination renderer for a low-detail scene.

EVOLVING A CONSISTENT LOOK FOR A 3D TOON CAN TAKE CONSIDERABLE TRIAL AND ERROR. A LOT OF THE WORK IS IN TEXTURING, WHICH WE HAVE ALREADY DISCUSSED, BUT RENDERING BRINGS UP A WHOLE NEW REALM OF CHOICES. EVEN IF THE BASIC APPROACH AND LEVEL OF REALISM HAS ALREADY BEEN DECIDED, THERE ARE MANY SMALLER DECISIONS TO BE MADE THAT END UP HAVING A LARGE EFFECT ON THE FINAL IMAGE.

RENDER STYLES 2

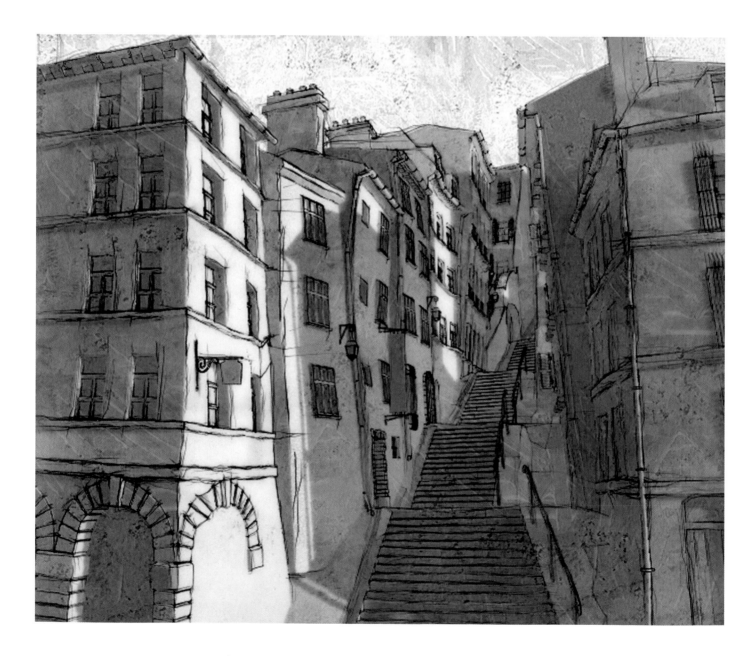

The artist is presented with numerous options for such (often obscure) aspects as shadow edge quality, motion blur passes, fog falloff, and volumetric lighting, not to mention more image-processing oriented-adjustments such as contrast, color space, film grain, and various artistic filters that make the image look like it was created with a traditional art medium such as watercolor.

French animator Yves Dalbiez and his collaborators used Alias's Maya software to develop a unique look for the world of their short film *Riba*. Several stages are shown on

final work, was to give the image a hand-painted look (in fact, the textures were created in Adobe Photoshop). Streaks of color suggest gouache and scratched cray-pas over pen-and-ink. This could be a scene whipped up by a skillful street artist like Georges Jamet; it is exactly the antithesis of the typical plastic 3D look. Another view up the street suggests even more clearly the cheerful morning light, mellow city colors, and human scale of the scene. Dalbiez's careful choices at render time have resulted in an unmistakable visual style for his first major directorial effort.

these pages. The model of the charming street stairs and 19th-century buildings is in fact based on a real location in Lyons, "deformed according to our sensitivities," as Dalbiez says. A wireframe stage shows the scene before any texturing or lighting; it's easy to see where artistic license has been taken with the geometry.

Lighting tests mark the next important stage of look development. "The aim," notes Dalbiez, "was to find a morning environment." Soft-edged shadows clearly show that the light is coming from a low angle, as it would early in the day; the bright quality of the lit areas is also more typical of morning than evening. Note in this lighting test that 3D details pop out much more obviously; for example, window and drainpipe forms read more clearly than in the wireframe.

Once lighting is set, further renders are attempted with textures applied. The aim, successfully achieved in the

ABOVE LEFT: The wireframe render of a street scene, from the short film *Riba*, directed by Yves Dalbiez.

ABOVE RIGHT: A lighting test to determine the angle, degree, and intensity of lighting.

LEFT: The final frame, with rendered textures.

RIGHT: A later frame from the sequence, with even clearer detail of shadows and wall textures.

TOONS ARE SELDOM RENDERED OUT IN A SINGLE COMPLETE PASS. MORE OFTEN, SEVERAL PARTIAL IMAGE ELEMENTS ARE COMPOSITED OR LAYERED TOGETHER TO MAKE A COMPLETE FRAME. THIS LAYERING TAKES PLACE IN A SEPARATE COMPOSITING PROGRAM SUCH AS APPLE'S SHAKE OR ADOBE'S AFTER EFFECTS.

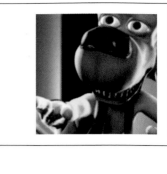

COMPOSITING

FAR LEFT: This background for Richard Rosenman's *Sammy the Intergalactic Troublemaker* required several layers of color and blur effects.

LEFT: A global illumination (GI) layer controls the degree of ambient light on Sammy's surface.

BELOW FAR LEFT: The color layer; Sammy's skin was rendered with micro-triangle displacement technology in conjunction with conventional bump mapping techniques.

BELOW LEFT: Note the additional edge glow effects, each of which was on its own layer, in the final image. Sammy was modeled and textured with Discreet's 3ds max, rendered with Chaotic Dimension's VRay 1.09, and composited in Adobe Photoshop.

Think of a composite as a stack of glass panes with different but related artwork on each. Higher panes always affect the appearance of lower panes, and various effects can be applied to each pane. From the top, you can see the combination of all the images on the panes. Now imagine that each pane has its own movement. A camera, which can itself move, is mounted above the panes and photographs them as they move. Assemble that in your mind, and you have a good approximation of how compositing software works.

Why take the extra steps of compositing? The animator might be called upon to layer animated characters over a separate 3D set or background plate supplied by an outside source. It is often easier to blur some elements of a shot for depth of field if those elements are on their own separate layer. Or the animator might anticipate the need to paint out rendering problems, add a new object or a special effect, or achieve certain special lighting effects that are difficult to do another way. Seamless and convincing are the operative concepts here. Subtly wrong details of an edge, movement, color, or texture produce a "pop-out" effect in which poorly composited elements look like paper cutouts. Modern rendering systems take care of some of these "human error" problems because they can be set to automatically render out each lighting or object channel of the animation as a separate image sequence (meaning potentially dozens or hundreds of images for each frame of animation). These sequences can be modified as needed in the compositing program and still align perfectly (which doesn't always happen otherwise).

The sequence with Dennis the dog against the pillared background is a simple example of compositing. The background and the character are rendered as separate layers with alpha (transparency) channels, then comped together to make a single image. The aim is to create a depth-of-field effect without the computational cost of actually doing this in the 3D scene. Instead, a simple 2D blur filter is applied just to the background with the compositing program, faking the effect that the background is far away and therefore beyond the focus range of the lens.

Richard Rosenman's *Sammy the Intergalactic Troublemaker* was rendered in multiple layers for maximum compositing control. There were seven layers in total for the final composite, several of which are shown here. The background alone was produced from three separate layers: two gradients and a heavily blurred depth-of-field abstract scene. In addition, there was the main character layer, a global illumination layer (controlling the indirect or ambient light distribution in the scene), a diffused soft glow, and a harder edge glow that can be seen along the left edge of the character.

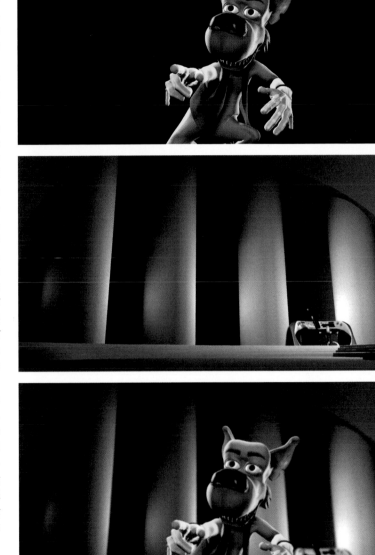

ABOVE: Composited layers show how background and foreground are combined in post-production. A blur has been added to the background to create a depth-of-field effect.

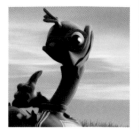

SET PIECES: THE RACE

I'm Walking, a great CG commercial from The Soulcage Department, has all these elements. Soulcage is a group of five young diploma designers from Germany—Elmar Keweloh, Joachim Bub, Michael Meyer, Martin Ernsting, and Wilhelm Landt—who in the last few years have made a name for themselves as transmitters to CG of the authentic toon esthetic. The *I'm Walking* spot was funded by the German ministry of agriculture as a promotion for organic chicken products. The plot is simple: a hurdle race in which a healthy and fit chicken from an organic farm wins against its less-healthy competitors coming straight from a laying battery.

When producing a commercial, the agency and client typically call the shots, but Soulcage was allowed considerable creative input on *I'm Walking*. "Due to its cool producers, the Braunmuehl Brothers," says Keweloh, "we had great freedom in all stages—from the first sketches to the last rendered frame. More or less we were co-directing the spot. Our own roots are classical illustration, design, and cartoons, so the pre-production of any of our projects gets a lot of our affection. That means we take great care to craft appealing character designs and detailed storyboarding."

BELOW LEFT: Free-range versus ordinary chickens compete in Soulcage Department's commercial spot *I'm Walking*. Each character represents an extreme of body design and behavior.

BELOW RIGHT: Thousands of cheering fans line the balconies of the laying towers. Soulcage rendered different groups of cheering chickens from a front view and applied these rendered animations as decals on planes, which then were positioned on the balconies.

Greatly aiding the spot is the fact that the chicken is one of those animals that most people find inherently funny. "Our aim," Keweloh adds, "was to design as many different freak chickens as possible—which was pretty funny! Gero (one half of the Braunmuehls) called us after we sent him our first sketches: 'Guys—the kids I showed your drawings to didn't recognize them as chickens!!' So we knew we were going in the right direction."

Underlying any toon race, including the one in *I'm Walking*, is an age-old logic and rhythm of gags. In the classic *Wacky Racers* manner, each chicken competitor is carefully individualized, with its own body type and its own special "crash." One scrawny crook-necked bird keels over at the starting gun. Another, artificially fattened for the market, can barely lift off the ground. As a result it collapses at the very first hurdle. The only nonorganic chicken who stands a chance of winning is, of course, the villain, inevitably undone by his own foul play. When the finishing tape is broken, the confident winner carries off the trophy into the all-natural sunrise, in a green track sweater that for a German audience would have both an ecological and a political resonance.

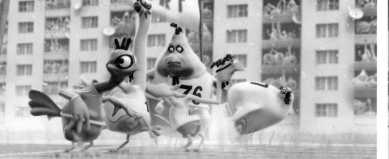

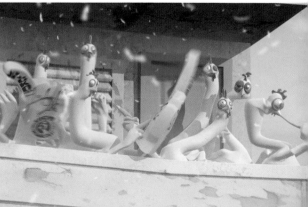

RIGHT: Heading for the first hurdle. Wacky Racers tradition requires that the bird on the right will lose his spectacles.

BELOW: Illegal comb pulling doesn't help the villain of the piece prevail. Note the extreme stretch on the chicken's neck.

BELOW RIGHT: A photo finish—effect added in post-production—shows the all-natural winner flanked by hapless losers.

BOTTOM: One of the best gags has this apparently jet-propelled hen smash uncontrollably into the hurdles.

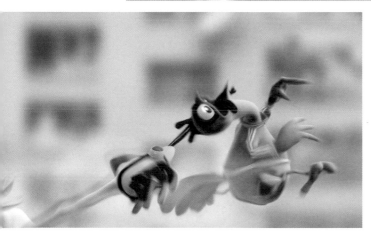

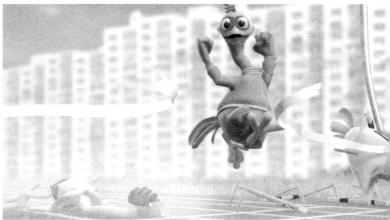

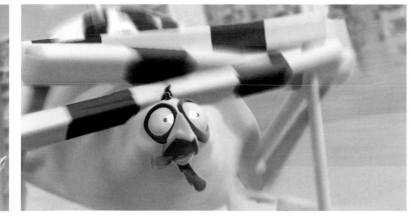

For Soulcage, post-producing *I'm Walking* was both a blast and a race of its own. "It was funny as hell," recalls Keweloh, "us all gathering around the microphone, cackling and clucking our brains out—we couldn't speak for days afterward. But, as always, the last days and nights before the final deadline melted together to become a mash of hours, minutes, and seconds. We'll always work obsessively until the very last minute on an ambitious project like this, because it's the only way to realize your vision the closest you can."

IF TOONS AREN'T CHASING EACH OTHER AROUND, THEY MIGHT BE FOUND BEATING EACH OTHER UP. AS A CARTOON ELEMENT, COMBAT IS A SURPRISINGLY RECENT DEVELOPMENT (AS OPPOSED TO CARTOON VIOLENCE, WHICH IS INTEGRAL TO THE ART). ITS ARRIVAL HAS BEEN FUELED MAINLY BY THE GROWTH OF SUPERHERO CARTOONS IN THE LATE 1970S, THE RELAXATION OF STANDARDS FOR DEPICTING VIOLENCE ON FILM AND TV IN THE 1980S, AND THE EXPANSION OF ANIME TO A WORLDWIDE MARKET IN THE 1990S. IT'S HARDLY LIMITED TO BOY TOONS, EITHER, AS ANY FAN OF CARTOON NETWORK'S *POWERPUFF GIRLS* CAN TELL YOU.

SET PIECES: THE BATTLE

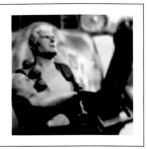

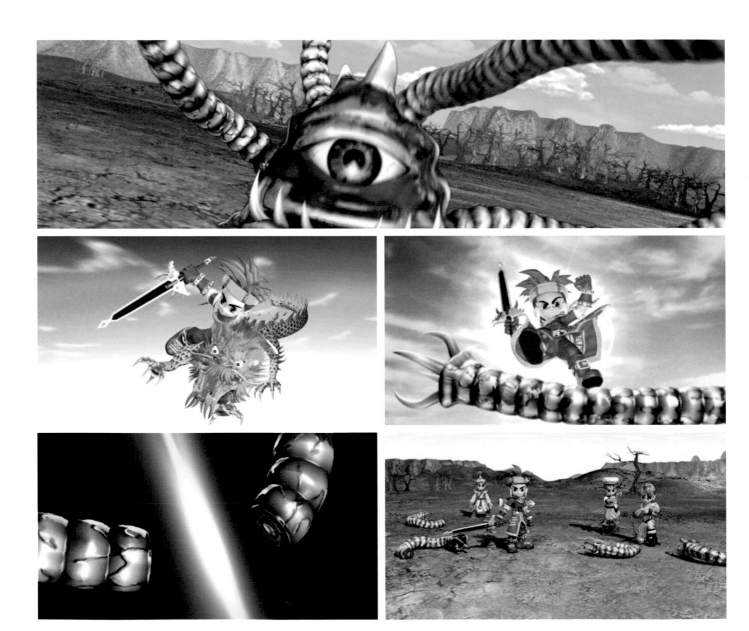

Battle scenes are great fun for animators who excel at physical action—they offer scope for playing with extreme poses and devising intricate, kinetic choreographies, and there's a wealth of reference material to draw upon (many an animator has spent hours watching Jackie Chan flicks as "research"). What's more difficult is to create original combat action that avoids the standard clichés. Extended face-offs between rivals have been a staple of combat action since *The Iliad*, and anime is positively stuffed with such scenes. In *GI Joe: Spytroops*, Reel FX Creative Studios wanted an encounter between two ninjas, the noble GI Joe ninja Snake Eyes (in black) and the evil Cobra ninja Storm Shadow (in white). As in any good battle, the two deadly adversaries—both from the same ninja clan—cannot be restrained from attacking each other on sight, swords drawn. Glowing speed lines (masquerading as laser bolts) and low, low camera angles emphasize their impossibly high ninja jumps, whereas subtle differences in their poses—Storm Shadow has a more clenched pose; Snake Eyes' body is graceful and open—indicate their different moral levels.

Action-oriented games are a trove of combat sequences; simulated battle is the reason for most games'

existence, after all. A series of cut-scene screens from the Chinese console game *Five Lucky Star*, designed by Antony Wong, shows typical monster-battle dynamics. In this scene, the hero uses his special sword to defeat a one-eyed tentacled monstrosity. There are only two ways to kill such a creature: stab it in the eye, or chop it to bits. Option two is chosen; the hero leaps off his dragon, slices through the tentacles—a close-up showing chopped tentacle interior is de rigueur—and surveys the remains.

Bigger battles pose their own problems. How do you create hordes of combatants with a limited budget? The high road is to generate artificially intelligent crowds of CG actors—bots, vehicles, orcs, or what-have-you, each interacting with its neighbor, but with a degree of unpredictability. The cheaper approach is to use cloned elements. Fully animated "hero" characters and vehicles carry the eye through the shot; background elements are low-resolution "proxy" models that require less computation to render. Establishing a rhythm of elements—large vehicles alternating with marching regiments, fast-moving aircraft layered over slower-moving armored companies—adds vitality and excitement. Making sure big shots don't last too long, so the eye doesn't have time to notice cheats, is also a key "low-road" technique, as is obscuring areas of the action with explosions, dust clouds, and other atmospheric effects.

LEFT: Chopping up a monster is all in a day's work for the heros of the Ace Brock Computer game *Five Lucky Star*.

ABOVE: Classic anime ninja combat, CG-style: Storm Shadow from the ReelFX/Hasbro feature *GI Joe: Spytroops*.

BELOW: Major battle scenes in *GI Joe: Spytroops*, were constructed from layers of cloned battle bots and vehicles.

BELOW: Clouds of dust, added in post-production, help obscure the fact that the background battle bots are copies of foreground ones.

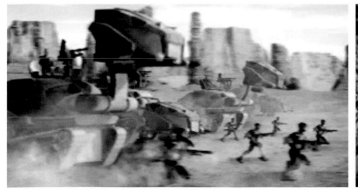

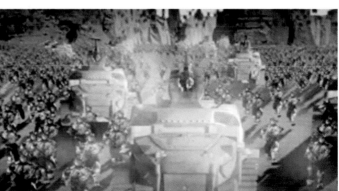

TOON MEDIA

OPTIONS, ALTERNATIVES, AND OLD-SCHOOL TECHNIQUES

BEYOND BASIC TOONS —

6

CEL ANIMATION TECH AND ART DEVELOPED MAINLY VIA THE PRODUCTION OF SHORT FILMS, AND CG ANIMATION HAS FOLLOWED MUCH THE SAME PATH. MANY OF THE EARLY 3D SHORTS ARE SHORT INDEED; SOME OF THE EXPERIMENTS BY ROBERT ABEL AND OTHERS IN THE 1970S AND '80S LAST A FEW SECONDS, AND WERE BETTER SUITED TO INSERTION IN TV COMMERCIALS THAN TO SCREENING ON THEIR OWN.

THE ANIMATED SHORT

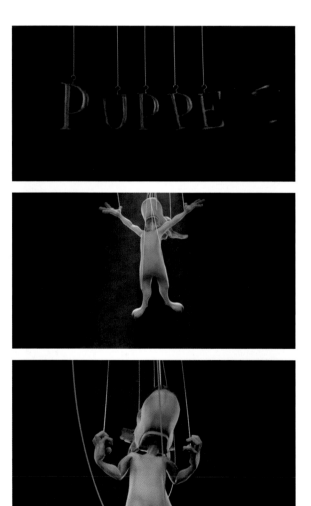

Even Pixar's early shorts, in which so much of today's 3D tech was developed and which do have complete little stories to tell, are much briefer than the standard 2D toon's seven minutes. (*Boundin'*, Pixar's latest short at the time of this writing, does reach the seven-minute mark.) This is a good indicator of just how hard 3D animation actually is, if one is needed—all those minutes take immense effort to create. It also shows that length doesn't really matter; art does.

Today, there is more 3D short-form animation in circulation than any one person can possibly view. Students taking 3D animation courses at the better schools are required to produce a short, or at least work on one. Talent scouts at the major studios screen reels endlessly and snatch up the best talent. Every working animator, it seems, has a personal short on the web, or one in production, or at least a character or two that might work in a short, if only there was some spare creative time. New studios hustle to get a short out on the CG talk boards, strutting their stuff before prospective clients and rivals. Established studios produce shorts to compete for awards, to extend the lives of characters seen in past feature films, or to satisfy the personal storytelling urges of key creative personnel. This flowering of the animated short not only represents a prime example of a creative renaissance powered by technological innovation, but is also a powerful democratizing force, extending to all levels of the heavily interconnected CG world.

Sometimes short films get made for reasons that initially have nothing to do with the desire to create art. Anzovin Studio's *Puppet* grew out of the need to test a planned software product, an automated character rigging system. The best way to do this was to take a rigged character and animate it through some extreme poses. From there, it was only a short step to deciding to make a short. The concept of a puppeteer and marionette was inspired by magazine cover art we'd done a few years earlier, and finding just the right music—*Funeral March of a Marionette*

LEFT: Several title concepts were tried and abandoned before this version, where the letters swing down and jostle one another.

RIGHT: A strong poster is an important asset for any short.

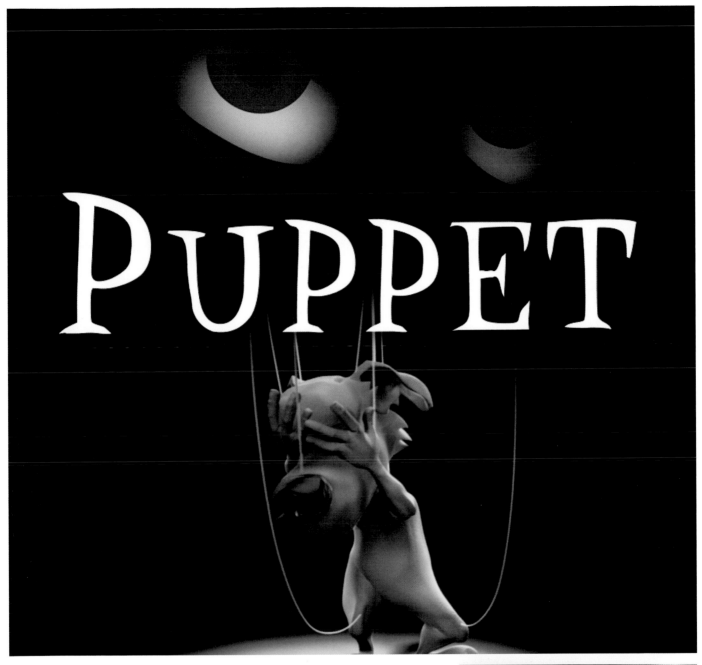

PUPPET

by Gounod—helped pull together the sequence of actions. A pose reel was used to figure out the timing and character poses; then the individual sequences were farmed out to animators in the studio. Production of the two-minute short took about two months. The title animation (all good shorts need an eye-catching title sequence) was the last to be created. A poster and a web page later, and *Puppet* went out to join the river of bright new animation.

CUT SCENE ANIMATION (SOMETIMES CALLED CINEMATICS) IS DISTINCT FROM WHAT'S CALLED IN-GAME ANIMATION, THE MOVEMENT YOU SEE AS YOU ARE PLAYING THE GAME. IN-GAME MOVEMENT IS MAINLY CYCLES—WALKS, RUNS, LEAPS, WEAPONS FIRING, GORE SPLATTERING, AND SO ON—THAT CAN BE LINKED TOGETHER AND PLAYED IN NONLINEAR SEQUENCE ACCORDING TO THE DEMANDS OF THE GAME ENGINE.

GAME CUT SCENES

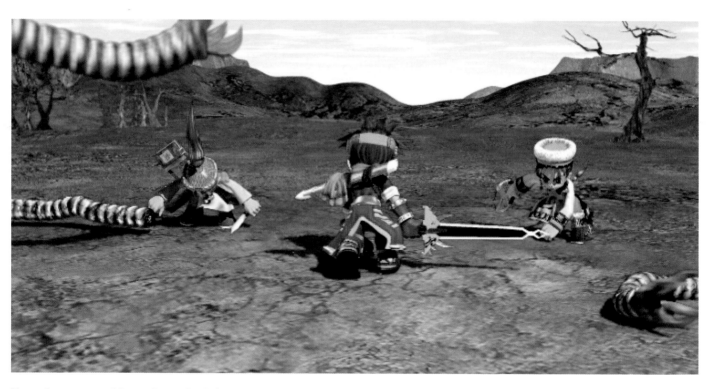

Players learn to control the motion cycles their own character is capable of and predict the movements of their opponents. By contrast, cut scenes are animated without excessive use of cycles and other animation shortcuts, and are usually as cinematic as it is possible to make them. They are in fact like little minimovies embedded at strategic points in the game, starring the same 3D assets—characters, environments, and so on—but immune to player interaction.

Why have a cut scene? Why not just fold the action into the game play? Game designers have found that sometimes you want to convey information to the player without distractions. The most obvious place is at the start of the game, when it's time to set up the plot and game premises and

ABOVE: Cut-scene animation may closely resemble the in-game motion, using the same models, environments, and other 3D assets. A frame from Ace Brock's *Five Lucky Star.*

demonstrate how to play. Other likely times for cut scenes are when the player jumps up a game level. Or the player may need to "overhear" some plot-important conversation or event or situation, and a cut scene is the most effective way to handle this. Such plot turns can occur throughout a complex game.

Finally, cut scenes showcase the animation mojo of the game developer. Game studios like Avalanche, Oddworld Inhabitants, and Eidos lavish considerable effort in making great-looking cut scenes for their creations. Some have boasted that the assets created in the course of game development are sufficient to create an animated feature film. SquareSoft used the superior cut-scene and in-game animation in its Final Fantasy series of games as a base from

BELOW: One of the characters in Avalanche's console game *Tak and the Power of Juju* has been turned into a sheep by evil magic.

RIGHT: An unrendered cut-scene sequence from the unreleased game *The Red Star*, based on Christian Gossett's comics universe. Cinematic excitement is key to most cut-scene animation.

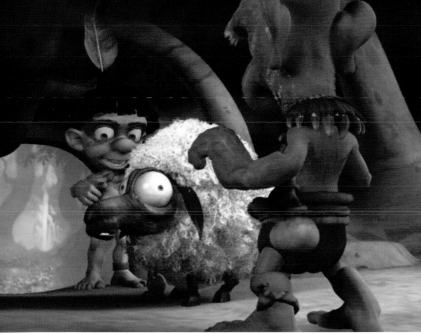

which to produce the film *Final Fantasy: The Spirits Within* (2001). Unfortunately, a movie's story and acting requirements are different from those of a game—a point Square failed to grasp— and although *Final Fantasy* was the most real-looking 3D film of its time, it was a dismal work of cinema.

Unlike with animated movies, which are rarely canceled once begun, bad luck or bad planning may mean that great cut-scene animation may never be seen by the public. Case in point: the eagerly awaited *Red Star* game, based on Christian Gossett's highly popular and imaginative Soviet-fantasy comics universe, was sent to limbo when the game developer, Acclaim, announced bankruptcy in 2004, shortly before the project was completed.

BEGINNING IN THE LATE 1990S, THE RAPIDLY INCREASING POPULARITY AND GRAPHIC SOPHISTICATION OF COMPUTER GAMES CREATED A SPIN-OFF INDUSTRY OF OPEN-SOURCE AND COMMERCIAL GAME-CREATION ENGINES. WITH A GAME ENGINE, SAVVY GAMERS COULD MAKE THEIR OWN MONSTERS, LEVELS, AND EVEN ENTIRE GAMES IN THE STYLE OF THEIR FAVORITE SHOOTER, SUCH AS *HALF-LIFE* AND *UNREAL TOURNAMENT*.

MACHINIMA

The game engines themselves also went through a rapid evolution to make them more user-friendly for non-programmers; their simplified production interfaces tapped into the intricate underlying code of the game without requiring a great deal of technical know-how.

It did not take long for 3D animators, many of whom are also devoted gamers, to realize that game engines also could be used to create animated cinema. ("Quake movies," made by fans of the early Quake game engine, started appearing as early as 1997–98.) This new animation process, dubbed *machinima* by its practitioners, employed existing game-creation tools but substituted a predetermined linear story line for a game's typical interactivity and branching action.

The real appeal of creating film with game tools is that much of the animation work is performed by the software. Instead of painstakingly modeling environments and keyframing characters, the artist uses automated level-building tools and employs cameras, characters, and motions provided by the game engine. Moreover, the game engine uses the host computer's video card to render out the machinima in real time; long rendering times and expensive renderfarms are not needed. Another major draw of machinima is that the final work can be distributed, not as a huge video or film file, but as a small executable that can be run by viewers who also possess the appropriate game engine. Machinima is thus well suited for distribution over the web.

"Look on my works, ye mighty, and despair!" In Strange Company's machinima animation *Ozymandias*, a traveler views the shattered remains of an ancient monument.

MACHINIMA 2

ABOVE: A tender moment from Strange Company's *Steelwight*. Facial expression is one of the hardest things to accomplish with machinima, as many game engines do not include well-developed facial animation tools.

ABOVE RIGHT: The machinima drama *Rogue Farm*, produced for Scottish television, will be rendered in a manga (Japanese comic book) graphic style.

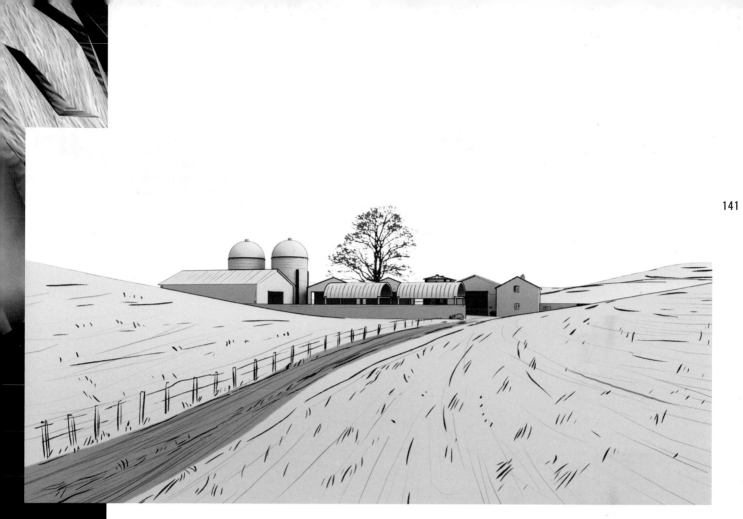

RIGHT: The lonely traveler crosses the ancient desert in Strange Company's *Ozymandias*.

The technological advantages of machinima are also its artistic dangers. Overdependence on built-in game scenarios (and, perhaps, a worldview constrained by excessive game playing) makes for too many machinima dramas in which moody characters roam dark corridors. But high-quality work is not hard to find. Strange Company (www.strangecompany.org), founded in 1999 by Scottish filmmakers Hugh Hancock and Gordon McDonald, has created a number of unusual machinimas with a literary flavor. *Ozymandias* (2002) gives a machinima spin to Shelley's famous poem, as a modern traveler encounters a crumbled monument to an ancient king. Other Strange Company works are based on the stories of H. P. Lovecraft and the modern sci-fi author Charles Stross.

"Machinima as an artform is still in its infancy, with only a small number of devotees," says Hancock. "But it has evolved over the past seven years from a toy for game hackers to a third way of making films distinct from both video and animation. But what's really exciting is where it's going to go next, as games technology continues to advance."

Hancock and others are now driving machinima into mainstream animation production. In March 2004, Strange Company began production on *Rogue Farm*, a 24-minute drama that is the first machinima programming created for broadcast TV. It's a sure bet that many future cartoons will, at bottom, be games as well.

BETWEEN THE WORLDS OF 2D AND 3D LURKS THE TRANSITIONAL REALM OF WHAT CG ARTISTS CALL 2.5D. THIS IS CONVENIENT SHORTHAND FOR A COLLECTION OF TECHNIQUES WHEREBY 3D CG IS USED TO EMULATE THE LOOK OF 2D GRAPHICS. OFTEN THIS IS AS SIMPLE AS USING A 3D ANIMATION PROGRAM'S CEL SHADER TO MAKE THE 3D ANIMATION LOOK FLAT AND HAND DRAWN—NOT THAT ANY CEL SHADER IS QUITE GOOD ENOUGH TO BE FULLY CONVINCING IN THIS WAY—BUT SOME CG ARTISTS HAVE FOUND MUCH CLEVERER MEANS TO EXPLOIT THE UNIQUE OPPORTUNITIES OF 2.5D.

TWO-AND-A-HALF DIMENSIONS

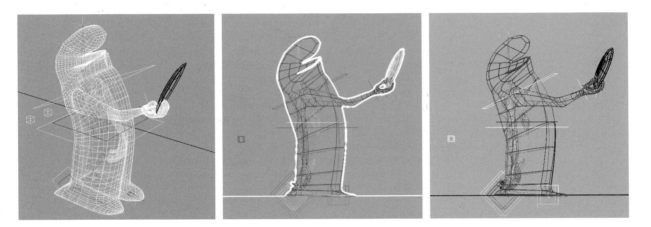

Case in point: this technological updating of La Linéa, the series of award-winning animations by veteran Italian cartoonist Osvaldo Cavandoli. Cavandoli's concept was breathtakingly simple: each toon is composed of nothing but a single infinitely flexible white line on a flat colored plane; the line warps and buckles to form characters, objects, and whatever else the artist requires. Achieving this required some serious mental housecleaning. "One day I cleared up my desk and also threw out everything from my head that bound me to the past," recalled Cavandoli in a 1999 interview. "I stared at the blank paper and started to doodle. When I regarded the lines, I found that the best idea was to reduce everything to only one line, and with this line tell all that I wanted to express." Cavandoli's linear everyman caught on and eventually became Europe's best-known animated character, appearing in more than 80 TV commercials and shorts between 1969 and the 1990s.

La Linéa's intrinsic, fundamental simplicity—it could even be called a 1.5D cartoon, seeing that it appears to exist somewhere between the one-dimensional world of the line and the two-dimensional plane—would seem to be a particular impediment to anyone trying to recreate it in 3D software. But Israeli animators Oz Adi and Raz Oved handily conquered that issue. Their 3D version of the La Linéa man is rigged, modeled, and animated like an ordinary CG character; what's unusual is how the scene is rendered for the final short.

A white, flat, self-illuminated texture was applied to the character and the cube model of the floor. At output time, a contour shader was used that rendered only a white outline or silhouette of the scene—and that silhouette is the only thing that appears in the final. The animators tweaked the width, color, and variation of the contour as they sought to approximate the look of Cavandoli's original.

The result is nearly indistinguishable from the original La Linéa—except that it looks a bit too perfect. No 3D shader, however cleverly specified, has the hand-drawn spontaneity and individuality of penstrokes by a master draftsman like Cavandoli.

ABOVE: Israeli animators Oz Adi and Raz Oved built a new version of Osvaldo Cavandoli's classic La Linéa man using Softimage's XSI. Note the heavy white outline: this is a silhouette produced by a contour shader and is the only thing rendered to produce the final image.

RIGHT: The rendered version looks remarkably like the original hand-drawn La Linéa. Variations in line width are the product of settings provided by the contour shader.

AS HIGH-SPEED WEB CONNECTIONS HAVE BECOME COMMONPLACE, SO HAS WEB ANIMATION. THE RAPID INSTALLATION OF BROADBAND HOOKUPS HAS INCREASED THE APPEAL OF 2D ANIMATION, AND CONFIRMED MACROMEDIA'S "FLASH" FORMAT AS THE DE FACTO STANDARD FOR WEB-BASED TOONS. WITH NO STRONG COMPETITOR ON THE HORIZON, AND NO AGREEMENT ON A WEB FILE FORMAT FOR 3D ANIMATION, MANY 3D ARTISTS HAVE PREFERRED TO INTEGRATE THEIR IMAGERY INTO THE 2D FLASH ENVIRONMENT.

FLASH 3D

Many 3D Web standards have been proposed, including Macromedia's Shockwave 3D and Adobe's Atmosphere, but toon artists—who don't really need to create interactive environments—still prefer the 2D Flash environment. A common approach is to render out 3D animation frames in a cel-shaded style that looks like typical Flash work, convert them to the vector-based format that Flash uses by an automated tracing process, then layer the traced frames into a Flash animation.

The Italian multimedia studio Officine Pixel (www.officinepixel.com) used a version of this technique to create its award-winning web animation *Fivezerozero*, one of the more accomplished and amusing meldings of 3D and Flash. In this five-minute spoof of Kubrick's epic *2001: A Space Odyssey,* director Lamberto Tedaldi, with collaborators Claudio Tedaldi and Davide Romboli, suggest that some well-known, old-millennium Italian technology may still have a place—albeit not an entirely reliable one—in the new-millennium exploration of space. According to Lamberto Tedaldi, *Fivezerozero* deals with the theme of the new technologies (real and mythical) and science fiction in a

paradoxical key. It is ironic about the Italian contribution to the International Space Station, presenting the old Fiat 500 as a sophisticated alternative to the space shuttle.

Several key elements in the animation, notably the space station and the Fiat, were built, animated, and rendered in 3D using discreet's 3ds max software. (It's particularly useful to use 3D to animate rotating mechanical objects, which are hard to draw accurately in 2D. Disney pioneered this technique as early as 1986 in *The Great Mouse Detective*, and it is now used universally in cel-animated 2D work.) Each frame of 3D animation was then imported and auto-traced in Flash. The final images were produced using several layers of 2D backgrounds, foreground elements, and mattes. Characters are mainly 2D, animated with a real feel for weightless motion. Especially notable is the use of reflections to add verisimilitude to the action.

But what really distinguishes *Fivezerozero* is not only its seamless use of 3D, but the piece's graphic sophistication (rare in the often-crude Flash animation world) and its clever inversion of Kubrick's narrative of technological and moral evolution.

OPPOSITE PAGE
TOP ROW: *Fivezerozero* begins on the International Space Station. Astronauts (created in 2D) review the landing sites.

MIDDLE ROW: The Fiat 500 "Topolino" ("Mickey Mouse") still has its place in the new millennium. Earth is reflected in the astronaut's visor as he prepares for reentry.

BOTTOM ROW: The Fiat begins its return to Earth. Man returns to his violent beginnings when a flat tire grounds the reentry vehicle.

ABOVE: Passing through the atmosphere, wipers are required.

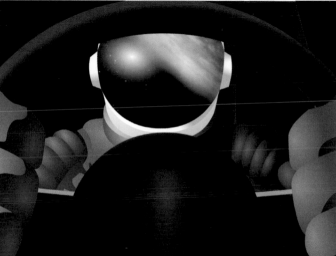

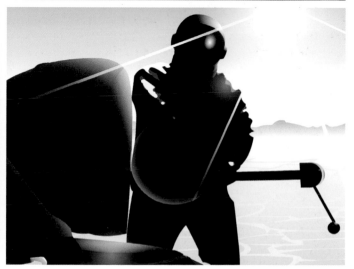

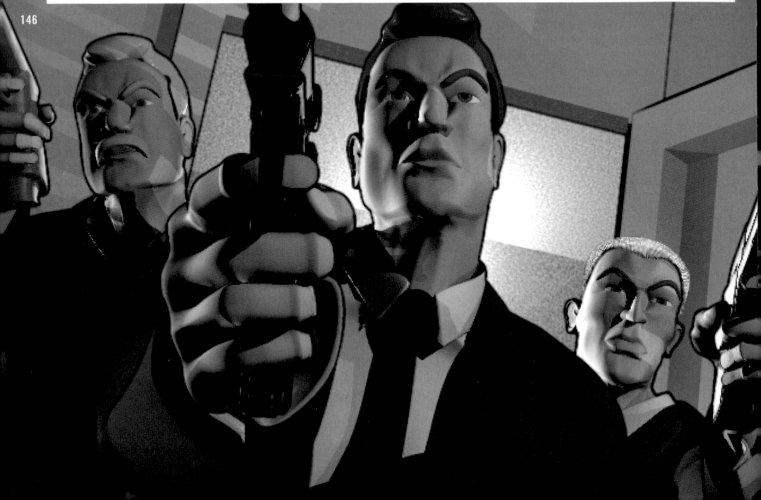

3D IS CHANGING THE CLASSIC COMIC BOOK, BUT THAT EVOLUTION IS PROGRESSING AT A SURPRISINGLY DELIBERATE PACE. THE ADVANTAGES OF 3D FOR COMICS CREATION—THE ABILITY TO SET THE POINT OF VIEW ANYWHERE IN THE 3D WORLD AND HAVE ALL THE ISSUES OF CAMERA AND PERSPECTIVE TAKEN CARE OF, THE QUICK POSABILITY OF CHARACTERS, AND ABOVE ALL THE FACT THAT THE ARTIST DOESN'T HAVE TO KNOW HOW TO DRAW—TEND TO BE OUTWEIGHED BY THE DIFFICULTY OF BUILDING 3D ELEMENTS AND CHARACTERS IN THE FIRST PLACE.

3D COMICS 1

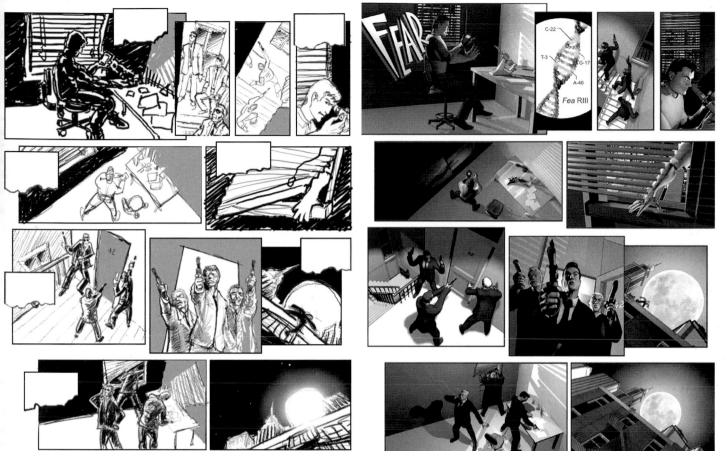

3D also does not lend itself easily to the graphic conventions of comic art. The spontaneous squiggles of ink that so efficiently indicate facial expression in a hand-drawn comics character, or the extreme foreshortenings and distortions of typical superhero poses, are very difficult to reproduce in 3D. So 3D characters can look stiff in comparison to their drawn counterparts. Finally, many top comics artists have committed years to the honing of their 2D layout and drawing skills, and are reluctant to adopt 3D tools and ways of thought. That is likely why no major comics title has yet moved to 3D.

Comics artists who venture into 3D have a range of options: to use 3D solely as an aid to visualization (for example, building a city environment, then viewing it from various angles to act as a guide for hand-drawn backgrounds); to composite rendered 3D elements such as cityscapes, spaceships, or the like with hand-drawn characters; or to create the entire comic in 3D. So far, relatively few artists have chosen option three, and, generally speaking, those who have have not been completely successful. Scott Sava's 3D treatment of *Spider-Man* is one exception.

Mike Sanderson, an American artist with extensive experience as a graphic designer, character modeler, and animator—just the right mix of skills for success in 3D comics creation—crafts a strong 3D look in this promotional panel for *Fear*, a modern noir novel. *Fear* is a dark tale of intrigue and suspense, so Sanderson has employed an array of film noir compositional elements. He emphasizes the strong interplay of light and darkness, uses high and low angles to frame each panel, and defines his characters through silhouette and shadow. "In the classic black-and-white noir movies," Sanderson says, "the contrasts and tensions between light and shadow were uniquely utilized to create the mood for each scene. One of my favorite effects is that of light diffused through blinds, introducing unusual patterns of shading. Low and high views and deep spaces generate dynamic compositions, while adding to the ominous and threatening situation unfolding in the sequence." Not all of Sanderson's inspiration came from movies, however. He also looked at *DareDevil* as drawn by Gene Colin in the 1960s, and the classic 1970s *Batman,* as drawn by Neil Adams.

HERE WE'LL LOOK AT THE EVOLUTION OF A SINGLE COMICS PANEL FROM MIKE SANDERSON'S *FEAR* (DISCUSSED ON THE PREVIOUS PAGES). IT'S INSTRUCTIVE TO SEE HOW SMALL DETAILS, ACCUMULATED IN STAGES, ADD GREATLY TO THE PANEL'S SENSE OF VITALITY. THIS PANEL SHOWS THE THREE GUNMEN POUNDING UP THE STAIRS EN ROUTE TO THEIR HIT. "THE CHARACTER DESIGNS WERE INSPIRED BY THE AGENTS FROM *THE MATRIX* FILMS, THE G-MEN OF *THE UNTOUCHABLES*, *MEN IN BLACK*, AND OTHER GUN-WIELDING, SUIT-WEARING TOUGH GUYS FROM CLASSIC FILMS," SANDERSON SAYS.

3D COMICS 2

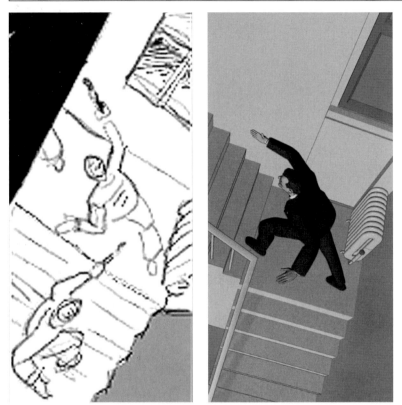

Version A shows a low-res scan of Sanderson's original pencil sketch. The basic visual concepts are there: a wide lens; a steep overhead down angle; the stair landing providing a centerpoint for the composition; the three figures leading the eye (and imagination) up to the coming deed.

Version B translates the sketch concepts into 3D. Sanderson is working here to find the exact camera and figure placement, which are already significantly different than in the drawing. He's positioned the middle figure first (because the poses and placement of the others depend on where the middle guy is), but note that the figure is not yet fully posed and lacks full detail, as does the set.

In version C, the camera is now in its final position, higher and pulled back to give the characters more posing space; the viewer is now more distanced from the action as

ABOVE LEFT: Sanderson's sketch version of panel three of his *Fear* layout on the previous pages.

ABOVE: Preliminary stages of camera and character positioning.

RIGHT: All three figures establish a driving upward rhythm.

FAR RIGHT: The completed render, with final lighting, shadowing, and texture settings.

well. Sanderson has established a driving rhythm in the character poses; the arms and legs inexorably pull your eye up and to the left. The gunmen are now clearly racing to the kill, as indicated by the fact that they are taking two or more steps at a time. "The characters are portrayed in extreme positions, true to the classic comics style," notes Sanderson. Important secondary elements such as the radiator and window have achieved their final scale. Full character textures are included, and there is some shadowing.

The changes from version C to version D are small, but they make a dramatic difference. First, this image is at final render quality, with all texturing, lighting, and shadowing options set. The lighting creates a "hot area" for the figures. The strong light source, with falloff noticeable in an arc along the wall, picks out details of the figures, such as the deformation of their clothing, that were not visible before, and, by giving them more contrast against the stairs, sharpens the impact of their poses. It's also easy to see the outlining option selected in the 3D program's cartoon renderer, notably around the hands and faces. Unobtrusive textures are now visible on the walls and radiator. Shadow elements in the stairwell and on the walls create a strong noir mood that is echoed in the other interior panels on the page. Finally, the window shows an exterior fire escape—foreshadowing one way the victim might escape death.

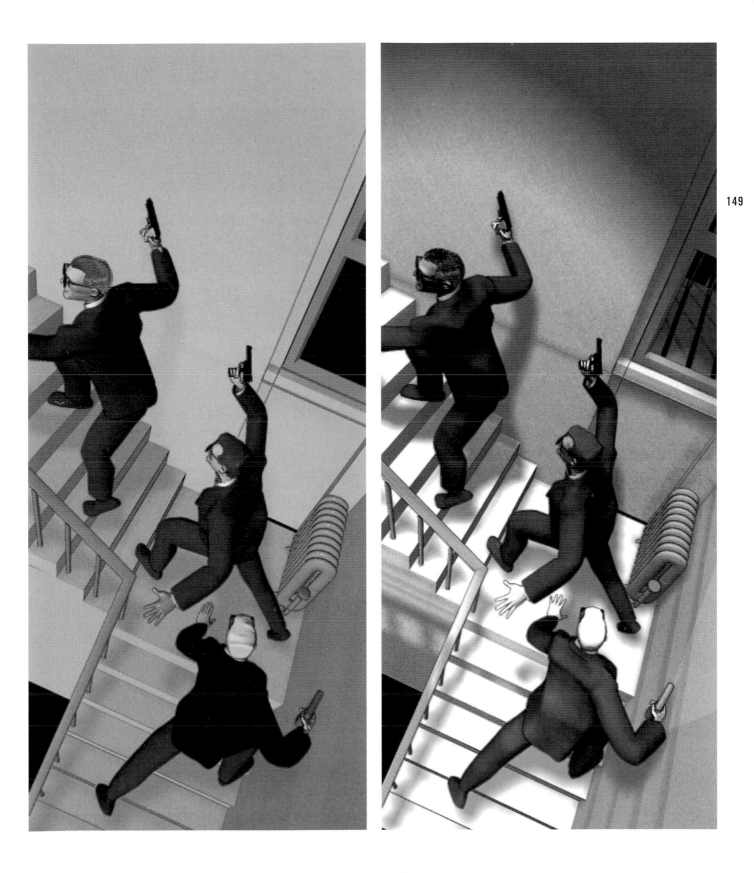

GEORGE LUCAS BECAME A VERY RICH MAN LICENSING *STAR WARS* TOYS, AND THAT LESSON HAS NOT BEEN LOST ON TODAY'S ANIMATION STUDIO MARKETEERS. AN ESSENTIAL PART OF THE MODERN CARTOON FEATURE JUGGERNAUT IS THE ACTION FIGURES, PLUSH TOYS, HIGH-PRICED COLLECTIBLE MODELS, AND OTHER TOYS DERIVED FROM THE FILM CHARACTERS. JUST TO TAKE ONE EXAMPLE, THE DISNEY TOYS DIVISION OF DISNEY CONSUMER PRODUCTS, WHICH HANDLES ALL TOY PRODUCT LICENSING FOR THE WALT DISNEY COMPANY, IS FAMOUS FOR ITS AGGRESSIVE LICENSING PROGRAMS.

TOONS AND TOYS

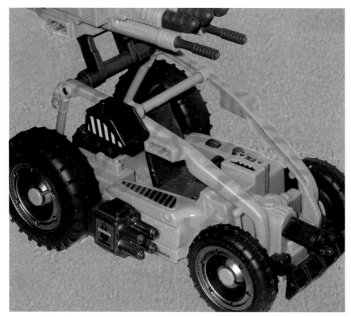

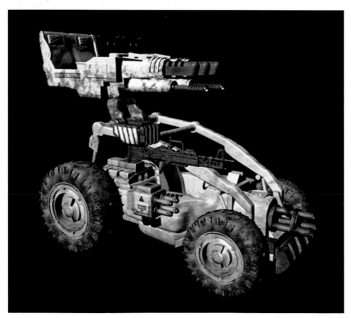

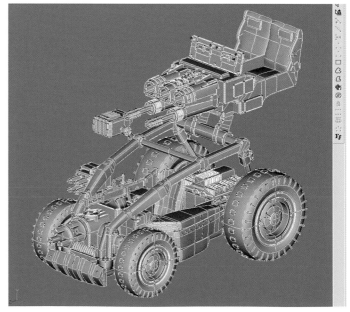

RIGHT: Frames from a *G.I. Joe: Spytroops* teaser trailer showing the Sand Razor in action.

OPPOSITE PAGE
TOP LEFT: A photo of the actual Sand Razor toy as manufactured by Hasbro.

TOP RIGHT: Part of the Sand Razor vehicle schematic drawing Hasbro provided to Reel FX Creative Studios during production of *G.I. Joe: Spytroops.*

BELOW RIGHT: The Sand Razor was modeled primarily in Animation: Master software.

BELOW LEFT: A test render of the Sand Razor showing final forms and textures.

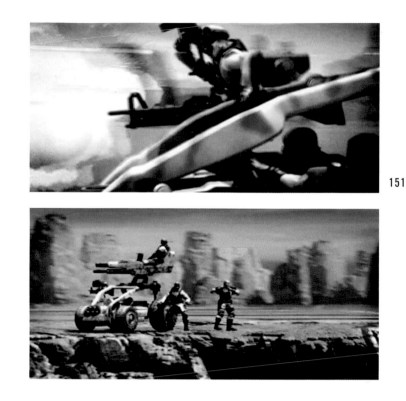

These greatly benefited Pixar during its years as a Disney affiliate. In fact, a modern toon film budget usually depends on licensing revenues from toys to put the whole production into the black. When the film is a box office success, like Pixar's *Finding Nemo*, the toys sell like hotcakes and add millions to the overall bottom line. Little kids clutching plush clown fish helped keep Pixar afloat during the long hiatus between Nemo and Pixar's next film, *The Incredibles*.

Agreements with toy companies are often signed a year or more before the film is released. Likenesses of characters and other film assets are closely guarded while toy production lines are tooled up. Toys must be available in stores and fast-food chains, and in massive numbers, by the film release date. Then, unless the film is a megahit, they've got to disappear in a matter of weeks to make room for the next film's toys.

An interesting situation arises when the film production company is also the toy company—then it's really all about the toys. That's the case with the series of G.I. Joe CG films masterminded by American toymaker Hasbro, the world's largest, and produced by Reel FX Creative Studios (Dallas). G.I. Joe was introduced in 1962 as the world's first action-figure toy. After a brief hiatus from the market during the post-Vietnam period, G.I. Joe returned in 1982 as a playroom staple in smaller scale. The reintroduction of G.I.

Joe was a tremendous success for Hasbro and spawned an animated TV series, a best-selling comic book line, and a 2D animated feature.

Key to Hasbro's conception for the CG films (*G.I. Joe: Spytroops*, 2003, *G.I. Joe: Valor vs. Venom*, 2004) is to portray as many Joe toy items as possible—to act essentially as high-detail, acton-packed advertisements for the entire toy line. (Kids don't seem to mind this—they like to see their toys acting out adventures on-screen that they can reenact and build on later.) Cool war vehicles are as important to the line as the action figures themselves. Reel FX and Anzovin Studio devoted considerable effort to building carefully detailed 3D versions of Joe vehicles for the first film, *G.I. Joe: Spytroops*.

Images on these pages show stages of the evolution of a dune-buggy-type vehicle, the Sand Razor. It was provided by Hasbro to the 3D modelers as an already completely designed and manufactured toy, along with a simple orthographic schematic drawing for use as a rotoscope (background image to guide the modeling work). Among the difficulties were mediating between the drawing and the actual toy, which were not quite identical in proportion and detail, and also interpreting the toy forms so they would convincingly scale up to apparent full size in the film. The completed CG Sand Razor made its debut in Reel FX's teaser TV trailers for *Spytroops* in spring 2003.

ALTHOUGH CGI ANIMATION IS TAKING OVER HOLLYWOOD, OLDER TECHNOLOGIES ARE MAKING A COMEBACK. THE OLDEST FORM OF 3D ANIMATION, STOP-MOTION, GOT ITS START IN 1899, WHEN BRITISH FILMMAKER ARTHUR MELBOURNE COOPER CREATED MOVING IMAGES OF REAL MATCHES FOR HIS PUBLIC SERVICE SPOT *MATCHES: AN APPEAL*. IT REALLY FOUND ITS FEET, HOWEVER, WITH THE CLASSIC EARLY EFFECTS MOVIES, NOTABLY WILLIS O'BRIEN'S *KING KONG* (1933). NOW A NEW GENERATION OF STOP-MOTION ANIMATORS ARE AT WORK, AND ALTHOUGH THEY'RE NOT ADVERSE TO DIGITAL METHODS, THERE'S SOMETHING IN THE OLD TECHNIQUE THAT'S IMPOSSIBLE TO REPLICATE USING OTHER MEANS.

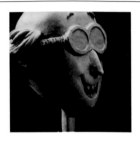

STOP-MOTION

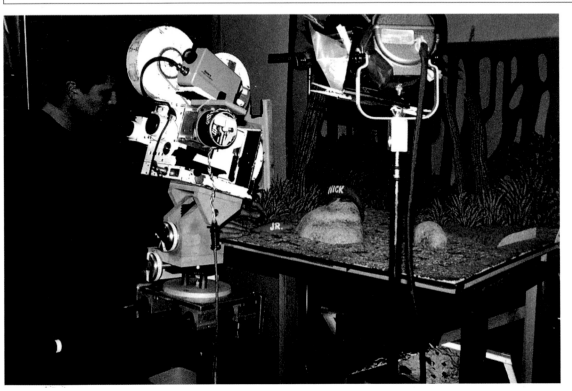

LEFT: The miniature world of a stop-motion animation table: Webster Colcord animates a Nick Jr. station ID bumper.

BELOW: Colcord's simple but effective hippos for Nick Jr.

CG is the future, but many toon artists still keep one foot in the past. In fact, many CG animators credit stop-motion master Ray Harryhausen as a major influence, and his famous creature battles are copied again and again in CG films.

But the influence doesn't stop with replicating stop-motion using CG techniques. There continues to be a small but thriving group of stop-motion artists who love the physicality of the medium—it is the only form of animation hospitable to sculptors and creative tinkerers—and find great charm in the medium's unique esthetic. Among the best stop-motion artists working today is Webster Colcord. Like many animators, Colcord taught himself basic stop-motion techniques as a teenager. That led to jobs with Will Vinton Studios, Fox, PDI, and Nickelodeon. For the last, he created the well-known Nick Jr. hippo and croc bumpers.

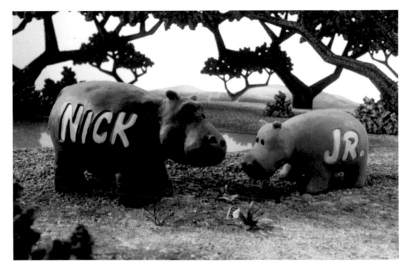

Stop-motion animators live for months focused on a miniature world under the camera. The work is literally painstaking—days moving handmade models a fraction of an inch at a time. Artists are always fighting against gravity and entropy, the tendency of soft arms and legs to slump out of position, the likelihood of small parts falling down or getting lost. Character design in clay, foam, or found materials also imposes its own opportunities and restrictions. "There are limitations to what you can do with stop-motion puppets," says Colcord. "For instance, it's hard to create a flexible character who is extremely fat. You have to build mechanisms to get some movement into those very thick areas of the puppet. It's very hard to make a clear character—like an ice sculpture come to life. It has only been done a few times, with varying degrees of success. At the same time, making one-of-a-kind puppets using 'found objects' can lead to some interesting results. In my commercial work, I would sometimes use clay heads on foam puppet bodies, which I thought was very successful."

Colcord learned CG techniques and has worked on CG features, including PDI's *Antz*. But his medium of preference is stop-motion. "Esthetically speaking, stop-motion has a physical presence on-screen that is hard to achieve in any other medium," he says. "It's like miniatures in fantasy films; if they are done well there is nothing better. There is no reason NOT to use a physical model. You can see it, judge the textures and lighting together, shoot it, and you're done. [The American film critic] Roger Ebert, comparing the recent CG version of *Godzilla* to the original stop-motion *King Kong*, said that the CG looks real, but feels fake, whereas stop-motion looks fake, but feels real. It's that physical presence—and it's tough to put your finger on what it is exactly that the best CG lacks in comparison. It's not one thing in particular, though; it's many things together that give stop-motion that feeling."

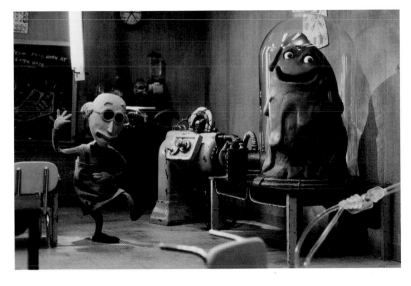

ABOVE: Colcord shows his affection for mad scientists in this spot for Converse.

RIGHT: Stop-motion characters often have the tubular arms and big heads of classic toons. Inside the character is a wire armature that makes it possible to create stable poses for the torso, arms, and legs.

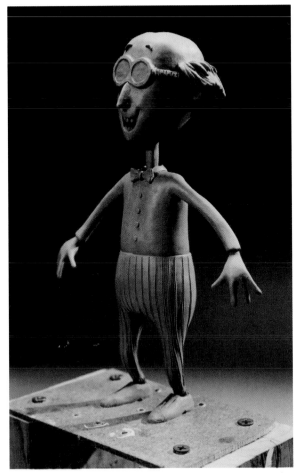

SKELETONS AND ANIMATION JUST NATURALLY SEEM TO GO TOGETHER, AT LEAST IN THE IMAGINATIONS OF ANIMATORS. THE FLEISCHERS KICKED OFF THE CONNECTION WITH THEIR JAZZ-DANCING SKELETONS IN THE TALKARTOON *MINNIE THE MOOCHER* (1932). RAY HARRYHAUSEN'S GROUNDBREAKING STOP-MOTION SKELETON SWORD-FIGHT FOR *JASON AND THE ARGONAUTS* (1964) ENERGIZED A WHOLE GENERATION OF ASPIRING STOP-MOTION (AND CG) ARTISTS; HE HAD ALREADY ANIMATED A LIVING SKELETON FOR THE *7TH VOYAGE OF SINBAD* (1958), ANOTHER HUGELY INFLUENTIAL FILM.

MAD DOCTORS OF BORNEO

154

Clunky stop-motion skeletons subsequently popped up in any number of low-budget horror films, but class returned to the skeleton flick with Tim Burton and Harry Sellick's all-stop-motion feature *The Nightmare before Christmas* (1993). It starred a veritable Fred Astaire of bonesmen, Jack Skellington, the debonair king of Halloween Town.

Mad Doctors of Borneo, Webster Colcord's mock-macabre series of short animations (1993, 2001–02), digs into the scary-silly roots of skeleton animation. Colcord has a great affection for monsters, mad scientists, and grotesqueries drawn from '50s schlock horror and the fevered imaginings of comic-book artists. The main character in *Mad Doctors* is

a mad-eyed skeleton obsessed with the usual preoccupations of the medically trained undead—vivisection, resurrection, biological monstrosities, electroshock therapy, and so on. "Of course," says Colcord, "like most stop-motion animators, Ray Harryhausen was a big influence on me as a kid and I have always wanted to animate skeletons like he did. When I was older I saw Ladislas Starevitch's work, which gave me the urge to create characters using animal skeletons." And a remarkable number of bone-animation opportunities presented themselves. "For my film "Backyard Barbeque" I made a dog/chicken thing and I also animated a frog skeleton for a Roger Waters music video."

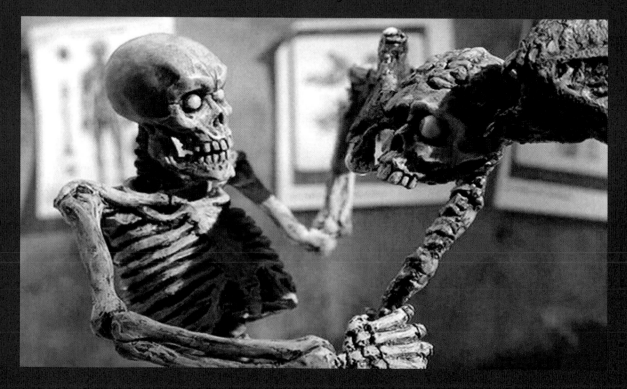

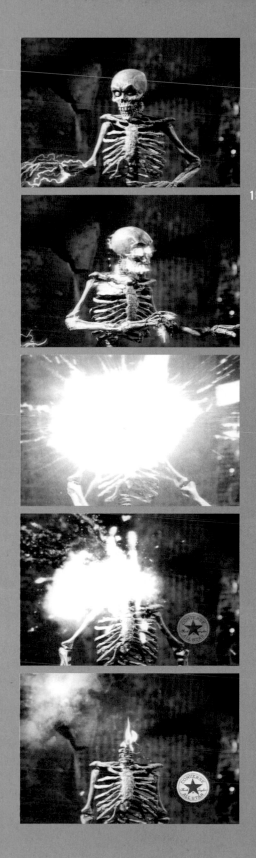

The pathetic brain bat featured in the original Mad Doctors short was specifically inspired by a stereo 3D comic book by Ray Zone called *BRAIN-BAT 3-D* (1992). The mobile brain concept was surely influenced by the crawling brains of the low-budget British feature *Fiend Without a Face* (1958). "The book featured variations on the theme of brains with bat wings," says Colcord. "XNO and Rick Sloane were two of the artists. I thought that it would be cool to realize a similar character in stop-motion animation. I was working at Will Vinton productions at the time, shooting some stop-motion scenes for a Frosted Flakes commercial. We wrapped that shoot and the camera rig was sitting around, so I brought my brain bat in at night and shot the master shot on the same rig."

Skeletons aside, stop-motion remains something of a cottage industry, but its future looks surprisingly strong. "People have come to accept CG as commonplace and in many ways have tired of the look," Colcord maintains. "In order to stand out from the crowd, I think that many producers and directors are turning to this medium."

BRICK FILMS—SHORT-FORM ANIMATIONS CREATED USING A CHILDREN'S PLASTIC-BLOCK BUILDING SYSTEM, SUCH AS LEGO—CONSTITUTE AN UNUSUAL SUB-GENRE OF STOP-MOTION, WITH THEIR OWN AMATEUR ANIMATION CULTURE, WEB SITES, AND FILM AWARDS. AS A MEDIUM FOR ANIMATION, BRICKS HAVE THE UNDOUBTED ADVANTAGES OF BEING EASY TO FIND, EASY TO WORK WITH, AND EASY TO AFFORD. MOST SETS COME WITH SIMPLE READY-MADE FIGURINES OF VARIOUS KINDS—LEGO OFFERS *STAR WARS*, PIRATE, AND MEDIEVAL MINIFIGURES, AMONG OTHERS.

BRICK FILMS

These save animators the trouble of building characters, as long as they are willing to work within, or parody, those familiar story realms. The figures are already jointed, are molded to tight tolerances, and lock firmly to the sets, eliminating much of the difficulty of manipulating traditional stop-motion puppets. Above all, most of the artists who make brick films have been playing with bricks since childhood, in some cases using those same childhood brick sets as the tools of their art. The sense of returning to an earlier and purer state of creative play, transferred to the adult pursuit of animation, is a powerful attractant.

Award-winning brick animator Jay Silver started brick animating as a hobby because he wanted to make "real" live-action movies but lacked the funds and connections. "Going bankrupt building sets and props or going crazy balancing schedules and squeezing performances out of friends didn't appeal to me. Instead I decided to keep it simple by digging out my old Lego bricks and buying a webcam." Silver's early brick films were shot on small sets, lit with ordinary task lamps, and recorded on low-res video. (He has since traded in his webcam for a mid-range DV camera.) Despite the aggressively low-tech approach, he says, he frames his shots as if he were creating a full-sized film. "I shoot close-ups, worm's-eye views, and tracking shots. Of course, when the puppets are just a little over an inch and a half tall, it's hard to pull some of this stuff off, but it's worth it."

The limited range of motion of the minifigures at first appears like a serious handicap, says Silver. Making the tiny movements required for any slow or subtle movement at that scale is almost impossible. But, once the artist understands how to work within those strictures, much can be done with careful poses, timing, and editing. Likewise, the geometric

ABOVE: Jay Silver's award-winning short *Rise of the Empire* was made for a contest held by Brickfest, an annual convention for Lego fans in the United States. It makes unusually sophisticated use of Lego *Star Wars* play sets.

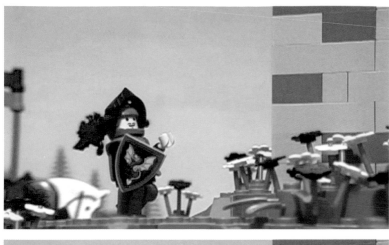

stylization to the sets, props, and the figures is not always a hindrance; the inherent brick film limitations of shape and color force the filmmaker to find creative ways to suggest information, rather than showing it realistically.

"Another serious issue is facial expression," Silver adds. "Except for some attempts with replacement heads, it remains a brick-film universal that the faces stay static—an even bigger storytelling hurdle than the limited range of body motion. The problem is more in conveying the emotion than dialog (audiences seem to get speech without actual lip movement just fine). I've been experimenting with digital faces to overcome the problem."

Ultimately, Silver claims, "The advantage of being able to shoot at home in a corner or on a desktop more than makes up for the limitations. Brick films are cheap to get into, easy to learn, and come with a near-guaranteed audience— the whole world knows and plays with Lego bricks, and they love seeing them brought to life."

STOP-MOTION HAS LONG BEEN THE DOMAIN OF BUDDING ANIMATORS, AT LEAST SINCE THE FIRST 8MM HOME MOVIE CAMERAS MADE IT POSSIBLE TO SHOOT YOUR OWN CLAY DINOSAUR OR MONSTER EPIC ON THE KITCHEN TABLE. THAT AMATEURISM HAS BEEN IDENTIFIED AS A PRIME MARKET OPPORTUNITY BY TOY AND SOFTWARE COMPANIES. BRAND-NAME ANIMATION STUDIOS IN A BOX, AVAILABLE AT TOY STORES, HAVE HELPED MAKE THE ANIMATED MOVIE-MAKING PROCESS AS FAMILIAR TO THE YOUNGER GENERATION OF CREATORS AS, SAY, ORGANIZING A POLITICAL PROTEST WAS TO THEIR PARENTS. THE IDEA MAY BE DISCONCERTING TO PROFESSIONALS, BUT IT HAS BEEN IMMENSELY LIBERATING FOR THOSE WHO LACK PROFESSIONAL TRAINING BUT STILL WANT SOME WAY TO TELL THEIR OWN STORIES.

BRICK FILMS 2

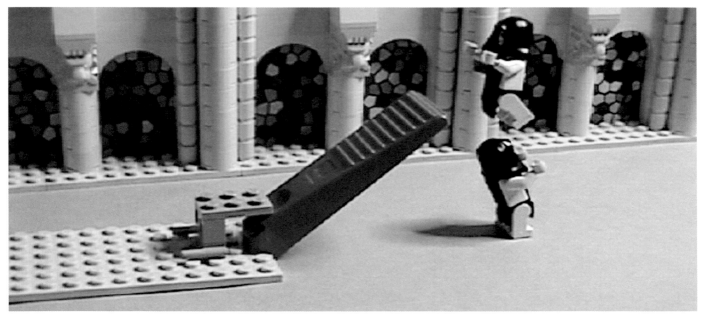

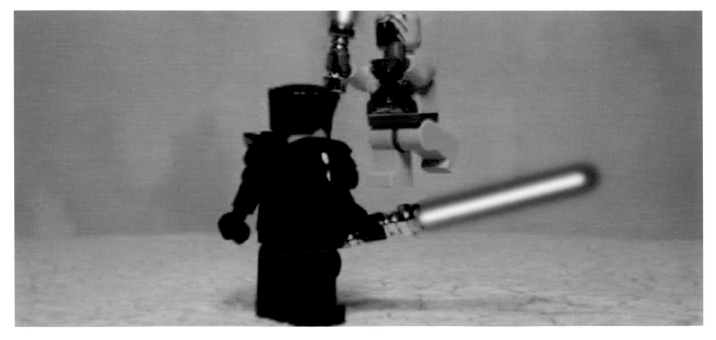

Like Jay Silver (see previous pages), brick animator Ben B of Egoless Productions (Maine) got his start with a kid's toy set and some low-tech ingenuity. "My eyes fell upon the Lego Steven Spielberg Movie Maker Set in a store," recalls Ben, who does not use his last name. "The box said make your own movies. I said to myself that I could do this. I dug out my Lego pieces from my parents' attic and bought the set. I built a studio out of two pieces of wood and drilled a hole in the top for a fluorescent light. The Lego studio had a camera and the software to make a stop-motion animation film, and it came with instructions on how it all is done."

After buying a book about cinematography, says Ben, he had the whole process down for making his first film. "First you write a story, or find a story or a song to animate. Storyboard it out. Check your Lego supply. Order some pieces if you want to. Record the voices. Animate the scenes. Add special effects and sound effects. Make a title intro and credits. Edit it all together. Then throw it up on the Internet and add it to the directory at www.brickfilms.com [the leading brick film web site]." Ben soon found that the Spielberg kit was too limited for his ambitions and moved up to more professional effects and editing software, enabling him to do masking, glows, and face animation.

Ben has made the de rigueur *Star Wars* brick film—*Lego Wars* (2002), a popular favorite on the brick film circuit—but his more recent films are concerned with spiritual questions.

For example, in *Prayer of Rabia* (2003), an animated Islamic prayer, skateboarding in paradise is related to seeking God for God's sake. Even *Lego Wars* is about how a Jedi Knight teaches a warlike Tusken Raider to become a defender of peace and justice.

Do toy plastic bricks really lend themselves to this sort of subject matter? "I am an amateur filmmaker," he says. "So that means I can do whatever I want. And I like making films about a higher power. Just as God breathed life into a lump of clay to create man, you can bring life to a Lego person."

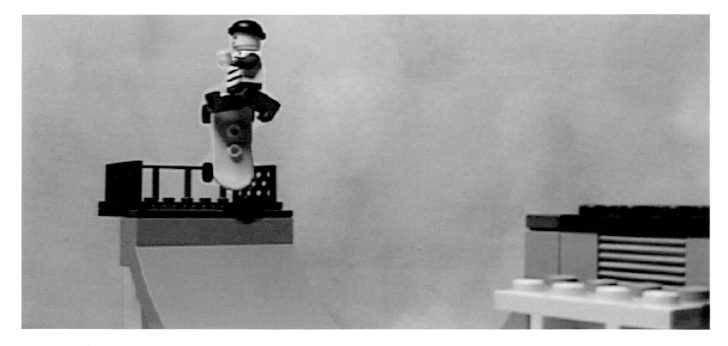

3D TOON GALLERY

PRESENTING THE BEST OF 3D TOON ART

7

ARTIST GALLERY SUSTAINED CREATIVE RUNS ARE UNUSUAL IN THE WORLD OF 3D TOONING. RARER STILL IS A 3D IMAGE SERIES APPEARING AS OFTEN AS A DAILY COMICS-PAGE CARTOON—LIKE GARY LARSEN'S *FAR SIDE* OR GARRY TRUDEAU'S *DOONESBURY*—AND WITH AS ORIGINAL A POINT OF VIEW.

JIMMY MAIDENS

Maryland artist Jimmy Maidens has created just this on his site www.boring3d.com. For one year (roughly October 2002 to October 2003), Maidens posted a new 3D image almost every day—about 250 in total, more than the likely lifetime output of many 3D artists. Given the numerous technical difficulties of 3D creation, this is an impressive achievement by itself. Even more impressive is the fact that so many of the images are strikingly original, technically complex, and cleverly subversive.

A Boring 3D image is instantly recognizable. Maidens's "Gumby on acid" scenes are colorful, off-kilter, childlike, even silly. In the series Sunday Fluff, comprising pictures posted on Sundays, goggle-eyed creatures romp in or float over grassy hills. In other scenes, bemused, iconic figures face miniature conundrums, or go on extended quests that lead nowhere in particular. Occasionally, Maidens ventures into social commentary, something almost nonexistent in the 3D art world. The shallow depth of field and odd camera angles give viewers the sense of peering down into a small-scale play world that operates by cartoon rules. As with the panels of newspaper cartoons, captions are the essential key that unlocks the meaning of each image.

Maidens readily admits to the influence of newspaper cartooning and Claymation on his work. "After I found [Bill Watterson's] *Calvin and Hobbes* I really wanted to be a cartoonist. Watterson would have to be one of my all-time favorite artists. I also love [*Wallace and Gromit* creator] Nick Park's stuff, which I think shows a little in some of my work. And Sam Brown, who does www.explodingdog.com, is directly responsible for inspiring me to start the daily pictures."

Boring 3D images appear very simple, but employ the latest shadier techniques. Many objects are rendered using sub-surface scattering, which accurately mimics the look of materials that allow limited light penetration (such as human skin and certain kinds of soft plastic). Maidens also uses global illumination and glossy reflections to achieve a plasticine look. The same models and environments appear again and again, but most scenes also require new objects—a nontrivial task if done day after day. "I never hesitate to use an old character or object if it works with an idea," he says. "But most days I make all the 3D objects from scratch. The things I reuse the most are my materials. I have a small library that I use over and over with lots of small tweaks. I also use all kinds of other stuff here and there. Pretty much whatever speeds things up so I can get some sleep."

ABOVE: "Box finds a note at dinner." Maidens uses discreet's 3ds max and VRay rendering software, plus a variety of plug-ins. Note the characteristic use of sub-surface scattering on Box.

OPPOSITE ABOVE: "Here comes good luck."

RIGHT: Sunday Fluff.

FAR RIGHT ABOVE: "Look at that! You've got magic in your head!"

FAR RIGHT BELOW: "Don't forget to smile today."

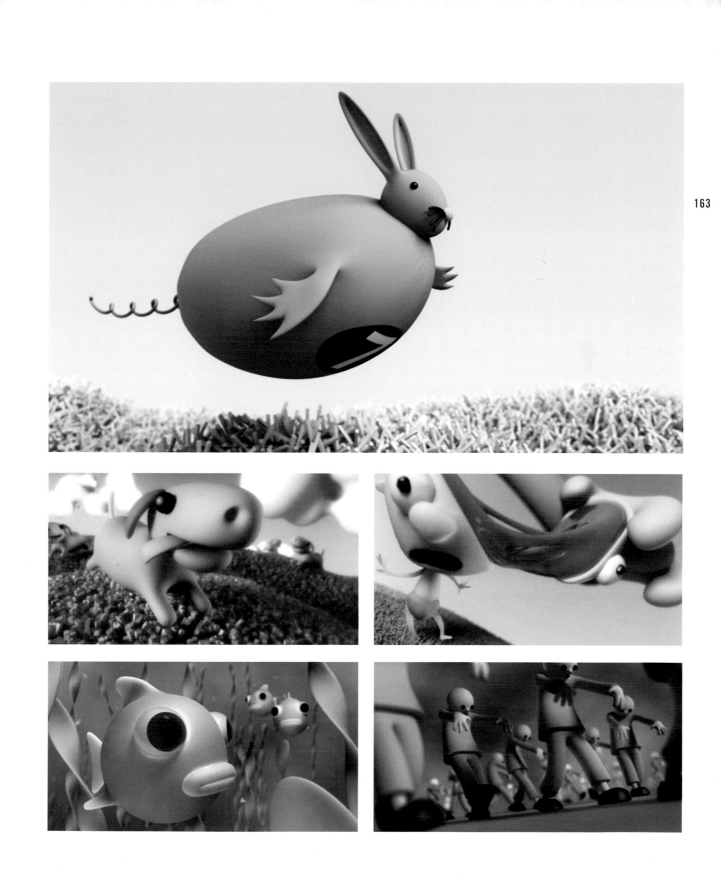

ROBERT J. TIESS

With so much CG, even cartoony CG, influenced by horror, *hentai*, and hyperrealism, Tiess's interest in gentle New Agey subjects—love, growth, butterflies, crystals, an open window letting in light and air—also sets him very much apart. He is still wide-eyed about the revolutionary potential of CG tools. "In the unlimited universe of 3D graphics we can and do create anything we imagine, from whimsical characters to epic scenes and entire worlds—even compelling works of art," Tiess writes. "Some 3D images entertain, while others educate or unnerve. Some portray impossible situations, while others render unreal indiscernible from the real. This is the awesome power and expressive flexibility offered by 3D computer art.

"Speaking as an artist, writer/poet, musician, and programmer, I believe 3D graphics offer the best of all possible worlds, a place where you can channel all your creative energies. You can essentially create anything given sufficient motivation and effort. Artistic opportunities abound once you master the fundamentals of 3D graphics. You will

RIGHT: Robert Tiess's *Blossom* was created with the open-source 3D application Blender. The tropical color scheme and "fairy" lighting set it apart from most CG efforts.

BELOW LEFT: Tiess adds detail and expression to the head area.

BELOW: An early concept model for *Blossom*; the model evolves considerably in later versions. Note the use of cages to indirectly deform the model mesh.

rediscover and gain new appreciation for the world and people and objects around you as you seek to replicate the real in virtual 3D space. Learning the structure, movement, and nature of the simplest things, the mannerisms of certain persons or creatures, or the way the light and shadows interplay—these are only a few of the many things you become newly attuned to as a 3D artist and animator. Imagine seeing everything, everyone, everywhere again as if for the first time!"

In keeping with his artistic philosophy, Tiess is an avid proponent of open-source graphics software. Commercial versions of capable 3D software typically cost thousands of dollars, but open-source is free, developed with the volunteer efforts of programmers and users. "Thanks in particular to efforts within the open source software community," says Tiess, "a number of capable programs are now freely available so that anyone may begin to explore 2D or 3D graphics. Blender (www.blender.org), the software I used to create *Blossom, Love in the Air*, and many other images, is a great example of such a program." Openware applications may lack some essential features found in commercial graphics applications, but, as Tiess notes, artists interested in seeing tools added to the program can either request new functionality from the Blender developer community or submit their own code for consideration. "Open source is redefining the way many digital artists realize their ideas."

ARTIST GALLERY 3D ANIMATION USUALLY TAKES A LONG APPRENTICESHIP; WITH SO MANY SKILLS TO MASTER, SO MANY NEW AND UNINTUITIVE WAYS OF THINKING, NOT TO MENTION THE CHALLENGE OF DEVISING A FRESH AND ENGAGING STORY, IT'S RARE FOR ANYONE STILL IN SCHOOL TO PRODUCE ACCOMPLISHED WORK. (MOST OF THE SHORTS PRODUCED IN THE WORLD'S HUNDREDS OF ANIMATION PROGRAMS ARE CHARMINGLY CLUNKY AT BEST, PROFOUNDLY UNWATCHABLE AT WORST.) ALL THE MORE IMPRESSIVE THAT FRENCH DESIGN UNDERGRADUATE YVES DALBIEZ AND TWO SCHOOL FRIENDS WERE ABLE TO CREATE *RIBA*, A TRULY STYLISH STUDENT ANIMATION.

YVES DALBIEZ

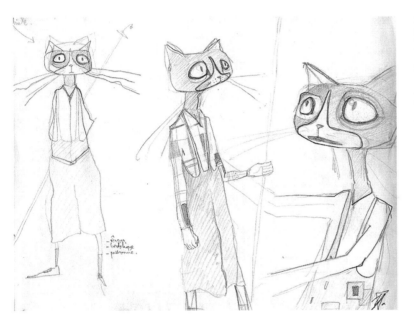

LEFT: Yves Dalbiez's character studies for his short film *Riba*.

RIGHT: Frames from *Riba*. The cat yearns for a grand piano in a shop window, but cannot afford one. Back at his apartment, the cat plays air piano to the music in his head.

"I was always really keen on the world of animation and the great artistic freedom it affords," says Dalbiez. "I won the admission contest for the school Supinfocom Valenciennes in 1999 and attended four years; in the final year, I directed my first short, *Riba*, with my friends Laurent Leleu and Elise Garcette." Production took six months; the short was modeled, animated, and rendered entirely in Maya 4.5 using a low-poly approach. Appropriately enough, the pen-and-gouache look of the piece is caused by the use of a cel shader called TomCat (www.toonshade.com).

Dalbiez is musically gifted (he plays the piano, guitar, accordion, saxophone, drums, didgeridoo, and berimbau) and developed a music-based plot for the short. The story is about a cat with unrequited dreams of becoming a pianist—he's too poor for a piano—until an immense flying fish comes to help him. The film convincingly portrays the cat's yearning for a fully realized creative life, to express in sound what he hears in his mind. But it also places him in a fully realized (and very French) city.

Riba's production design, with its echoes of Modigliani, Matisse, and Utrillo, is completely School of Paris—quite unusual and refreshing for a 3D toon. "For this film's design scheme," adds Dalbiez, "the aim was not to be logical, in which the colors used are real, but rather were chosen for the artistic process. We wanted to be close to the cat's musical mind. The universe which is close to the cat is based on warm colors. The outside, by contrast, is based on cool colors.

"The design part of the animation work is very important for me. I always spend a lot of time on this because the more the character is captivating, the better the story will be. I think first which people I am trying to reach with the film—I can draw better with this understanding. The creator has to feel in love with his character; he knows he is on the right track when he feels close to the character."

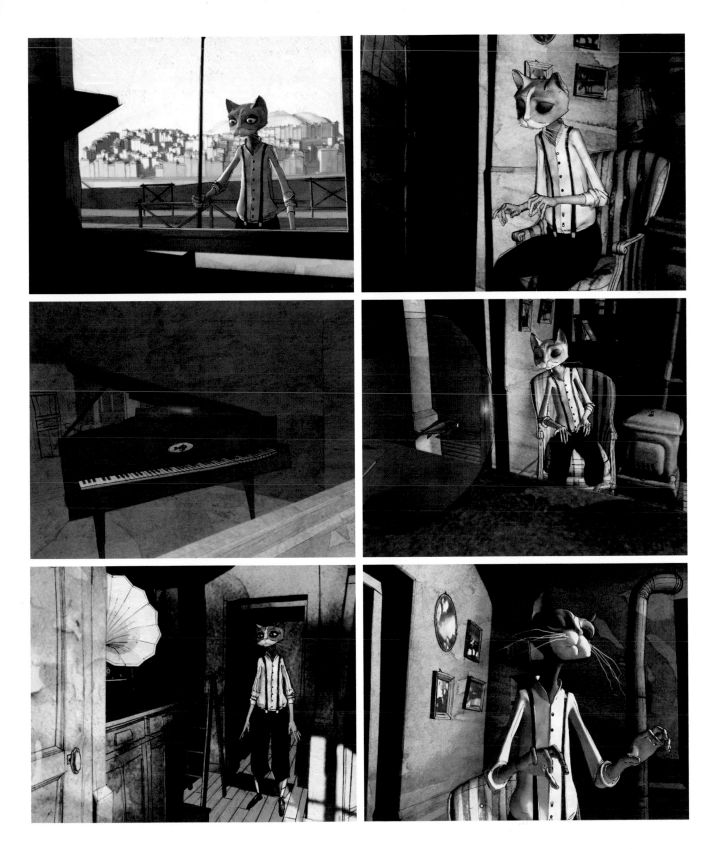

ARTIST GALLERY SEBASTIAN SCHOELLHAMMER, LEAD CREATURE DESIGNER FOR THE UNITED KINGDOM'S LIONHEAD STUDIOS (DEVELOPERS OF THE IMMENSELY POPULAR COMPUTER GAMES *BLACK & WHITE* AND *BLACK & WHITE 2*), IS ONE OF THE MOST TALENTED 3D FANTASY ARTISTS WORKING TODAY. HE'S ALSO AN ARTICULATE ADVOCATE FOR THE GENTLER FANTASY SCHOOL THAT PREFERS ELVES OVER ORCS; WITNESS THIS REMARKABLY LIVELY IMAGE OF A GRINNING WOOD PIXIE PERCHED ON A MUSHROOM.

SEBASTIAN SCHOELLHAMMER

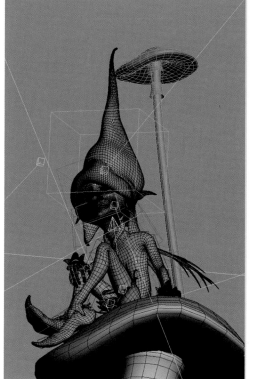

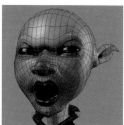

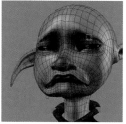

"Since my early childhood," says Schoellhammer, "I've loved fairy tales and later fantasy, which is probably what drove me into the job I have now—creating fantastical characters and creatures. The initial model for Pixie was heavily inspired by the artwork of illustrators Brian Froud and Alan Lee. I stumbled over their book *Faeries* in a secondhand bookshop and was amazed by the designs. Since then I worked on the model in my spare time, restructuring and adding details. Now that I look back, I can see that it changed a lot from the original concept, but I think that the typical 'Froud expression' is still very recognizable."

The pixies of English folklore are generally considered mischievous and cheerfully chaotic creatures, the artist says, with a great range of facial expressions that makes them especially interesting to capture in 3D. Schoellhammer strove to give his Pixie a puckish quality that viewers could easily connect to. In the artist's experience that's rather rare in CG imagery. "I've done many ogres, orcs, and giant people-stomping apes," he says, "but few things that can actually smile properly. So my main challenge, frankly, was making something nice!"

For modeling, Schoellhammer used discreet's 3ds max. The model geometry is a moderately low-resolution polygonal mesh. Rather than building fine details (such as the pixie's homespun garment and the rough bark of the tree) right into the geometry, as would probably be done for feature animation, he used displacement maps and bump maps. As a game artist, Schoellhammer prefers to use maps instead of geometry whenever possible because they keep the mesh light and workable and save time when rigging and UV mapping.

The model's body was primarily rigged in discreet's Character Studio, a program specifically designed to aid in character setup and animation. The face was rigged with bones rather than morph targets, again to meet the needs of gaming—morph targets, Schoellhammer claims, are still too computationally expensive to use in a real-time gaming environment. They nonetheless provide nearly the same amount of facial expression control. In fact, the pixie's expression is perhaps the most arresting aspect of the image.

As usual, the technical issues were less challenging than coming up with a good composition and attractive lighting. For maximum flexibility, Schoellhammer rendered the image in layers. "The pixie was a foreground layer, the tree, mushrooms, and grass in the mid-ground, and the distant trees in a background layer. The resulting images were put together in Adobe Photoshop, where I tweaked the colors and added final effects like depth of field to round everything off."

RIGHT: Fantasy illustrator Brian Froud was one of the main artistic influences for Sebastian Schoellhammer's wonderfully lively pixie.

LEFT: Schoellhammer's bone-based face rigging provides plenty of expressivity without morph targets. The character is ready for real-time facial animation.

FAR LEFT: The pixie was modeled in discreet's 3ds max; this view shows a somewhat earlier version of the work. Note the lack of modeled surface detail, especially in the environment—all was added with various texturing and mapping techniques.

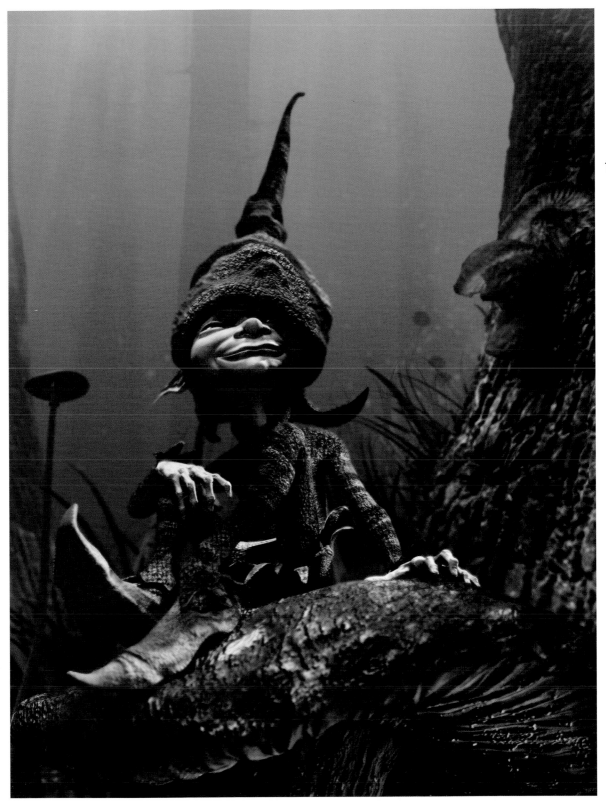

ARTIST GALLERY VIDEO-GAME ANIMATION REPRESENTS THE SINGLE-BIGGEST SEGMENT OF THE TOON PRODUCTION MARKET. A MAJOR GAME WILL HAVE MORE ANIMATION IN IT THAN A TYPICAL ANIMATED FEATURE FILM, MUCH OF IT CYCLES AND CLIPS OF MOTION FOR THE CHARACTERS AND OBJECTS IN THE GAME PLAY, BUT ALSO NEAR-FEATURE-LEVEL TOONING IN THE CUT SCENES, THOSE "STOP-AND-WATCH" SEGMENTS WHERE MOST GAME EXPOSITION TAKES PLACE.

AVALANCHE SOFTWARE

In addition, a big game is likely to have more characters, each of which goes through its own design process and, from the animation standpoint, requires many individualized motion cycles that must meld seamlessly in any combination. So the total tooning effort can be huge, a big reason why so many games don't meet their release dates. And we're not even mentioning the programming issues of working with next-generation game engines and the flaky, often maddening limitations they impose on animators.

One top game developer that consistently achieves unified and original designs for its games, and delivers great animation to boot, is Avalanche Software (Salt Lake City). The company was founded in October 1995 by four lead programmers from now-defunct Sculptured Software. As game graphics evolved and as art content grew more important to the success of a title, Avalanche added a strong art staff, including Jeff Bunker, art director for the popular family-oriented game *Tak and the Power of Juju*. Avalanche now specializes in games on the home console platforms; their titles include sports games (*Open Ice, NFL Blitz, Off Road Challenge, Show Time NBA/NBC*), action games (*25 to Life,* the Ultimate Mortal Kombat series, the Rampage series, and *Arabian Nights: Prince of Persia*), and kid games (the Rugrats and Tak game series). Tak was co-developed with THQ and Nickelodeon, with an eye to future development as a TV series and feature.

"Our design approach is all about concept," says Bunker. "We easily did hundreds of sketches for *Tak* alone, trying to find the design that visually described his personality the best. And then, we nearly go through as many revisions again as we narrow it down further when translating that sketch into 3D. What may have worked in a drawing may not work at all in 3D, especially when you begin animating

it. That's why we really try to have time to animate the model before we finalize it, so that we can go back and make any necessary adjustments."

For *Tak,* Avalanche came up with a colorful, cartoony design scheme that drew heavily on Pre-Columbian culture, with a strong admixture of fantasy tribal motifs from Hollywood jungle movies. Tak, the hero, is a plucky if klutzy junior shaman with a Matto Grosso haircut and Yanomamo eyeshadow. Like most of the other male characters, he has Popeye's body proportions and extra-prominent hands and feet (which help players when they have to position characters to cast spells or retrieve treasures). Ironically, says Bunker, despite their best efforts, the design for Tak ended up being off character. "He wasn't what he should have been by the end. The story, and consequently the age and personality of Tak, changed a great deal from when we first designed him and had him approved by THQ and Nickelodeon. By the time the story was nailed down, it was too late to adjust Tak. Luckily, we've been able to make those changes on the sequel, *Tak 2: The Staff of Dreams.*"

Tak's tribal gods and spirits, called Jujus, are designed with more freedom and more exaggeration. Moon Juju in particular is a luminous and alluring figure, the Glinda or Blue Fairy of Tak's world. There's an unusually rich creature ecology in Tak as well: a crusty rhino, an angry ram, hairy orangutans, bleating sheep, nervous emus, man-eating snapdragons, and more. Each provided Avalanche with the opportunity to create a unique personality and motion style, and Tak often has to use these creatures, or make them interact with each other, to proceed through the game.

ABOVE: Every fantasy jungle needs a giant man-eating plant; Tak must tame this one before he can retrieve a needed substance.

BELOW: Tak, the hero of Avalanche Software's *Tak and the Power of Juju.*

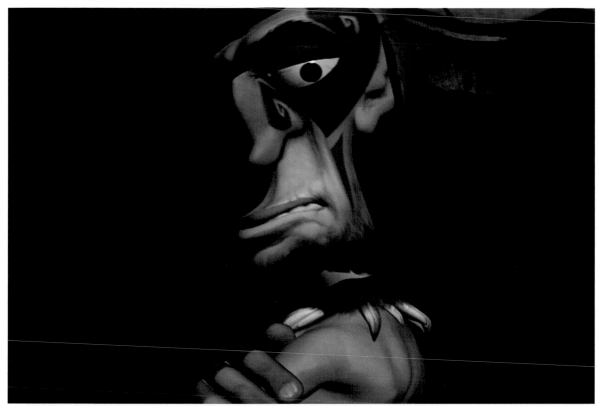

LEFT: Tlaloc has stolen the moonstones and imprisoned the beloved Moon Juju. His sneering superciliousness is clearly communicated by Avalanche's character design.

LEFT BELOW: Jibolba is the most powerful shaman in Tak's world—except possibly his rival, the evil Tlaloc.

LEFT BOTTOM: Lok would be the hero in any other game, but here he is merely an obnoxious egotist who is turned into a sheep.

BELOW RIGHT: The luminous Moon Juju bears a distant resemblance to Madonna.

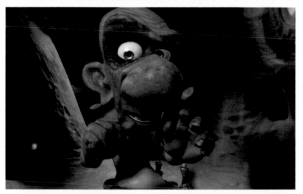

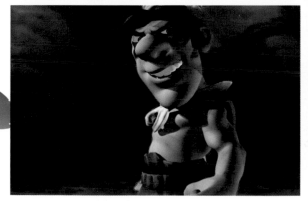

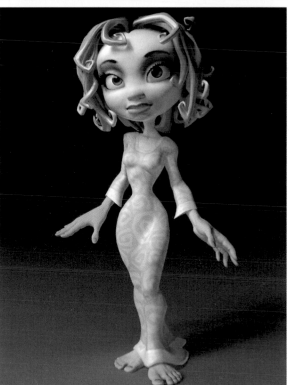

VICTOR NAVONE

172

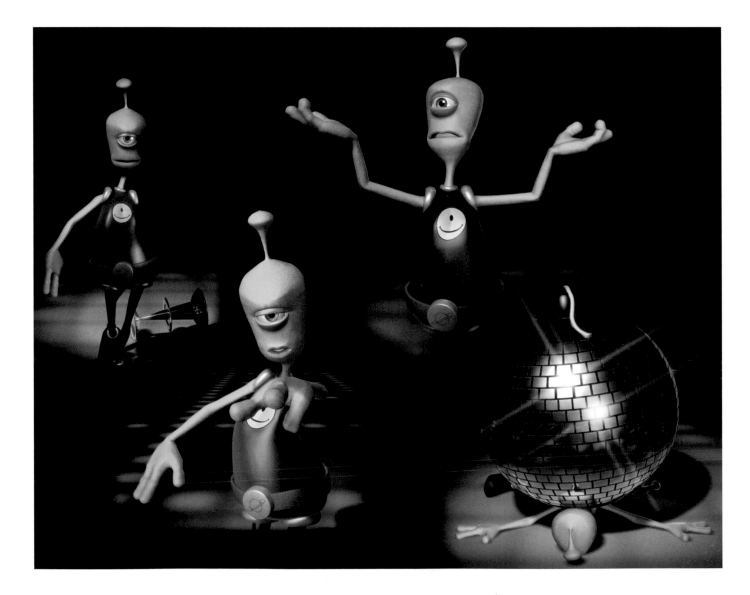

"I have a degree in art and I was amassing plenty of 3D experience on the job. Then I decided I wanted to learn character animation, so I started reading books on the subject, perusing Internet resources and forums, and working with friends who were animators. I designed and built a simple little character with one eye and three fingers on each hand for efficiency and ease of animation. I started animating this little guy in different situations.

"My third animation, *Alien Song*, was an exercise in lip sync, which I had never attempted before. I submitted it to a character animation forum for feedback, and the next thing I knew, the movie was circulating around the world by e-mail, proliferated like a virus. Luckily, I had the foresight to put my name on the movie, and fans used it to track me down. I was getting hundreds of e-mails from strangers telling me how much they enjoyed the clip. I was also getting lots of job offers. The best, of course, came from a guy named Ed at Pixar. It turns out he was the president of the company, and he wanted me to come in for an interview. I accepted, naturally. I've been happily employed at Pixar since 2000, and I've had the pleasure of animating on such films as *Monsters, Inc.*, *Finding Nemo*, *The Incredibles*, and various short projects. I continue to learn and grow as an animator to this day.

"I still have difficulty thinking of myself as an 'animator.' All my life I've been an 'artist,' and I never had any intention of getting into this field professionally. It just happens that my animation skills got me recognized a few years ago, and now that's how everyone thinks of me. I think there is an important point to be found here. Because of the availability of computer technology a lot of people think that they can pick up a mouse, push a few buttons, and make something like *Toy Story*. They overlook the fact that while today's 3D software can produce results very quickly, it still requires talent and training on behalf of the user to produce appealing art. Just as owning the best paintbrushes doesn't make you a good painter, having high-end software doesn't make you a good 3D artist. I believe an artist in any medium must have traditional training. The elements of color, composition, design, etc. are just as important in CGI as they are in traditional art. Thinking of computer graphics as '3D' can be misleading; most of the time these graphics are represented on a 2D surface, such as a piece of paper or a movie screen, and are therefore subject to the same considerations as 2D art. For these reasons I always advocate that students of 3D graphics and animation educate themselves in drawing, figure drawing, painting, photography, and filmmaking. For animators, I also recommend acting courses, because animation is basically acting. Of course it's important for an animator to understand the technical elements of weight, line of action, overlap, etc., but ultimately the goal is to imbue a lifeless model with a sense of thoughtfulness, character, and emotion, and this demands that the animator be an actor as well as a technician."

HAMMER

FLAG PUNCHER

ARTIST GALLERY IT TAKES A DUO TO MAKE A DUO—THAT IS, IT OFTEN TAKES TWO ARTISTS TO GIVE BIRTH TO A GREAT PAIRING OF TOON CHARACTERS. WILLIAM HANNA AND JOSEPH BARBERA CAME UP WITH TOM AND JERRY, YOGI AND BOOBOO, QUICKDRAW AND BABALOO. THE BERLIN-BASED HUSBAND AND WIFE TEAM OF DAVID MAAS AND TATJANA HERRMANN-MAAS CREATED THE LOVABLE PARTNERS *JASMIN AND GRIZZEL*, IN DEVELOPMENT FOR A 30-MINUTE SPECIAL AND A SERIES OF STATION IDENTIFICATION CLIPS. THAT DEVELOPMENT HAS TAKEN A LOT OF LOVING CARE TO PERFECT CHARACTER PERSONALITIES AND DESIGNS.

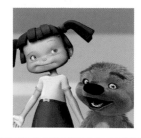

DAVID MAAS & TATJANA HERRMANN-MAAS

174

David Maas is an advertising creative who consults for feature animation production on pipeline efficiency and management, and also lectures on organic 3D modeling at the German Film School. He provides the 3D know-how for their projects. Art curator Tatjana Herrmann-Maas, who first came up with the Jasmin and Grizzel concept, specializes in event management and funding. Her experience with high-quality print projects gives the team an edge when preparing project sheets for clients.

The two wanted to create a kids' tale for the holiday season "that celebrates family values while recognizing the frosty edge that loving relationships have to warm over." Things start out a bit less than perfect. The headstrong Jasmin definitely does not want a teddy bear for Christmas—teddy bears are for babies. But then she notices Grizzel. After escaping from the Berlin Zoo, he's chosen a pile of teddies to hide out in. He looks cute and cuddly, but he is in fact a raging, untamed grizzly—or at least he'd like to be. Jasmin and Grizzel love each other but struggle to overcome their very unique manifestations of pride and selfishness to enjoy what matters most: each other.

Perfecting the character designs required extensive experimentation. The nature of the story and characters called for highly expressive faces that would read well on the TV screen. "After defining Jasmin's roundish face," notes David, "we set off to find a haircut that supports her annoying yet lovable personality." Jasmin's hair went through many iterations before the final design of purple bangs and pigtails,

which was judged to give her the pertness she needed. Grizzel's fur was even harder to define. 3D fur is still inherently troublesome—setting natural-looking hair variations takes lots of careful grooming, and fur takes a long time to render—as was coming up with a hair look that was appropriate for both a teddy bear and a baby grizzly. "We used Worley's Sasquatch hair renderer. The look of fur is controlled by over 30 elements. Next to obvious factors like color and length, there are less obvious but equally important factors such as combing and clumping. Combing defines the direction (and degree) in which the hair fibers lie while clumping defines the tendencies of these fibers to bunch together into tufts." As the pictures show, all this care resulted in characters that are appropriately cute and appealing—but not bland.

Illustrations for the project sheet for *Jasmin and Grizzel*, a TV special in development by the Berlin-based creative team of David Maas and Tatjana Herrmann-Maas. Their friendship is rocky at first, but Jasmin and Grizzel eventually come to appreciate each other. In exploring possible visual styles, David and Tatjana developed this composite (below) to show how Grizzel might look in the real world.

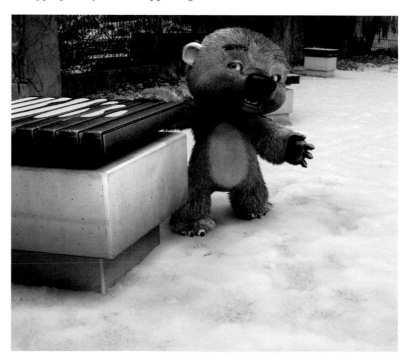

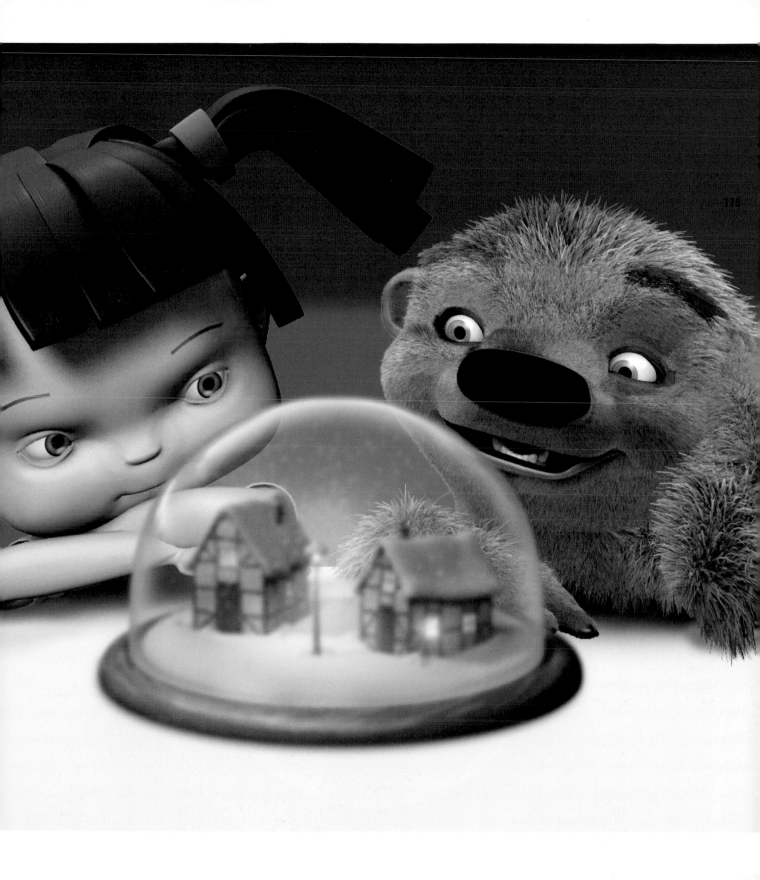

ARTIST GALLERY MELBOURNE-BASED SCIENCE AND CHEMISTRY TEACHER SHAUN FREEMAN MOONLIGHTS AS A FREELANCE ANIMATOR FOR MOMENTUM ANIMATION STUDIOS, ONE OF THE LARGEST ANIMATION AND EFFECTS HOUSES IN SOUTHERN AUSTRALIA. HE IS SELF-TAUGHT, AS ARE SO MANY IN THE FIELD, AND WAS ORIGINALLY INSPIRED BY JEFF LEW'S POPULAR *KILLER BEAN* SHORT. FREEMAN IS PRODUCING HIS OWN SHORT FILM, *THE CUCKOO*; IT REVEALS THE HIGH QUALITY OF WORK THAT CAN BE ACHIEVED BY SOMEONE WITH NO FORMAL TRAINING BUT WITH A SHARP FEEL FOR TIMING AND A GOOD SENSE OF HUMOR.

SHAUN FREEMAN

176

"Once an idea for a film concept occurs to me, I begin developing the characters. If possible, I try and keep the story line as simple as I can. The story line was storyboarded down to quite a detailed level (using words only, not sketches). The only sketches I produced involved the design of the characters. As I was the only person completing the film, sketching out the storyboard was not as crucial as it would be if working with a team of people, as I had most of the detail in my head. However, physically sketching out the characters helped me to perfect them.

"Modeling the characters has proved to be a fairly lengthy process of multiple revisions. After he had been roughed out, I found that the design of the cuckoo did not have the audience appeal I was looking for. So I spent some time redesigning the face (particularly the beak) and also increased the size of the toes in my characters to give them a more 'cartoony' flavor. The facial modeling was particularly important—so much of a character's appeal rests in the way emotions are expressed through the facial movements. The cuckoo chick lacked the usual eyebrow ridges, but his highly prominent eyeballs and eyelids allowed for complex emotions and thoughts to be portrayed through their movement alone.

ABOVE: One of Freeman's character sketches, used both as a design tool and as a guide for modeling.

RIGHT: A frame from Australian animator Shaun Freeman's short film *The Cuckoo*. The mother wren finds an unexpected guest in her nest.

BELOW: A series of frames from a "screen test" designed to develop the movement and personality of the main character.

"My technique involves blocking out the basic poses for sections of the animation. This allows me to consider the timing of the action and ensure the animation is on track to deliver the proper emotion or action. After blocking out the poses, I go back and add detail to any in-between poses that I think need work, including any anticipation before a movement, as well as adding arcs and curves to the actions. At this stage, I don't animate the extremities—the fingers and toes—but the eye movement is blocked out to make sure the character is behaving the way I want. It's then a case of going back again and again to ensure my arcs and secondary actions are natural and enjoyable to watch. The final stage also involves removing any 'twinning' movements, such as arms or hands moving at the same time; this gives the impression of a forced or unrealistic action.

"With the Cuckoo character, lip syncing is a fairly simple process, as no complex mouth shapes are required. The most difficult aspect is to ensure the mouth doesn't open wider than necessary. When syncing words, the mouth should hit the shape before the actual sound, nor should the mouth shape every phoneme in each word, as the animation tends to look too busy if you do."

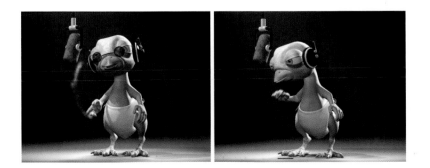

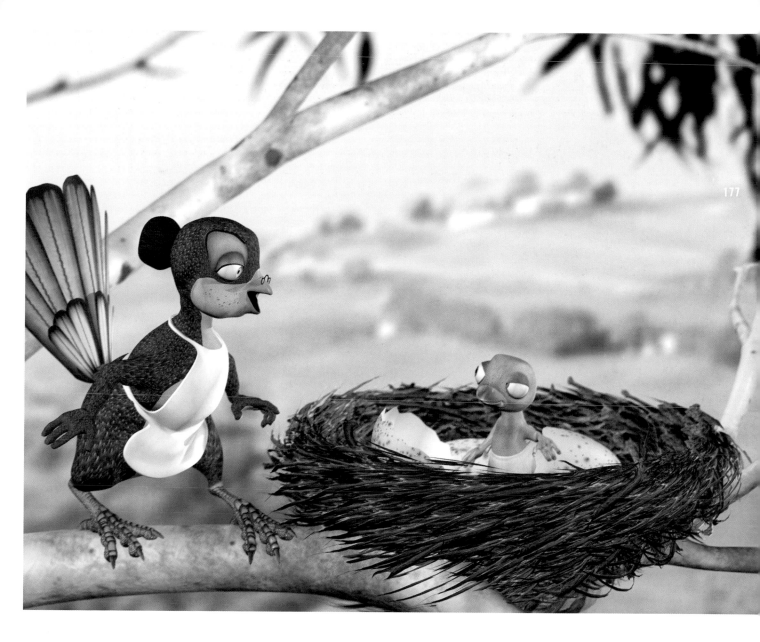

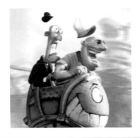

MICHAEL SORMANN

178

Theme Planet takes place in a planet-sized theme park floating in space. The hero, a pig, is satisfied at first with his boring life as a repair engineer alongside his assistant, an elephant. But extraordinary events cause the pig to seek answers to what is really going on inside the huge planetary structure. After numerous adventures with a variety of cartoon characters, pig and elephant reach the center of *Theme Planet*, where they encounter the "Mad Constructor" and learn of his plans for universal domination.

Sormann's first steps in computer graphics were in 2D on the old Commodore Amiga platform, long popular in Europe, using Electronic Art's DeluxePaint software, a 2.5D animation tool. After graduating from design school, he was hired by Rockstar Vienna (formerly Neo Software). Here he had his first contact with Alias/Wavefront's Power Animator, then with Alias's Maya software, which he uses today.

Sormann puts strong emphasis on developing good concept art and sticking with it in the 3D modeling process. Case in point: the lizardlike creature that works Sormann's roller coaster. The final 3D version is extremely close to the concept sketch. "The main idea," he says, "was that it should be a chameleon-styled creature, able to do a lot with an oversized tongue and very flexible eyes—an interesting basis to create different, hopefully funny, animations. Most difficult was to build in all the cartoony character features I wanted without destroying the impression that it is a chameleon.

"When going to 3D," Sormann says, "I used simple box modeling, with a mirrored instance on the other side. Later, I added a lattice box to gain control over the overall proportions. Texturing was quite straightforward. I created UV coordinates via simple frontal planar mapping, and tweaked the border UVs in the UV Editor. Then I took a screen shot of the UV mapping, and based on that I painted color, diffuse, specular, and bump maps.

"The environment is a rendering of the *Theme Planet* outside world—a scene I created a few weeks earlier. I looked for an interesting perspective, rendered it, and used it as background plane. Additionally, I added a few props from other scenes. Everything is 3D; nothing is a painting."

Given the scale and quality of the images and animation Sormann has released so far, it's actually hard to grasp that *Theme Planet* is the work of a solo artist (working in his spare time!) and not a large team, so vast and well integrated is the project, and at such a high level of accomplishment.

ABOVE: Two *Theme Planet* tourists take a ride. Sormann has perfectly captured their two opposing expressions.

RIGHT ABOVE: The roller coaster operator from Michael Sormann's work-in-progress animation, *Theme Planet.* This chameleonlike fellow is responsible for keeping an eye on the roller coaster and works the controls in a small hut.

RIGHT: *Theme Planet's* Fun Police get around in this barracuda train.

LEFT: The official poster for *Theme Planet.*

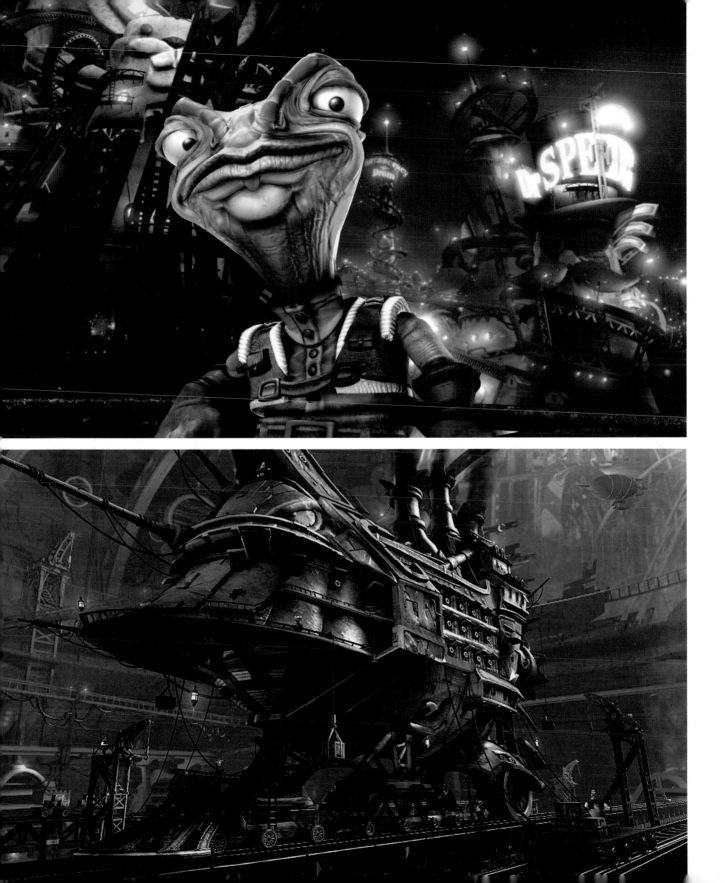

ARTIST GALLERY REEL FX CREATIVE STUDIOS (DALLAS) IS AN AWARD-WINNING HOUSE WHERE ARTISTS AND TECHNOLOGY CONVERGE TO PRODUCE EXCEPTIONAL VISUAL EFFECTS, ANIMATION, AND DESIGN. FROM PRE-VISUALIZATION ON, REEL FX STRIVES TO PROVIDE A UNIQUE PRODUCTION EXPERIENCE WHERE IMAGINATION IS NOT LIMITED AND EXPECTATIONS ARE EXCEEDED. THIS DRIVING PHILOSOPHY IS QUICKLY MAKING REEL FX THE PREEMINENT ANIMATION AND EFFECTS HOUSE IN THE SOUTHWESTERN PART OF THE UNITED STATES. IT HAS PROVIDED CG ANIMATION FOR SEVERAL FEATURE FILMS, INCLUDING ROBERT RODRIGUEZ'S SPY KIDS SERIES, AND IS A MAJOR PRODUCER OF CLEVER EFFECTS COMMERCIALS.

REEL FX

Founded in 1993 by Dale Carman and David Needham, Reel FX was conceived from the first as a company providing creative solutions to any problem—no excuses, no exceptions. "Our core philosophy has always been that the tools can be taught…raw talent can't," says Carman, Reel FX's chief visioneer. "That is not to say we haven't invested in the tools. We have. We understand the power of the digital pen and have invested in the best tools available." But, Carman continues, "the most important asset at Reel FX is not our hardware or software, it is our peopleware. The Reel FX team was developed from diverse backgrounds and art disciplines…each with an inherent strength that allowed our collective team to see things from different perspectives."

The studio also is careful not to limit itself to one type or style of animation. "It may be 2D, 3D, photorealistic, stylized, or stop-motion," notes Carman. "We even work with miniatures and explore experimental approaches in order to create new and innovative forms of animation. Though we specialize in CG, we let the story decide the right approach through intense pre-visualization. Regardless of the style, we create animation with the sole purpose of breathing life into stories."

Reel FX's creative problem-solving approach was on display in a recent project, the direct-to-DVD 3D feature *GI Joe: Valor vs. Venom*. Based on Hasbro's popular action figures, the movie was intended primarily as a promotional bonus for purchasers of selected toy packs. *Valor vs. Venom* received Reel FX's usual careful design treatment; the goal was to stay true to the look of the existing action figures and toys while keeping the CG versions fresh—and easily animated.

The real challenge came when Carman decided to take the project up a notch by delivering a theatrical-quality feature in less than half the time and with a far lower budget than the typical CG toon flick. The studio's existing structure was augmented by the creation of a nationwide distributed animation network, where smaller studios and freelance animators all over the United States were connected by an Internet-based production and asset management system. This gave Reel FX the ability to grow quickly to the size needed to complete the project on time, then shrink to a manageable size again once the project was over, without the round of painful layoffs that follows the completion of most large CG jobs.

ABOVE: Reel FX design sketch of the villainous Cobra Commander, showing Saddam-inspired details of his paramilitary costume.

RIGHT ABOVE (LEFT): Getting just the right facial proportions for the 3D version of Cobra operative the Baroness.

RIGHT ABOVE (RIGHT): In *GI Joe: Valor vs. Venom*, Cobra Commander's face is covered by a mirror mask; his emotions are conveyed by exaggerated pantomime.

LEFT: Concept art for a new GI Joe villain, Venomous Maximus.

RIGHT BELOW: A series of four stills from *GI Joe: Valor vs. Venom*. Intense effects work was required to create sky, sea, and secret base environments.

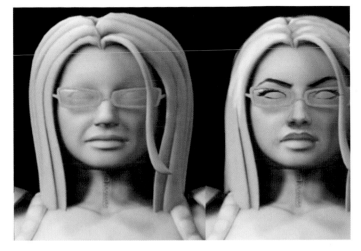

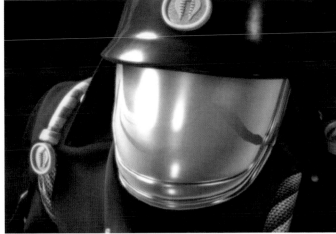

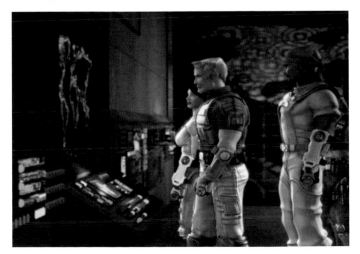

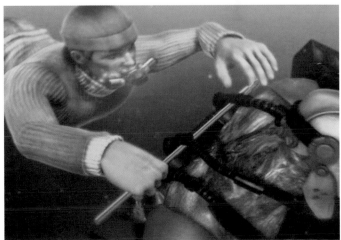

PATRICK BEAULIEU

182

Like Chris Wedge's Skrat, the proto-squirrel from *Ice Age*, Beaulieu's characters communicate mainly through eye twitches and sudden squawks; in fact, this artist has brought the art of the twitch to a high pitch. That's not all that is highly polished about Beaulieu's work. His designs are impeccably constructed and textured. Beaulieu is a master at feathers, one of the hardest challenges in 3D texturing. And his creations are most definitely alive. In his best work, you feel an almost unbearably anxious intelligence staring back at you.

"I believe that the most important stage for a character is to give it life, to sense a presence," says Beaulieu. "For Freaky Bird, my main idea was to make a character with a stupid air—an expression full of life but void of intelligence. My main inspirations were the Pixar short *For the Birds* and Skrat, the squirrel-rat from *Ice Age*. This is the type of character that shows my work at its best. Each character that I make begins as a sketch or a sculpture based on a principal idea. For me, the sketching stage is absolutely necessary to the creation of the character, in order to have a clear and concise plan for modeling."

Beaulieu's animation style might be described as "extreme cartoonish." Movements are rapid-fire; characters whip from held pose to held pose with mainly blur in between. Or they may wait for a cue, a constant twitching marking their thought processes, until they explode into a mad dash off screen, a style favored by many animators seeking to emulate the energy and spontaneity of the Tex Avery shorts. In the image sequence of his Charley the bear, Charley peeks, leaps into frame, then pauses as if for audience approval. At that moment he catches an irresistible scent, does a huge back-windup that practically sends him off screen right, then zips off screen left. The test is all about pose, exaggeration, and impulse.

"Animation is something that always fascinated me," Beaulieu adds, "to give expressivity to a character, to choose the poses, to put it in every kind of situation. I love to animate

snappy things with extreme acceleration and brusque movement. I am always on the lookout for good films like *L'Empereur Nouveau Genre* (*The Emperor's New Groove*), *Monsters Inc.*, and *Eldorado*, with the aim of acquiring new knowledge and evolving my notions of animation. My artistic goal is to make something beautiful, droll, cute; something that attracts the eye with its colors, proportions, pose, character traits. To create a style, and then to evolve and deepen it with each new work."

Beaulieu is working on a feature film at Hybride Technologie in Quebec.

ABOVE: Canadian animator and character designer Patrick Beaulieu's Freaky Bird, an award-winning design, is ready to bolt on the instant.

RIGHT ABOVE: Arnold tries to be a hopeful, upbeat rodent, but those goggling eyes can't help projecting an air of nervousness.

RIGHT BELOW: Either Mr. Blue has something important, perhaps earth-shattering to say, or he has just heard something shocking.

LEFT: Is Chunky an alien emissary, or just a friendly plush toy?

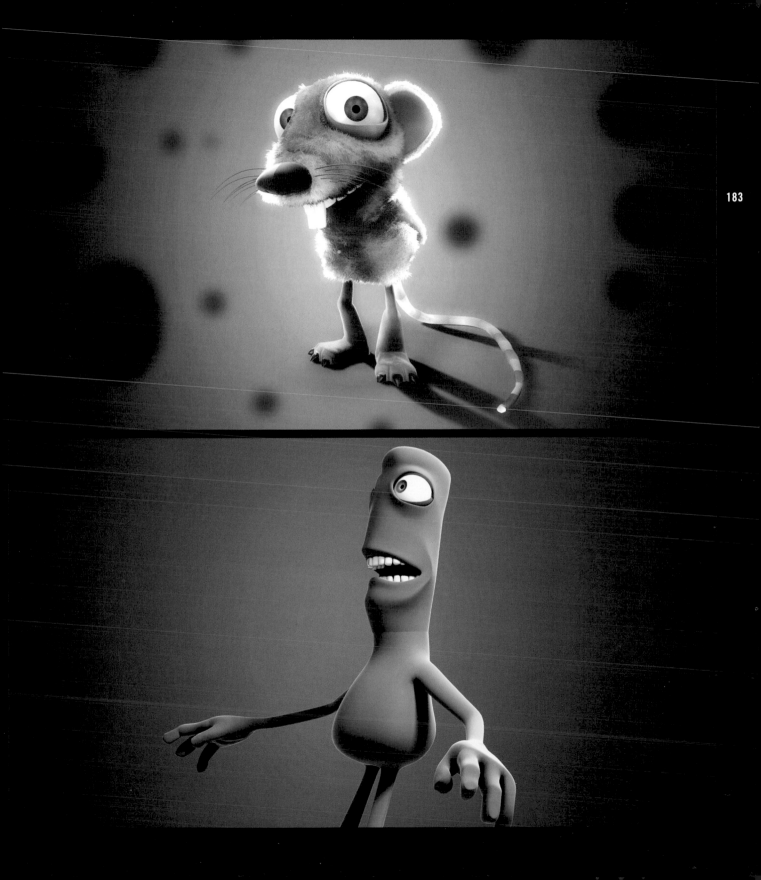

GLOSSARY

2D: Two-dimensional images or animation not created with 3D software or other 3D techniques. Often refers to classic drawn or cel animation.

2.5D: Two-and-a-half dimensions, a jargon term for a technique of 3D animation that emulates the look of 2D while allowing limited motion in all three Cartesian axes.

3D: Three-dimensional images or animation, created with computer software; also, any animation created using real-world objects with true dimensionality, such as dolls, brick blocks, clay, and so on.

Animatic: A "planning" movie for an animation, an aid to visualization of shot layout, camera angles and moves, and blocking of basic character moves. Created with scanned drawings, toys, video, or simple 3D models and edited together to establish pacing and continuity.

Animation: Moving graphics. Created by quickly displaying a succession of related images, called frames, so that the brain blends them together into one continuous sequence.

Anime: Japanese cartoon animation, with idiosyncratic stylistic conventions now widely emulated in world animated cinema.

Booleans: Holes cut in a 3D model. Often used in mechanical objects, but not so often in characters. The term derives from Boolean algebra, the math of the intersection of sets.

Brick Film: Animation created using toy building bricks, such as Legos. A popular option for inexpensive amateur productions.

Cartoon: 1) Any graphical work that employs stylization, economy of design, exaggeration, and caricature. 2) A humorous character-based animation with a simplified graphic style and frenetic, exaggerated motion and pacing.

Cel Shader: A software rendering technique that gives 3D images the hand-drawn, outlined, flat-color look of classic cel animation. Also called toon shader or line shader.

CG: Computer graphics. Shorthand for the use of 3D in TV and cinema.

Compositing: Post-production process of layering images or animations to create a final work of many combined elements. Often shortened to comping.

Cut Scene: Animated cinematic sequence inserted into a video game, often to set up the game premise or to introduce new levels and new characters.

Decal: An image map; see Map.

Deformation: Change in the shape of a model's mesh occurring when the mesh is manipulated or animated. Deformations can be undesirable and unpredictable, requiring careful adjustment of weight maps, rigging, and other aspects of the model to produce attractive results.

Dope Sheet: A guide and outline for animators, in which frames of an animation are listed by number on a paper list or in a database or spreadsheet, with notes about what happens in each frame.

Fan Art, Fan Animation: Amateur art, often extremely skilled, but featuring well-known and copyrighted superhero, anime, manga, or feature film characters, often without official permission.

Feature: A full-length motion picture, usually at least 80 minutes long. Animated features are traditionally somewhat shorter than live-action features.

FK (Forward Kinematics): A form of hierarchy in which parent objects affect child objects but not vice versa.

Flat Shading: A quick 3D imaging mode that renders solid colors and volumes without subtle shading or shadowing; often has minor imperfections.

Frame: A single image from a motion picture. There may be more than 100,000 frames in an animated feature.

Frames Per Second: The rate that frames are played in an animation. The standard feature film frame rate is 24 frames per second.

Game Engine: Software development kit for creating video games. Some game engines contain character animation tools that can be adopted to make automated or script-driven noninteractive movies, called machinima.

Geometry: The "skin" of a model, made of polygons or splines, before rigging and texturing. Also called mesh.

Global Illumination: A rendering approach in which the light bouncing among all objects in a scene is calculated. Provides high realism at high cost in computation.

Hierarchy: Parent-child relationships along a sequence of linked objects.

IK (Inverse Kinematics): A form of hierarchy in which child objects affect parent objects but not vice versa.

Keyframe: Frame that defines the beginning, ending, or important pose of a character motion or object animation sequence.

Kinematics: In 3D, the hierarchical articulation of motion.

Layout: Stage of production in which character motion and camera moves are roughed out before finished animation is added.

Machinima: Movie animation created using a game engine.

Manga: Japanese comic books. Frequently the sources of graphic styles, stories, and characters for anime and fan art.

Map, Mapping: 1) Image applied to the surface of a 3D model. 2) The process of applying such maps. Maps can apply photographiclike textures, and also control bumpiness, specularity, color, surface displacement, and other surface characteristics.

Mesh: See Geometry.

Model: A 3D object built from polygons or splines.

Model Sheet: Design document specifying the look and characteristic poses of a character.

Motion Detailing: Adding secondary actions and other fine movements to complete an animated sequence.

Motion Graph: An aid to 3D animation; a graphic, editable representation of time plotted against keyframes or other motion parameters.

Pipeline: The sequential production process of an animated film. In most cases, this means the channeling of animation assets through the main stages of production, including modeling, surfacing, layout, animation, lighting, rendering, and compositing.

Polygon, Poly: A patch, often triangular, used to define the surface of a 3D model.

Pose: A key position of a character. The pose should convey emotion, motivation, or other important information about the character and its situation.

Pose Reel: A form of animatic in which drawings of key poses are edited together to synchronize with the sound track.

Proxy: A simplified version of a character that is less computationally intensive to manipulate for animation.

Ray-tracing: High-quality but slow render mode in which light rays are traced from each point on every 3D surface to the camera.

Render: To create a 2D representation of a 3D scene.

Renderfarm: A system of networked computers—often incorporating thousands—used exclusively to render frames for animation.

Resolution: 1) The number of pixels in an image. 2) The number of polygons or patches and the amount of fine detail in a character.

Rigging: The process of adding bones, constraints, and controls to a character or other articulated model to prepare it for animation.

Ripomatic: A form of animatic created using clips from existing feature films and other ready-made, probably copyrighted sources.

Setup: See Rigging.

Shader: A procedural (algorithmic) texture for models, ready-made or written in a shader programming language. Shaders are more computationally intensive than maps and therefore slower to render, but use memory much more efficiently and can be made to permeate the entire volume of a model, not merely lie on the surface.

Short: A brief independent animation, usually less than 10 minutes long.

Skeleton: The underlying bone structure of a 3D character. Required to control the deformation of the character during animation.

Spline: A curve used to define the shape of a model. Splines may also be used as editable controls in various interface elements, such as motion graphs.

Spot: A television commercial.

Stop-Motion: Form of animation in which real-world objects are moved incrementally, with each incremental move recorded to a single frame of video or film. Stop-Motion was used intensively for monster movies, including the original *King Kong*.

Texture: Surface characteristics of a 3D model. May be composed of many individual layers.

Toon: A cartoon character.

Wireframe: Representation of a 3D model as unshaded polygons or splines. A good way to view the model's structural details.

BIBLIOGRAPHY

Further reading

Anzovin, Rafael: *Nonlinear Animation.* (Anzovin Studio, CD-ROM edition, 2003)

Barrett, Justin: *Animating a Face.* (Anzovin Studio, CD-ROM edition, 2004)

Blair, Preston: *Cartoon Animation.* (The Collector's Series). (Walter Foster Publishing, 1995)

Birn, Jeremy: *Digital Lighting & Rendering.* (New Riders Press, 2000)

Cantor, Jeremy and Valencia, Pepe: *Inspired 3D Short Film Production.* (Muska & Lipman/Premier-Trade, 2004)

Culhane, Shamus: *Animation from Script to Screen.* (St. Martin's Press; reprint edition 1990)

Demers, Owen: *Digital Texturing & Painting.* (New Riders Press; Book & CD-ROM edition, 2001)

Eisner, Will: *Comics & Sequential Art: Principles & Practice of the World's Most Popular Art Form!* (Poorhouse Press, 1985)

Eisner, Will: *Graphic Storytelling.* (Poorhouse Press, 1996)

Ford, Michael and Lehman, Alan: *Inspired 3D Character Setup.* (Muska & Lipman/Premier-Trade, 2002)

Hartas, Leo: *How to Draw and Sell Digital Cartoons.* (Barron's Educational Series, Inc., 2004)

Johnson, Ollie and Thomas, Frank: *The Illusion of Life: Disney Animation.* (Disney Editions, revised edition 1995)

Kerlow, Isaac Victor: *The Art of 3-D Computer Animation and Effects, Third Edition.* (John Wiley & Sons, 2003)

McCloud, Scott: *Reinventing Comics: How Imagination and Technology Are Revolutionizing an Art Form.* (Perennial Currents, 2000)

McCloud, Scott: *Understanding Comics: The Invisible Art.* (Perennial Currents, 1994)

Osipa, Jason: *Stop Staring: Facial Modeling and Animation Done Right.* (Sybex Books; Book & CD-ROM edition, 2003)

Ratner, Peter: *3-D Human Modeling and Animation,* Second Edition. (John Wiley & Sons, 2003)

Roberts, Steve: *Character Animation in 3D: Use traditional drawing techniques to produce stunning CGI animation.* (Focal Press, Book & CD-ROM edition, 2004)

Simon, Mark: *Storyboards: Motion in Art,* Second Edition. (Focal Press, 2000)

Williams, Richard: *The Animator's Survival Kit: A Manual of Methods, Principles, and Formulas for Classical, Computer, Games, Stop Motion, and Internet Animators.* (Faber & Faber, 2002)

Young, William. *Modeling a Face.* (Anzovin Studio, CD-ROM edition, 2003)

INDEX

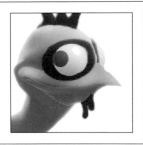

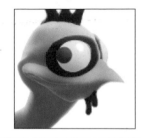

INDEX 2

RIGHT: Jérôme Denjean's Frost Giant, from original art by Paul Bonner.

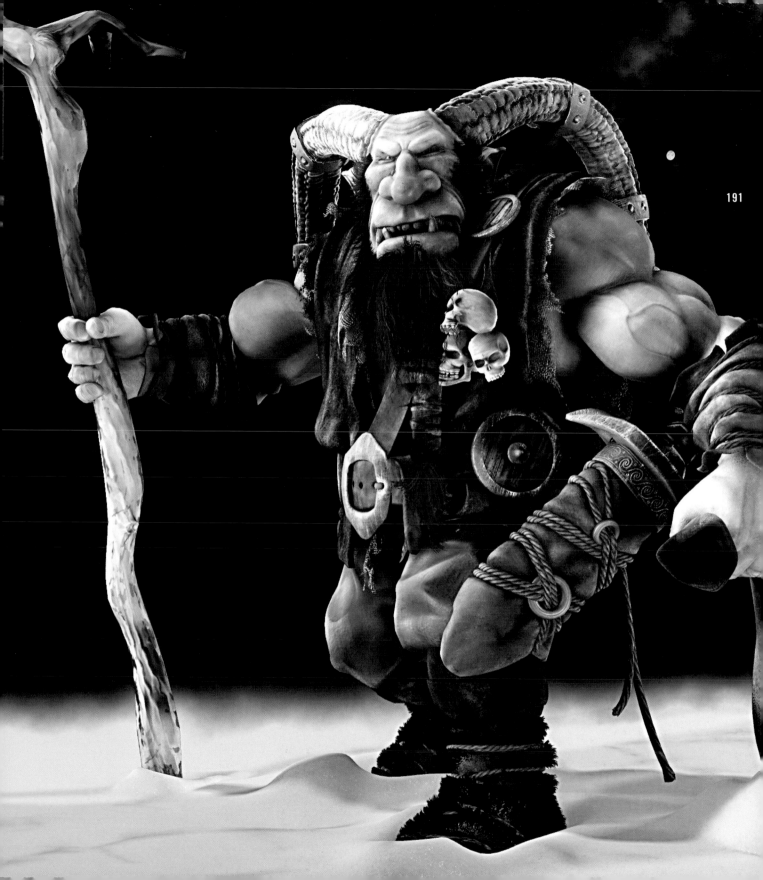

ACKNOWLEDGMENTS

We'd like to thank, first, the artists who graciously agreed to contribute their work to this book; Bill Young and Morgan Robinson, for vital assistance at very short notice; Joey Cade and Daley Miller of Reel FX; Jeff Bunker of Avalanche Software; Stuart Andrews and Alastair Campbell of Ilex Press; Dan Lombardo and Karen Banta, for offering support in trying times; Dr. Ken Anolik; Jen, Dick, Bella, and the IC staff at Cooley-Dickinson Hospital; and above all Janet Podell, beloved wife and mother.

Steve Anzovin
Raf Anzovin
Amherst, MA
December 2004